THE
BEST
JOB
IN THE WORLD

THE
BEST
JOB
IN THE WORLD

HOW TO MAKE A LIVING FROM
FOLLOWING YOUR DREAMS

BEN SOUTHALL

WILEY

First published in 2015 by John Wiley & Sons Australia, Ltd
42 McDougall St, Milton Qld 4064

Office also in Melbourne

Typeset in 11/13.5 pt ITC Giovanni Std

© Ben Southall 2015

The moral rights of the author have been asserted

National Library of Australia Cataloguing-in-Publication data:

Author:	Southall, Ben, author.
Title:	The Best Job in the World: how to make a living from following your dreams / Ben Southall.
ISBN:	9780730313762 (pbk.)
	9780730318217 (custom)
	9780730313779 (ebook)
Notes:	Includes index.
Subjects:	Southall, Ben.
	Life change events.
	Self-realization.
	Vocational guidance.
	Tourism — Queensland — Hamilton Island.
	Hamilton Island (Qld.) — Description and travel.
Dewey Number:	650.14099431

Cover design by Wiley

Cover image © Eddie Safarik

Extracts from Tourism and Events Queensland Best Job in the World campaign on pages 86, 87, 88 and 94 Copyright © Tourism and Events Queensland. Reproduced with permission.

Printed in Singapore by C.O.S. Printers Pte Ltd

10 9 8 7 6 5 4 3 2 1

Disclaimer
The material in this publication is of the nature of general comment only, and does not represent professional advice. It is not intended to provide specific guidance for particular circumstances and it should not be relied on as the basis for any decision to take action or not take action on any matter which it covers. Readers should obtain professional advice where appropriate, before making any such decision. To the maximum extent permitted by law, the author and publisher disclaim all responsibility and liability to any person, arising directly or indirectly from any person taking or not taking action based on the information in this publication.

Contents

About the author

Ben Southall was born in 1975, the son of Margaret and Duncan Southall. Educated at Ropley and Perins schools, Ben went on to study his A levels at Alton College before moving to Kingston University, where he gained a BSc in Automotive Systems Engineering.

Ben spent the next few years swapping between the northern and southern hemispheres on a mission to follow summer around the globe, working for Mumm Champagne as an event manager, promoting the brand at major sporting events such as Cowes Week sailing, Lords cricket, Wimbledon tennis, Henley rowing, Ascot racing, Silverstone F1 and the Round-the-World Yacht Race in Cape Town.

From this posting in South Africa his love of the African continent grew, with extended travels along the coastline being the best place to spend the UK winter... and his hard-earned cash. Having found a base in the town of Port Edward, Kwa-Zulu Natal, Ben worked as a tour guide for Wild Coast Tours taking backpackers and tourists on local adventures.

In 2000, Ben embarked on his first overland expedition to witness a total solar eclipse in Mozambique, followed by another a year later in Botswana—enough to whet the appetite for later expeditions. While working at the Royal Star & Garter Home in Richmond as an event manager, Ben developed a love of running and endurance events, creating the Charlie Hankins 24hr Challenge in 2006.

In 2008 Ben departed on his solo adventure, Afritrex—an ambitious overland expedition to circumnavigate Africa in his trusty

Land Rover, Colonel Mustard. Together they travelled over 65 000 km through 38 countries. His return to the UK was short-lived however. Ben won Tourism Queensland's internationally acclaimed Best Job in the World, beating 35 000 other applicants from around the world to the title of Island Caretaker. He spent six months living on Hamilton Island while exploring every metre of Queensland's coastline and diving the length of the Great Barrier Reef, filming, photographing and blogging about his experiences.

2011 saw Ben embark on his next challenge: the Best Expedition in the World — a four-month, 1600 km kayak along the Great Barrier Reef retracing the route of Captain Cook back in 1770.

In 2013 Ben, Luke Edwards and Pat Kinsella set a world record for the fastest ascent of the tallest mountain in each state in Australia — the Aussie 8. The subsequent 42-minute documentary aired in Australia on Channel 7.

Ben has worked with television, radio and print media from around the world, including the BBC, CNN, Sky, ABC and Oprah Winfrey. He holds the unofficial world record for the most interviews in a 24 hour period — 124!

Ben has completed over 15 marathons to date, in Morocco, Kenya, Australia, the US, Japan and Scotland and England, including two 90 km Comrades races in South Africa. Ben is an Ambassador for Alton College, University of Queensland Business School, Tourism Queensland and Alpina Watches, and the Patron of Sailability.

He is a keen supporter of the Royal Star & Garter Homes, FARM-Africa, IDE-UK, ZigZag Foundation and Sailability. Ben married his sweetheart, Sophee, in 2012 after meeting her while emceeing an awards ceremony in the Whitsundays, Queensland, in 2010.

Acknowledgements

Life is full of 'stepping stone moments' that have helped me jump from one chapter to the next. Some have been good and some bad, but they've all helped shape and steer my direction through life.

Over the years the incredible support of my friends and family has allowed me to take full advantage of the opportunities that have come my way. By nodding positively as I reel off my plans for the next adventure, supporting my ludicrous ideas and firmly believing I'll succeed, they've given me the confidence to think big and fully embrace life.

If only everyone had friends and family as wonderful as mine, the world would be a much better place.

To my darling Sophee. The moment you walked into my life it became a much better place. Having someone to share the world and its wonders with, to bring me back down to earth when my internal chaos takes over and to be the rock in my brilliantly stupid life needs someone with your inner beauty, intelligence and understanding. I can't thank you enough for standing by me and being my wonderful wife and best friend.

Mum and Dad — simply the Best Parents in the World — you gave Becky and me a childhood to cherish. Nothing was ever too much hassle, you instilled morals in us I still value today and you were always there to pick up the pieces whenever I screwed up! Words fail to explain how much you mean to me.

To my sister Becky, I may have been a brat of a brother but as long as you know how important you've been throughout life as my little sister, a voice of reason, my shoulder to cry on and mother to the most wonderful nephews and niece I could hope for, then I'm happy.

Africa. The birthplace of my sense of adventure. Without its rawness, beauty and addictive personality I wouldn't have embarked on a personal journey of exploration that continues today.

My friends in Port Edward, of which there are too many to name. My second home and somewhere I cherish and think about all the time. Happy days and even happier nights!

Without the team at Tourism Queensland and Hamilton Island, the Best Job in the World would never have happened and consequently I'd never have met Sophee. Your vision and creativity to produce a campaign that gripped the world's media, all 34 684 of the applicants and especially the 15 other finalists has gone down in the history books as one of a kind.

Thank you to all the friends who've come on parts of this journey with me. Owen for being both the most brilliant and useless friend at the same time. Luke for just being you. Josie, Rosie, Zoe and Alison for being the splendiferous sunshine friends who helped my Best Job campaign get through to the final.

And to those dearly departed friends who left Planet Earth far too early — Guy Kilgallon, Charlotte and Alan Jones. Your friendship, zest for life and stories of travel and adventure sit with me every step of the way as I continue to push myself on to yet greater goals. Your lives were not in vain.

Jay Byrde — I miss you.

Am I dreaming?

I covered my face with my hands and stifled a gasp, frozen to the spot by the shock of what had just happened. For a moment time stood still.

Then came the crush. Hands grasped me, arms wrapped around me, hugs forced the air from my chest. I struggled to stay upright as more people joined in and the sound in the room got louder. A throng of blue t-shirts surrounded me.

I took a deep breath and felt a kiss on my cheek that woke me from my stupor. I focused on the people around me. They were all grinning from ear to ear, jumping up and down, celebrating—and *I* was the centre of attention!

The other finalists cheered and showered me with congratulations, the sound of their voices merging into one. Slowly they separated and fell back into line as a microphone was thrust into my hand. I walked towards the lectern, lifting my gaze to the audience before me and outwards to the line of cameras at the back of the room. The media was watching.

How on earth did I get here? Twelve months ago I was covered in sweat and mud in equatorial Gabon rebuilding a broken bridge on my journey around Africa. Now here I was on Hamilton Island in front of the world's media, winner of 'the best job in the world'.

After five months of hard campaigning I'd beaten 34 684 other contestants vying for the job of 'Caretaker of the Islands of the Great

Barrier Reef'. Behind me on the stage stood the 15 others who'd made it all the way through to the final.

I had no idea what the next few months would bring — apart from a change of country, a salary of $150000 and a $3.5 million luxury villa to live in. With 2300 kilometres of coral reefs and more than 600 islands to explore there'd be travel, and lots of it.

'Wow! Ladies and gentlemen, we've all been involved in a marketing campaign that has been an enormous worldwide success. To all of the candidates standing behind me ... everyone is an absolute winner and I think we've had the most incredible three days of our lives — thank you!'

With my brief acceptance speech out of the way the media interviews began. I worked my way out into the bright spring sunshine, ready to face the paparazzi.

'How does it feel to have won the "best job in the world", Ben?' one journalist asked.

'It's absolutely crazy if I'm honest. I can't wait to get started,' I replied, almost bursting with excitement.

'How lucky do you feel right now, moving from the outhouse to the penthouse?' she came back.

I worked through the question in my mind. How 'lucky' did I feel? Had luck really played any part in the last five months of hard work or the 10 years of expeditions, training and logistics before that?

The reason I was standing there giving that interview wasn't down to luck, but to the hard work I'd put into each and every one of the projects I'd been involved with. Taking a dream and turning it into reality was something I'd become used to doing, following the age-old adage that 'the harder you work, the luckier you get'. So the 'best job' didn't just fall into my lap by chance; there was application and strategy involved at every stage of the process.

* * *

Over the years I've read many travel and adventure books written by inspiring people who've completed outrageous journeys around the planet. From driving a pink *tuk-tuk* across Africa to skateboarding across Australia to running a marathon on every continent in seven days — all of them have challenged the human spirit and confirmed the theory that life is there for the taking.

With this book I want to offer more than just a chronicle of my travels. There are writers who wrap their travel stories in beautiful words and conjure up breathtaking images of life on the road and their experiences along the way.

Unfortunately I don't have that kind of creative or artistic mind, and I often struggle to find ingenious words to summarise an escapade. But what I can share are the many lessons I've learned planning, executing and delivering successful projects in far-off corners of the world. Threaded through my stories of travel and adventure you will find the tools you need to turn your own 'could-do' journey into a 'have-done' adventure!

The Best Job in the World: How to make a living from following your dreams is my story, but it is also a guide that can help you make key decisions when planning your own journey or adventure. My hope is that it will inspire you to live your dream while also providing you with practical advice on how to get there — from turning an idea into a plan, to gaining sponsors and partners, to using digital and social media platforms to build an audience and tell your story.

Finding my way

Despite the success I've enjoyed in my adult life, I always struggled in school. My first memory of it was sitting in a classroom in Bournes Green Infant School at age six wasting an entire morning working out whether 'this morning' should be written as one word or two.

It didn't get much better when I moved up to the junior school. I can't quite remember how at the age of eight I managed to send my teacher home in tears, but suffice to say Ms Murray didn't list me as one of her favourite pupils. My school report constantly referred to my inability to concentrate in class.

Back in 1985, Attention Deficit Hyperactivity Disorder (ADHD) wasn't recognised. My hyperactivity as a child was blamed on excessive E-numbers in my food and drink. I clearly remember being forbidden to drink orange and lemon squash because they contained a dangerous combination of the additives E102 and E110.

Mum and Dad struggled with my schooling, especially on the annual Parents' Evening. I dreaded their first words when they got back. I would ask optimistically, 'How did it go?', hoping that one day they'd say, 'You've been a model student, Ben. Well done'. It never happened. My sister Becky got enough brains for both of us, always topping the class and putting me to shame. She's been a source of inspiration all my life, but I felt that as the older sibling it should have been the other way around.

An education

One of my favourite subjects at school was geography. Learning about the world and what makes it tick provided fuel for my mind even at an early age. As soon as I opened my first *National Geographic* magazine with its yellow-framed cover, I was hooked. I remember folding out the map of an unknown country and poring over it, mesmerised by all the squiggly lines, trying to work out what the legend meant.

Seeing magnificent images of distant lands and strange-looking people only added to my fascination and curiosity. In my final year at Bournes Green, I crossed the path of a teacher named Mr Barton, a bald dictator who put the fear of God in me. If I acted up in class, he'd tower over my desk and stare intensely at me from behind his thick-rimmed glasses.

'You, Ben Southall, will amount to absolutely nothing in life if you continue as you are', he would bellow at me across the classroom. The memory still sends shivers down my spine.

As to my other favourite class, physical education, Mr Barton did have a few good words to say in my school report: 'In PE, Ben is extremely enthusiastic and competitive.'

It may not have meant much at the time, but what I was introduced to by those two subjects — a love of travel and physical challenge — still shape my world and motivate me every day.

When I was 10 years old my father changed jobs, which took the family from the delights of Southend in Essex to rural Hampshire. Our house no longer fronted onto a main road but instead looked across a huge arable field with glorious views of rolling countryside.

The move brought a change of schools of course, and with it a change of teacher. Enter Mrs Wilson. I walked into my classroom at Ropley School for the first time, lost in a uniform I'd 'grow into', with my school kitbag slung over my shoulder, and sat next to the nearest boy, Dan Kieran, who looked friendly enough.

In the corridor outside I heard the raised voice of an angry teacher before a frightened looking girl hot-stepped through the door followed by Mrs Wilson, her hand clutching a slipper raised to head height, poised for the strike.

I sat motionless for the next five minutes, watching as Jessica received every centimetre of that size nine moccasin across her backside. I'd left the city behind and arrived bang in the middle of Victorian England, where corporal punishment was standard practice.

Mrs Wilson turned out to be the best teacher I've ever had. Her tough exterior quickly melted away as she took me under her wing. I learned more about life in one year at Ropley Church of England School than I had in the previous five at Thorpe Bay. A combination of tough love and an understanding of how to channel my hyperactivity gave me direction for the first time in my school life.

Stepping up to 'big school' at the age of 11 was another huge shock to my system. I no longer had to walk for five minutes to get to the school gates; instead, I faced a 10-minute journey in the other direction to wait for the scary school bus. My love of sport and outdoors really took off at Perins Community School, and nowhere more than on the Wednesday cross-country run. Come rain or shine, 30 unlucky souls would take to the tracks and trails around the town in a desperate race to get back to the warmth of the showers.

I loved every minute of it — splashing through the mud, crossing the ankle-deep River Arle and fighting my way through the bramble-lined footpaths of Hampshire. There was something exhilarating about throwing off the shackles of organised sport in the school yard, being let loose in the real world to take on the elements. It felt stimulating to explore even this small corner of the planet.

Sport was fast becoming my main creative outlet. I joined the hockey team at age 11, when Perins became the first school in the county to lay an astroturf pitch. It was 1988 and England had just won gold in men's hockey at the Seoul Olympics, so I rode the wave of enthusiasm all the way to my local club, Winchester. For 10 years I couldn't get enough of it, spending five evenings a week training and playing, representing my club, Winchester; my county, Hampshire; and Kingston University.

At the time, family holidays didn't offer much insight into my future love of travel. Year after year we'd pack up the car and drive for hours to the north of Scotland to spend two weeks gazing out of a rental cottage window at the driving rain.

Yet these holidays were also wonderful. Mum and Dad loved exploring and took us on all kinds of crazy adventures around the highlands and islands of west Scotland. Their love of the great outdoors was instilled in Becky and me from an early age.

Apart from a couple of long, challenging weeks spent on French exchange programs while at school, by age 16 the only foreign adventure I'd had was a two-week school cruise around the Mediterranean. Mum and Dad saved for two years to pay for the ticket that saw me join 30 other lucky kids to explore the wonders of Greece, Israel, Egypt and Turkey.

My school shirt was signed by a hundred friends when I walked out the gates of Perins for the last time. I'd scraped through my exams, just about getting the grades required to attend Alton College. Not

that I particularly wanted to go; it was simply what everyone expected of me, so I toed the line and signed up for three A levels: Design Technology, Computer Science and Physics.

It didn't take me or my teacher, Dr Colley, long to realise I'm no mathematician. Physics and figures weren't my forte so I dropped the most mind-numbing subject to concentrate on my newfound loves of design and engineering.

Dad spent 40 years working as an engineer, so a hands-on approach to technology played a huge part in my childhood. I can remember few occasions when Dad had to call on the services of a tradie of any kind, always preferring to 'have a tinker' himself. Although this approach can result in a few unfinished projects, it also provides a wealth of knowledge and experience of how you can fix just about anything if you put your mind to it and keep your patience.

For two years I applied myself at Alton College with the help and guidance of two inspiring lecturers, Steve McCormack and Steve Goater, who provided their own style of tuition. Along with Dad, both helped me create my finest engineering project — a bright green half Volkswagen Beetle trailer. It matched the very 1990s snot-coloured car everyone knew me for at the time.

The expectation of university loomed large over me during those final few months at Alton. I'd had my fill of formal learning and more than anything wanted to get out into the real world, but I decided to risk it all with one final attempt at educating myself to a reasonable level. University, after all, is about proving you can apply yourself — for a fixed period of time. Apparently it's something employers find attractive. Many years before, Mr Barton had declared my chances weren't good. It's amazing how long such slights can stick with you.

The practical side of engineering was proving to be where my aptitude lay. I was good at pulling things apart and almost as good at putting them back together, bar a mystery screw or bolt here and there. I enrolled for a Bachelor of Science degree in Automotive Systems Engineering at Kingston University and spent my first year living in student digs, my first taste of what life was like living away from home.

It didn't last long, but not because I didn't enjoy it. I was playing more and more hockey for my Hampshire-based teams, picking up a stick almost every day. Back then I considered my commitments to my chosen sport more important than being part of university life.

I look back now and wonder whether I'd have done a little better at university if I'd actually stayed there and given it my all.

The pressure was building from all sides during my final year at Kingston. My course was becoming more analytical, requiring total application, but I just wanted to play hockey down in Hampshire. Driving 50 miles a day up and down one of the UK's most congested roads probably didn't help my sanity.

One morning I cracked. I walked out to my car to start the long drive to London, but then stopped and broke down. I sat on the driveway with my head in my hands, sobbing uncontrollably. The massive pressure of my final year had become too much. I was convinced I was doomed to failure. Mum spotted me from inside the house and rushed out.

'Ben, what on earth's wrong?'

'I just don't know why I'm doing this course. I'm no good at it and I've no idea what I want to do after uni!' I blubbered, tears rolling down my cheeks.

As usual, she was ready with good maternal advice: 'If you can just get through the next couple of months, apply yourself as best you can and get any sort of grade, we'll be massively proud of you. Then you've got the entire summer to decide what you want to do.' It was a reassuring and practical take on my mountain of a problem.

She made 'getting through' sound so easy, but I knew I had some serious work to do to have any chance of even scraping a second-class degree — a goal that had sounded so easy two years earlier.

I worked furiously hard over the next few weeks. The fact that it was the end of the hockey season helped, as it meant I could concentrate fully on the task without the distractions of my favourite sport. I became a social hermit for a month and applied myself like never before, revising for my exams and finally handing in a dissertation I was proud of. It took a massive effort of late nights to get there but at last I was free to breathe in the freedom of life after uni.

Mumm's the word

That summer proved to be a turning point in my life. With the shackles of education removed, I had to go out and find work. It didn't matter what it was — just something to fund the festival-packed lifestyle I wanted to lead over the next few months.

I fell on my feet.

An ex-girlfriend had been working for a public relations company called First Results that handled a number of high-profile accounts, including French Mumm Champagne. After we split up we'd remained good friends, and now she asked if I'd like to work with them at the exclusive Cowes Week sailing regatta on the Isle of Wight for a few weeks over the summer.

The offer sounded too good to be true. We'd get to drive brand-new sponsors' cars, serve champagne on luxury super-yachts, socialise with the yachting fraternity and live life to the full — while getting paid handsomely for it.

Only a few weeks earlier I'd walked out of university not knowing where my future would take me. Now I'd been given a wonderful opportunity to enter the world of public relations, event management and hospitality. I knew I was a 'people person' and could start a conversation with anyone, but until I started the job I didn't know what an asset this would be in the 'real world'.

Surely work wasn't meant to be this much fun. My team was wonderful, filled with active, dynamic, social young people happy to put in the hours and proud of the product we were representing. It didn't matter that we worked 13-hour days; life was all about smiles and good times.

As the summer rolled on I was in my element, out in the open air, working hard and saving money too. My best mate Jay, fresh back from a year living in South Africa, got a job with us for the last few weeks, which made the daily 'grind' even more enjoyable. I'd missed him, so when he said he'd be heading back in a few months I felt a pang of jealousy. His travelling lifestyle was truly enviable.

'What's stopping you from coming with me, Ben?' Jay asked nonchalantly, making it sound easy.

'Umm ... I've got a job to find and a career to start. I can't go off gallivanting around the world ... can I?'

'Well if you don't go, you'll never know', Jay replied smugly, walking away with a glint in his eye.

For a few days I didn't think about the proposition, until Mary, the owner of First Results, pulled me aside after another long day at work.

'Ben, you've been brilliant this summer; we've really enjoyed having you around. You live the brand, use your common sense, have an eye for detail and always wear a smile.'

That of course felt really good to hear. It hadn't been a tough job, and I'd felt an affinity for it from the moment I started. Working hard and doing what came naturally to me seemed to be paying off.

Mary continued, 'There's only a couple of weeks left until the end of your work here but I'd like to offer you another role, if you're up for it?'

I'd no idea where this was going, but I was intensely curious.

'Sure, what are you thinking?' I replied.

'The Whitbread Round the World Yacht Race departs from Southampton in a few weeks' time, and Mumm is one of the sponsors.'

I liked where this was heading. Mary was hinting there'd be more work in the world of sailing, which was wonderful as far as I was concerned. I was thrilled to learn that I wasn't quite done with this adventure.

'I'd like you to be our Land Manager, responsible for all of our branding and stock, making sure the Mumm name is everywhere at the event.'

I struggled to contain my excitement, doing my level best to affect an air of professional detachment. She continued.

'Then when the yachts have gone, I want you to head to Cape Town to prepare for their arrival, again making sure Mumm is clearly visible in any media activity.'

'Cape Town? As in South Africa?' I blurted out. I responded immediately, 'Mary, I'd love to do it. And I'll make sure everything happens just as you want it to.'

And just like that I'd committed to an adventure to a country I knew nothing about. Of course I could have no idea how much that one moment would shape the next 10 years of my life. I was off to Deepest Darkest Africa.

It began in Africa

With a week to go until I boarded the plane I met up with Jay to talk through the final details of his trip. He was heading back to his old haunt, Port Edward in Kwa-Zulu Natal on the east coast of South Africa to 'relax' and do nothing more than travel up and down the coast looking for surf with our mutual friend Alan.

Through good luck and good timing our trips would coincide in a few weeks' time. I was heading to Cape Town on the opposite side of the country to work for a month and then would head east and join him for three months of travel together.

A huge map of the country was spread out on the table before us. I learned pretty quickly that distances in Africa are measured in days of travel, not hours as in the UK.

'So I can catch a bus all the way from here to you, then?' I said tracing my finger along the coastline.

'Sure, there's a hop-on, hop-off coach service called the Baz Bus, but it'll take you a few days, and that's if you stay on board all day. You'd be better to take a week or so, stop off at some of the beautiful places along the way and actually see some of the country.'

Jay was talking like a hardened traveller now, and he had good reason to, having spent the best part of the last year living in the country. I was a little more sceptical, though. This was my first independent overseas trip so the idea of catching a bus through 'one of the most dangerous countries in the world' wasn't immediately appealing. I just wanted to get to Port Edward, and the measured safety of my best friend's company, as quickly as possible.

It's amazing how much you build up a perception of a place you've never been to based on what you read in the news. It's not until you hit the ground and experience life there for yourself that you can truly judge how 'dangerous' a place can be.

After years of travelling through Africa since, I've learned to take sensationalised news headlines and government travel warnings with a pinch of salt. Yes, of course it's good to be cautious, but it's quite often the country whose people have been persecuted the most by their governments and the international media who have the most to give. You can get yourself in trouble in *any* city in the world, no matter how peaceful, if you go out looking for it.

* * *

The taxi ride from the airport to the city was an eye-opener. Huge advertising hoardings lined the road. Behind them rundown shacks held up by corrugated iron sheets stretched off into the distance; life here looked rough and tough. Were people really walking down the sides of the main motorway? Surely the police wouldn't allow that? They certainly wouldn't in England.

But I wasn't in England. I'd flown 11 hours due south, passing over the world's second-largest continent before touching down on the south-western tip of Africa's most 'civilised' country — according to some people, anyway. From what I'd seen so far I couldn't agree.

It took me a couple of days to get my bearings and find my confidence. Working in the tourist-safe surroundings of the V&A Waterfront meant I didn't get to explore the city proper and was protected from the real world by over-zealous security guards and the fanfare of the Round the World Roadshow.

My walk home to the hotel in Green Point was the closest I got to the darker side of the *Kaapstad*, the Afrikaans name for the city. As a bright-eyed, bushy-tailed innocent I assumed the advances I was getting from slightly underdressed girls along Main Road were spontaneous, until one of my workmates pointed out I'd need to pay for their company.

I witnessed death first-hand on that walk. Not from a gunshot or knife attack as you might expect from a country with one of the highest murder rates in the world, but when a drunk guy walked into the path of oncoming traffic. I'll never forget his body cartwheeling over the roof of the car as it screeched to a halt.

Cape Town was a complete education for me, a young traveller still wet behind the ears. The most popular international tourist destination in Africa delivered everything I expected and so much more — from the iconic view of Table Mountain with its wispy tablecloth, to the wonder of penguins on the sands of Boulders Beach, to the foreboding isolation of Mandela's cell on Robben Island.

Working for Mumm Champagne was wonderful. Until now my work experience had been only with fellow Brits. This role threw me in at the deep end, and I met people not only from South Africa but, with 10 international sailing teams in the city, from all around the globe.

I was invited to social events and on dinner dates, which fuelled my desire to visit the countries I was hearing so much about. By surrounding myself with well-travelled, intelligent people I was opening my mind to places I'd never even thought of visiting. Suddenly my bucket list of 'must visit' places stretched wider than the UK.

Over the course of a fortnight I watched all 10 yachts cross the finish line after racing each other for nearly a month from Southampton. Part of my role was to jump on board at the first opportunity to hand each skipper two magnums of celebratory champagne. The real skill lay in jumping off just as quickly to avoid being showered in sticky bubbles.

Crossing the line in second place was *Merit*, skippered by the New Zealander Grant Dalton. The yacht arrived in the dead of night to the sounds of Chumbawamba's 'Tubthumping'. I could have no

idea I'd bump into the same boat at Hamilton Island Race Week 12 years later!

With the event over it was time for me to leave Cape Town and start the journey east to meet Jay and Alan. I'd been working for an English company and being paid in British pounds, which had earned me plenty of money to stay on for a few months. With no job waiting for me back home I was free to travel for as long as my heart desired, or until my money ran out.

The trip in the Baz Bus along the Garden Route was spectacular, crossing deep gorges opening up to coastal vistas, watching fixated as this new world passed by. The further we travelled outside the towns and cities, the more it felt like Africa. Small rondavels dotted the rolling hills many miles from any electricity or running water.

I took my time as Jay had recommended, stopping off at backpacker hostels on the way, and a week later rolled into the sleepy coastal town of Port Edward. In the car park outside the KFC a red VW Beetle (Rosy) sat waiting.

Alan wandered over with a fat smile on his face, hugged me, grabbed my bag and carried it back to the car. Poking my head through the open door, there was Jay with an equally broad smile.

'Welcome to Port Edward, bru.'

It was time to relax.

The drive to the beach took us down the sleepy main street of Port Edward. Tractors hauled fishing boats back up the hill after a morning on the ocean. Big-bellied Afrikaners stood around chewing the fat. Young surfer kids argued over whose turn it was on the skateboard they had to share. Life seemed relaxed and easygoing.

As we turned onto the beachfront road I gaped with amazement at the vista that opened up before us. The dark blue ocean stretched out to the horizon, glistening under the intense African sun. To the north a long sandy beach hemmed in by rocky points shimmered under a misty veil thrown up by the powerful Indian Ocean swell.

Jay stopped the car facing the ocean as a huge plume of spray was thrown high into the sky directly in front of us.

'That's why it's called Splash Rock!' Jay declared. 'What do you think Ben, can you understand now why I love this place so much?'

"It's just wonderful ... I think I'll survive here!'

For the next two months I wound down from the stress of university life, happy to just be. Our days were anything but tough.

We'd walk or drive to a beach searching for a surfable wave, relax at our beach shack reading books from the comfort of a hammock and socialise with the locals at The Webb, the pub where we spent many hours watching England get thumped in the cricket and rugby.

We had sunrise sessions watching monster swells pound the shore, but I never really grasped surfing, which I put down to a complete lack of balance.

Our presence in a town as small as Port Edward didn't go unnoticed. Our little house became a hive of activity as new friends dropped by on their way to work or the beach, everyone keen to welcome us into their lives.

I made lifelong friends in the short time I spent in Port Edward. Here university wasn't the be-all and end-all of life. You didn't need to have a degree to be successful and happy. It was more about hard work and good times, values I took away then and continue to live by today.

We took Rosy on long drives south into the underdeveloped Transkei region of the country. I saw a side of African tribal life that fascinated me. There was obvious poverty, and crime was pretty rife, but the smiling faces of the children are still ingrained in my memory today.

The old cliché 'time flies when you're having fun' couldn't have been truer for me in South Africa. Before I knew it the three of us were crammed into our little Volkswagen, surfboards strapped to the roof, on the hot, slow eight-hour drive to Johannesburg.

My last few hours in the country went by in a blur. I was leaving behind a new life I'd fallen in love with, to return to the cold and darkness of UK winter.

My mind drifted for a moment. I was still walking along the golden beach with a surfboard under my arm. I couldn't concentrate and just wanted to go back, momentarily scared by the thought of normality.

The migrating swallow

Back in England I couldn't settle and took jobs that paid well but had no future. My only clear goal was heading back to South Africa as quickly as possible; life out there was more in tune with my way of thinking.

The English winter had always been a serious test for me. It wasn't so much the cold or the rain — I could handle them. What really got to me was the darkness, heading to and from work outside of daylight hours for four months of the year. It restricted my lifestyle and passion for exploring the great outdoors.

I could feel my enthusiasm for life drain away as winter closed in. It only returned in March when the clocks jumped forward an hour with the return of British Summer Time.

Life followed a similar pattern for the next four years. My work with Mumm Champagne started each May as the summer events kicked into life. Our team of four toured events in the summer's exclusive social calendar in a 1950s open-top double-decker bus: the cricket at Lords, the races at Ascot and Epsom, the tennis at Wimbledon and the Formula One at Silverstone.

As summer drew to a close the events would dry up, meaning it was time to fly south again like a migrating swallow, always in search of the sunshine.

Every time I arrived back at the crossroads in Port Edward after the long drive from Johannesburg it felt like I was arriving home. I embraced life back in the sleepy coastal town, falling in love with its landscapes, people, beach life and culture.

Being back there without Jay and Alan allowed me to better understand *me*. It gave me time to work out what life was all about, what made me feel happiest and ultimately where I wanted to live my life.

The town of Port Edward lies on the southern border of Kwa-Zulu Natal Province before the N3 highway crosses the Umtamvuna River and enters the Eastern Cape. It's the last town before the road winds through a less 'developed' part of the country.

I started work for a local tour company, driving an old ex-army Unimog chock-full of backpackers and fishermen on off-road trips into the wilds of the Eastern Cape, formerly the Transkei. South Africa's tainted past committed this part of the country to independent isolation for 20 years as one of the 'homelands' for the Xhosa people during the apartheid era.

Today it's still underdeveloped and life is hard for the people living there. Many still live in traditional rondavels with no running water or electricity, relying on their own subsistence farming to make ends meet.

As I've found in many other parts of Africa, it's often the people with the least in the way of possessions who give back the most personally, and here that was certainly the case. Driving along narrow dusty roads, over rolling hills and past village schools children would run out to meet us, waving and smiling as they tripped over each other to get to us first.

Over the years I learned some important lessons about giving out treats to the inevitable outstretched hands that greeted us every time we stopped. When I first started the tours the kids were more than happy with a smile and a handshake. But as more and more tourists visited the region, their demands increased until 'Sweets, sweets, SWEETS!' became their welcoming cry.

It's easy to give in when faced with situations like this, but I did my best to resist. Instead of handing over teeth-rotting sugar balls I brought pencils and small notebooks from the UK, hoping they'd prove a little more useful and longer lasting. A few years later in Mozambique I learned the error of my idealistic ways!

Top travel tips

Everyone wants to be a traveller rather than a tourist. You just seem to get more out of the experience if time is on your side. But if you are limited to a week or two in a foreign land, then follow these steps to getting the most out of your holiday:

- Travel overland rather than flying between places.

- Meet, stay, eat and travel with a local.

- Rise with the sun.

- Sit back and watch the world go by.

- Walk or ride across a city rather than taking the bus.

- Take photos, lots of them.

- Smile, shake hands and be polite.

- Open your mind—that's why you're travelling.

- Say yes more (thanks to fellow adventurer Dave Cornthwaite for this one).

- Don't plan everything—leave some things to chance.

Tragedy strikes

It took two tragic events to wake me from the slumber of my life and give me the incentive to work out where I was heading. The realisation of how fragile life is was brought home at the turn of the century with two bombshells.

Both were terrible events, but for me at least some good came from them. They brought home to me more than ever that I have one chance on Planet Earth and that I need to grab it with both hands if I'm going to make anything of my life.

One of my best friends, Guy, had taken off on his own global adventure, backpacking around the planet for a year after university, before starting work in the world of finance. He'd stopped on the Cook Islands for two weeks to get his dive certification so he could explore the beauty of the island's coral reefs. But on his first-ever dive something went tragically wrong, and two hours after returning to the surface Guy died of a brain aneurism. He was just 21 years old and in the prime of his life. Right then I developed a fear of diving.

In 2004 I travelled with Mum, Dad and Becky to our aunt and uncle's house in Spain to enjoy the Christmas festivities together. As Boxing Day morning dawned we gathered around the breakfast table in the villa nestled in the hills of a traditional Spanish village surrounded by olive groves and citrus trees to watch the horrific scenes of the Asian tsunami unfold on television. Coastal areas around the Indian Ocean had been devastated by a seemingly unstoppable wave of destruction. The shattered lives of so many were played out on the global news networks, each hour bringing yet more graphic images of the tragedy.

'My god, I've got friends in Thailand at the moment. I hope they're okay,' I said anxiously as we began breakfast.

'I'm sure they're fine, Ben,' Mum tried to reassure me, the way mothers do. 'Do you know where they're staying?'

'Umm, I think it's a little island off the southern tip of Thailand, but I couldn't tell you which one. I might just call a friend back in the UK to see if he's heard anything.' I needed to put my mind at rest.

That phone call left me with a pang of uneasiness squeezing my stomach tightly—that sick, nervous feeling that can't be shaken by anything but a complete reversal of fortune. The news I'd heard was anything but reassuring.

'Dave, Becky and Char were all staying on Ko Racha Yai when the wave struck, and all communications to the island have been cut. There's no way to find out anything. We've just got to sit and wait.'

So we did. It took two weeks for Char's body to wash up on the island. She and Becky had been racing up the beach to escape the incoming monster, hand in hand, when the wall of water tore them from each other's grasp. Becky tried desperately to hold onto Char, but she slipped away — snatched from her best friend, and from the lives of her family and friends back home. Dave had been on higher ground when the wave hit.

Dave and Becky had witnessed first-hand one of the world's most harrowing natural disasters. Their eventual return to the UK was psychologically difficult; the experience still haunted them many years later. The tragedy brought our group closer together. For the second time in five years, one of our friends had their life cut short. Just as Guy and Char were setting out to explore the world, their lives were extinguished. Yet for all the grief and heartache the events caused, they also gave me a vastly different perspective on life — and why we're here at all.

Between stints in South Africa, my time back in the UK had been all about living for the weekend. I'd spend Friday and Saturday nights up late, drinking heavily and smoking weed until I passed out, usually at a friend's house. I can't claim it wasn't fun, because it was. I had some of the best times of my life with close friends on the edge of consciousness. But I wasn't going anywhere. I felt that this was the extent of my world and I didn't need to look any further. I was happy to earn money for six months of the year, then fritter it away for the next six months chasing the sunshine on the far side of the world.

Losing Char brought me closer to her parents, Liz and Alan. In the tough months that followed the disaster our friends rallied around Char's family and shared their grief, helping out where we could. One Sunday afternoon while enjoying a barbecue at their house we began to discuss the trust Alan was hoping to set up to raise funds for some of the disaster-hit areas of Thailand.

After an hour of brainstorming we'd formulated a plan. With a few months to go until summer we had long enough to organise a major fundraising event. Our friend Ian had a huge field where we could host it, loads of our friends played in bands or DJ'd — and before we knew it we'd created a music festival we named Onionfest and the committee to organise it.

After everyone else had left that day I stayed chatting with Alan, enthralled by stories of his travels through Africa in the early seventies. When he was 25 he'd crossed the Sahara from Algeria to Mali in the back of a smuggler's truck, and he'd taken photos of the entire adventure. I demanded a slide show and a week later listened as he described the wonders of Africa, overland travel and exploring the largest sand desert in the world. I left feeling inspired.

It wasn't just his travel stories that motivated me. Alan also had a hidden athletic side he masked well behind his grey hair and wine-lover's belly. He was a veteran of several half marathons and even ran the full 42 kilometres in his prime years.

'I've run the Reading Half for the last 10 years. Do you think you'd ever do one, Ben? If I can do it, then you definitely can!'

Alan was baiting me here and I knew it. 'It's been on my radar to run a marathon one day, but I've never actually gone through with it,' I replied, doubtful I'd find time to train with all my other life commitments.

I'd always loved sports and exercise, and spent childhood running around the school playground in shorts playing football in the middle of the English winter. Playing hockey five days a week for the past decade meant I was pretty fit. If I wasn't doing sprint training on the pitch I was out jogging the lanes of Hampshire in all weathers, often with a head torch lighting my way in the darkness of winter. In theory, running a half marathon shouldn't be that hard for me, right?

'Okay, I'll do it. Promise me you'll stick with me, though? I don't want to take off with the lead pack!' I jibed, knowing Alan was an old-fashioned plodder.

We shook hands on the deal. I now had two months to prepare for my first race. Little did I know this would be the start of my running obsession.

Tragedy motivates

The loss of two friends proved how fragile life can be and how quickly it can go wrong, through no fault of our own. At the same time it prompted me to focus on the things I wanted to achieve in life, the places I wanted to go and the physical challenges I'd so far only dreamed about.

But I was no longer content just with dreams. I had to turn them into reality if I was to fulfil my potential and take advantage of my

adventurous spirit. The transformation of my life happened on three different fronts: running, adventure and charity—challenges I still value every day.

My first Reading half marathon was an incredible experience. Alan and I arrived early in the morning and made for the start line past fun-runners, serious athletes and even an army guy carrying a huge backpack. I knew I'd be happy just to make it across the finish line!

The atmosphere and buzz at the start of any organised race is addictive. Everyone has trained hard to get to the start line, spending many hours thumping the footpaths and streets around their home. Runners go through their stretch routines at the side of the road, the smell of muscle relaxant wafts through the crowd. Conversation breaks out intermittently between strangers.

In the distance the starting gun fires. We're off, everyone moving en masse. After 50 metres we stop again, reduced to walking pace by the sheer number of runners. It's like trying to crank over an old engine by hand; it fires, then splutters and dies. Another hard turn on the handle and it starts: our feet are moving again.

Once out on the course proper the distance just flies by. It's something to do with the support of the people along the way who distract you from the isolation of running alone. I've never run with headphones in and music playing. I can understand people who do it when training alone or in the gym as a distraction from the monotony. But here in the great outdoors with sounds all around us, it seems selfish to lock yourself away from the carnival atmosphere. Plus, those are always the runners who bump into everyone.

Alan started to drop back, happy to run at his own pace while I forged on ahead. It felt great to be outside, pushing myself hard in a big event. I crossed the finish line after 90 minutes of strenuous exertion, filled with a strange euphoria. I should have felt exhausted with nothing left to give, but the adrenalin and endorphins still raced through my body, making me feel as though I could do it all again.

The physical pain subsided, and I was back to walking properly after a few days! It wasn't long after the race that a voice inside my head popped the question: *You've proved you can run a half marathon, Ben, so how about going the whole hog and running a full one?*

* * *

My transformation to adventure junkie had been going on for almost a decade; I just hadn't noticed. Since 1997 I'd been travelling to South

Africa in search of adventure but hadn't really travelled outside the country, happy to tour the parts I felt safest in. Strangely it was a 400 km road trip to the south-west of England in the summer of 1999 that sparked my insatiable appetite for overland travel and visiting far-flung places on the map just for the sake of it. My best friend Owen and I joined thousands of other revellers on the trip to the Lizard Peninsula to witness the total eclipse of August 11, 1999.

I became an *umbraphile*. For those who aren't acquainted with this term, it's nothing seedy — just someone who loves eclipses, often travelling great distances to see them. For three hours we watched in wonder as the sun was gradually masked by the moon. The last rays of sunlight were smothered and an eerie calm fell over the watching crowds, followed by the totality, when complete darkness fell, if only for a couple of minutes, before the return of day.

As the first rays of sunlight returned the feeling of euphoria was incredible; cheers and shouts rang out all around. I could picture the same scene hundreds of years before in medieval times when people must have been terrified by the spectacle, unsure if the sun would ever return.

'*Wahoooooooo* — that was frikking amazing!' I yelled across the vast grassy campsite, where we'd joined hundreds of others who'd pitched their tents in the open field the night before.

'Okay Ben, let's make a deal. Wherever the next solar eclipse is in the world, we have to be there, right?' Owen piped up, the emotion of the situation getting the better of him. Before I knew it we'd shaken hands, locking in a gentleman's agreement.

Overland, under the spell

Solar eclipses can occur anywhere on the planet at any time of the year, though they usually take place over water, which makes sense given that 71 per cent of the planet is covered by it.

Owen and I committed to visiting wherever the shadow of the next eclipse fell. This was fairly achievable. NASA's website indicated that the next event would take place over southern Africa on June 21, 2001. As I was living in South Africa for six months of the year, all it would involve would be hiring a car and driving there. Simple enough.

Our 2001 trip to Mozambique was the first time I'd crossed an African border. Our rental Land Rover was packed to the hilt with

supplies, camping gear and camera equipment, leaving just enough room for Owen, my girlfriend Kathy, my friend Duncan and his friend Nat to squeeze inside.

The 2000 km drive opened up a new world of overland travel to me. The road wound along the coast through coconut plantations, over archaic bridges and past vast flooded river systems. We'd arrived in a third-world country two weeks after some of the worst floods in its history. Roads had been washed away, villages inundated and people's lives changed forever.

It was a wake-up call, bringing home to me the comforts of life I'd until now taken for granted. My home back in the UK was always warm, dry and secure, and even my house in South Africa was somewhere I felt safe. Here people had nothing. Without warning their lives, dreams and even family members had been washed away by a torrent of muddy water that came surging down the Zambezi River.

I'd been a typical first-world child in England, surrounded by the luxury of toys, computer games and television. I was always dressed in comfortable, clean clothes, with three square meals on the table every day. My parents did a wonderful job of bringing me up in English comfort. But here in the village of Caia on the banks of the Zambezi River, life was very different. After the Red Cross had taken control of the area, refugee tents stretched alongside the town's airport as far as the eye could see.

Our plan had been to stay by the water, pitching our tents alongside Africa's fourth largest river. But after we'd spoken to one of the aid workers, we decided that the safest course would be to join them inside their compound.

The reality of the situation hit home the next day as we wandered through the refugee camp with our new friend. We saw first-hand the desperate conditions in which thousands of people were living — in tented camps subject to food rationing, with clean water delivered by tankers once a day. I had brought a bag full of pencils and notepads to give to the kids. How stupid I was!

The news that someone was giving away 'something' spread like wildfire through the camp. Before I knew it, my gesture had created a scrum. Children and adults raced towards me, and I was surrounded by a hundred people snatching at me, tearing everything from my grasp. They had no idea what it was that I had, and it didn't matter. I learned a hard lesson that day about how *not* to go about helping people in need.

I also took away from the experience an overwhelming love for the African smile: beaming from ear to ear, bright white teeth against dark skin. The children I spent time with had nothing more than the clothes on their backs but delivered some of the biggest smiles I've ever seen.

The eclipse was almost a secondary part of the trip for me. We awoke on a misty morning in the shadow of the Dona Ana road bridge (at three kilometres Africa's longest), having travelled 50 kilometres upstream into the path of the totality. By 10 am the clouds had parted, giving us an immaculate view of the sun and the approaching moon.

It seemed as though the entire village turned up at our campsite that morning. A few people had heard that something strange would be happening. We shared around a few pairs of special eclipse-viewing sunglasses and laughter filled the air as everyone tried them on, much to the amusement of their friends. They did look a little ridiculous!

Three minutes of totality brought the same silence I'd experienced a year before in Cornwall, with everyone stunned by the experience. Here, though, there were noticeable differences. As darkness approached, the temperature dropped sharply by a few degrees, dogs barked, cattle lay down and birds took flight to their roosts, all tricked by the early onset of a false evening. Sunset appeared on one horizon while sunrise emerged on the other.

Owen piped up, 'No less spectacular than the last one, Ben! Fancy another challenge?' I knew what was coming next.

Fast-forward 18 months and I'm in another Land Rover racing across Africa to an unmarked destination on the map. Again I am with my mission-partner Owen, girlfriend Kathy and a friend from the UK, Pete, with the goal of reaching the shadow of the totality, this time in northern Botswana.

I felt like a modern-day explorer. We drove with maps sprawled across the dashboard, not knowing what lay round the next corner, bush camping in the wilds of Africa with carnivorous animals moving through our camp. Maybe it was just a little stupid to leave our chicken carcasses at the base of the roof tent ladder 'just to see what happens'. I could hear my heartbeat thumping in my chest and the whirr of the video camera cassette rolling as the lion walked directly under the tent.

Our overland expedition took us to the vast expanse of Makgadikgadi Pan and the wonder of Kubu Island, without doubt the

most incredible place on Earth I've visited, with huge granite rocks set amongst giant baobab trees in the middle of a desolate saltpan. It would be the perfect place to write a book.

My third solar eclipse, as special as the first two, was spent in the tiny village of Kachikau on the northern border of Botswana. Surrounded by local children, their goats and a few dogs, we watched as the heavens darkened and the totality set in. The goats became quiet, the dogs stopped barking and a serene silence came over the land.

The children appeared both scared and curious to see what would happen to the life-giving orange ball in the sky, chattering nervously at first before becoming quiet, their attention focused on the dying sun. Five minutes later their world was normal again as the light returned; the goats stood up, the dogs found their voices again and normal life returned.

What I'd enjoyed more than anything about this trip was the experience of seeing different people's lives, if only for an hour or a few minutes. I felt blessed just to look through a window into their world. I was unravelling the mystery of language and cultural difference by talking and listening.

On the drive back to the airport in Johannesburg I mentioned to Owen that the next total eclipse was in Antarctica. We both agreed it'd be far too expensive to even consider, but that didn't matter — we'd fallen in love with overland travel and Africa. The seed for our next adventure together had already started to germinate.

The trip of a lifetime

Owen and I grew closer as friends, enjoying each other's company and shared love of mad ideas. Not happy with the ordinary humdrum of life we embarked on ridiculous projects, from organising enormous New Year's Eve parties, to overnight clubbing trips to Belgium, to … well I can't include everything here. But let's just say his mother's garage served a variety of purposes over the years.

Since our first road trip through Africa we'd considered the trip of a lifetime — an overland journey down the eastern spine of Africa from Cairo to Cape Town, following the path of many an adventurer.

In theory it was simple. We'd buy a Land Rover, prepare it for the journey and drive off into the sunset — two young men taking on the world.

Our characteristic visions of grandeur meant that travelling to Cape Town by the 'standard' routes wasn't bold enough. We needed to make the journey more of an adventure, something that would test our mettle and prove our worth as *men*. As twenty-somethings we fed off each other's lust for life.

Our brainstorming now threw up a new and ridiculously ambitious plan: to circumnavigate the entire continent. We'd cross the Strait of Gibraltar into Morocco, travel down the west coast to South Africa, back up the east coast and across the north, exiting by ferry from Tunisia into Italy. We'd travel through 31 countries, covering 50 000 kilometres on some of the worst roads in the world. Even on paper it looked huge.

All we had to do was work out how to pay for it.

So I did the unthinkable and got a full-time job in England. My days of swapping hemispheres were over for a while. If I was to realise my next dream, I needed to apply myself and earn some serious money.

I started work as an events coordinator at the Royal Star & Garter Home in Richmond, south-west London. I had a brilliant boss named Alistair Holmes who loved adventure, the great outdoors and rugby as much as I did. I was working for a charity, so it wasn't the most financially lucrative move I've ever made, but it taught me how to manage an event, raise sponsorship and deal with people from all walks of life — all critical skills to hone when planning an expedition.

Building an expedition

Even the least adventurous people dream about places and things they'd love to see and experience first-hand. The secret to getting the most out of life is turning your dreams into reality so that memories can be created.

Whether your 'expedition' is a simple as a weekend walk along the beach or as complex as a trek across a desert, keep these points in mind while you're planning it:

- **Make sure it inspires you.** Whether it's a weekend walk or a year on the ice, keeping motivated throughout your project is essential for you, your brand and your sponsors.

- **Read, research and revise.** Whatever your chosen project, there are bound to be people out there who have done something similar. Online forums are the most up-to-date, relevant and useful places to find out how to succeed (and fail).

- **Meet your mentors.** Nothing beats a face-to-face meeting with the people who've done it before. They will inspire you, share their knowledge and alert you to potential pitfalls.

- **Train.** Learn the skills you need to get the job done safely and successfully, whether it's navigation, first aid, water recovery or simply the fitness required to get over the finish line.

- **Assign specific jobs to the team.** Maintaining a healthy team dynamic is essential, especially in high-pressure environments. Give team members roles and responsibilities they can make their own.

- **Draw up a mission statement, an action plan and a budget.** Know from the outset what you're trying to achieve, how you'll go about it, and what funds you have or will require to get the job done.

- **Make a list of everything that could go wrong.** If it can go wrong, it will go wrong. Draw up a safety plan and practise your procedures so they become second nature for everyone involved.

- **Set a date and a timeline.** Nothing commits you more than having a date to work to. Once you've got that, set out an achievable timeline you can work to for sponsors, training, media, budget and so on.

- **Be gracious.** Once you make it successfully back, ensure you thank everyone who helped you out. A handwritten letter is still the best!

To beat the horrific traffic to London my day would start around 5 am. To this day I'm haunted by memories of the wasted hours sitting bumper to bumper on the A3. I did at least get plenty of thinking time, planning time, time to propagate the idea that had been swirling around in my head since leaving Africa.

The Royal Star & Garter Home sits in one of the prime real-estate sites in all of England, at the entrance to Richmond Park. My colleagues wouldn't get into the office until 8 am, which gave me enough time to run on the tracks around the park before work.

I'd found my place of Zen in running. To me, there's nothing better than hitting the trail, come rain, snow or shine, to get the blood pumping and the thoughts firing. I was enjoying the experience and increasing my distance every month, until finally I made the commitment to enter the London Marathon. I registered Owen at the same time without him knowing.

During my lunch break at work I'd stay fixed to my computer, reading online about other people's African adventures. I'd check out which routes they'd taken, the vehicle they used, where they stayed and, most importantly, which borders were open *and* safe.

Each weekend I'd meet up with Owen to discuss and further our plans. We knew the route we'd take, and that we wanted a Land Rover Defender to travel in (every Englishman worth his salt has to have one). We also knew we had to do something to raise money for charity — but what?

Birth of an expedition

The reality of life for many in Africa had been brought home to us by our experience in Mozambique. Seeing first-hand the suffering caused by a natural disaster on top of the already arduous conditions in one of the poorest countries in the world cemented our determination that this adventure should make a difference. We wanted to give something back to the people whose lands we were travelling through.

'Let's assume we get across the finish line of the London Marathon. How about we try to find a few marathons to enter during our trip?' I piped up, confident we'd complete the 42 km race.

'I know you love running, Ben, but it's not really my thing. Can't we try climbing some mountains instead?' Owen suggested.

I felt my fear of heights kick in but stupidly replied, 'Why not combine the two — a few marathons and a few mountains?'

'I'm going to throw down the gauntlet here, Ben. Let's try and find 10 challenges in our year on the road — five marathons and five mountains.'

It was done. We shook hands, realising the deal couldn't be broken.

'Our expedition needs a name, and I've been thinking about it. What about Afritracks?' Owen suggested.

'Well, if we're trekking up mountains and running marathons, surely it should be Afri-*Treks*?' I came back, confident I had a winner.

'Let's check and see if the domain's available before we commit.'

Owen tapped away at his laptop. It was taken — but we could have *Afritrex*. We grabbed it quickly before someone else could.

So we had it: a great project name, our own personal reason for driving around the continent and an exhilarating way of raising money for charity too.

Afritrex was born.

One of the principles I've tried to weave through my adventures is *travel with a purpose*. Giving something back to the people whose lives you touch and whose lands you visit — if only briefly — will likely have as great an impact on you as it does on them. It could be as simple as helping out with a volunteering project that benefits the people who live in the area, visiting the local school or raising charitable funds along the way.

Nowadays too many people throw on a backpack, jump on a bus and travel through a country without ever really understanding it. Travel has become about the destination, not the journey, and more often than not it is carried out for purely selfish reasons — to spend hard-earned cash on a personal life experience that fills our mind with contentment. People want to boast about visiting a place more than they actually care about being there. More often than not my most meaningful experiences on overseas expeditions have come out of the people I've met along the way.

There was Abi, a man who spent three days helping us source vehicle parts in Ethiopia and wanted nothing more than to better his English. There was a little girl in Morocco who spoke no English but brought me fresh mint for my tea when I camped by her local river. Or the group of guys whose eyes lit up when I produced a 17 mm spanner and helped fix their broken bus in the middle of the Sahara. They'd been waiting for three days! These were all moments I couldn't have planned and were simply part of 'the journey'.

Afritrex would allow me to combine my selfish desire for travel and insatiable appetite for adventure with my love of running, to produce a charitable financial outcome. It proved to be the biggest event I've ever organised, covering all aspects of sponsorship, marketing and logistics, while drawing on language, engineering and people skills I didn't even know I had.

* * *

For two years I commuted to London, the tedium slowly draining the life out of me, both mentally and financially. Working for a small charity simply didn't pay enough to save the funds I'd need for the 12-month expedition.

With a heavy heart I left the Royal Star & Garter and took a job with a friend's father in the Hampshire countryside. My salary increased when I began working as their project manager, and the commute to work took just 15 minutes. I was back in control of my destiny and started to build my savings quickly.

What I gained in the financial stakes, however, I lost in job satisfaction. Rather than managing exciting projects as I'd been promised, I was selling garden turf and topsoil over the phone. The job required me to work five days a week from 7 am to 6 pm and Saturday morning, and I had a boss who treated every day like Monday morning. The smiling faces of Africa seemed a million miles away.

It wasn't something I loved, but it really taught me how to focus on the end goal.

The monotony of days spent in a cramped portable office answering the phone was draining the life out of me. I was struggling to keep my sanity, especially through the long, dark days of winter.

Locking in an exact departure date was the best thing we ever did. Until then, whenever anyone asked when we were leaving, we always replied, 'Around the end of the year' or 'Sometime next year'.

Through extensive research, we'd managed to locate five official marathons we could enter on our year-long loop of the continent. These ultimately determined where we needed to be at what time of year. But we also had to take other factors into account. The wet season in central Africa meant impassable roads, so we'd have to be through there by May. And our expedition kitty would need at least another year of hard work before it was full enough.

It was too easy to continually push our departure date back. We needed to make a firm commitment.

'Let's stay for Christmas and hit the road straight after,' I suggested to Owen.

'Okay. How about the 27th of December?' he replied.

'Done. We have 13 months until we leave.'

Focus on the light

Tough times call for mental toughness. When everything around you seems to be falling apart or you feel like giving up, being able to see past the negative is the key to success.

- Focus on the light at the end of the tunnel—don't let the day-to-day get you down.

- Had a hard day? Research and plan your project—it'll take your mind off work.

- Set that date—and have something to work towards.

- Get a piggybank—one of the best ways to save without really noticing.

- Get outdoors and exercise—it clears the head, releases endorphins and relieves stress.

- The harder you work, the luckier you get—try it out.

Colonel Mustard

My motivation started to return when I reached a milestone in our expedition planning. I bought a bright yellow 1986 Land Rover Defender and named it Colonel Mustard after the character in the board game Cluedo.

'So it'll make it the 51 miles back to Winchester, won't it?' I asked the salesman.

'Oh, absolutely. It may be an old chugger, but it'll keep on going for a few thousand miles yet,' was his optimistic response.

One hour and 13 miles later I watched as the fire engine turned back up the dual carriageway and stopped behind the Land Rover, its blue lights flashing through the smoky veil we'd created.

'We were heading back to the station but thought you were on fire. Is everything okay?' the fireman asked.

'Ahhh yeah ... well I think so. Something just let go in the engine and all hell broke loose. I don't think I'll be driving anywhere. Thanks for stopping though,' I replied, embarrassed as hell and redder than the fire engine.

Colonel Mustard and I didn't have the best start to our global adventures together. I was expecting to travel over 50 000 kilometres around Africa in him, but couldn't even make it back home the day I bought into a slice of British motoring history.

I planned on spending a year on the road in what amounts to little more than an aluminium box on wheels that's renowned for being unreliable and a fuel guzzler, and offers limited legroom and less comfort. Welcome to the 45-year-old design that is the Land Rover Defender.

I bought Colonel Mustard knowing I'd have to change the engine before leaving for Africa. Replacing the tired old diesel clanger with a more modern, efficient 300Tdi was the first thing on my extensive list of upgrades. With it would come a new gearbox, plus tougher axles and disc brakes that would actually stop my three-tonne home when the anchors were called into action.

So began my ambitious project to turn Colonel Mustard into somewhere I could call home for 12 months. I'd live, work and sleep on board.

The architect behind all my aging vehicles has been my incredibly committed, engineering mastermind of a father, Duncan. Without him, I wouldn't have had the confidence to rescue a 1972 VW Beetle with holes in the floor from a farmer's field in Wales and turn it into my first car. And I could not possibly have picked out this Land Rover from hundreds of others we'd scanned in the classifieds as one with a decent enough chassis from which to build an expedition vehicle.

Together we stripped almost every component from the chassis, systematically checking, prepping and replacing anything that showed signs of corrosion or wear. Better to do that than have it fail on a remote track in the middle of the Sahara, we told each other.

By mid 2006 we'd finished all of the heavy mechanical work. We had gutted and re-upholstered the interior, replaced and repainted the doors, fitted the roof-rack, awning and roof-tent and splashed the

expedition logos across the body. We now had the expedition vehicle I'd been dreaming of.

With four months to go until our planned departure date things were flying along. Our friends helped us develop a professional-looking business plan that we circulated around local businesses seeking sponsorship, a flyer we dropped onto hundreds of doormats around town and a website we'd use to tell our story while on the road.

Getting sponsors to support our venture was the next step. It was simple enough for some companies to supply 'merchandise'; after all, they wanted their product tested and showcased in the field. From sleeping bags to sun cream to pocket multitools, we had more than enough goodies and gadgets to equip us or to give away should the need arise.

Any hope of a financial deal, however, was disappearing more quickly than the days to our departure. We were, after all, nobodies. We weren't filming a television documentary; we had no proven track record and could offer only minimal publicity in return. We'd have to rely on our hard-earned funds to get us through the next year.

With a month to go Afritrex was becoming a recognised brand, albeit locally. It even raised some interest in the local media. Having three well-known public figures — Sir Peter de la Billière, Sir Ray Tindle and Sir Ranulph Fiennes — as expedition patrons certainly helped. The story of our harebrained adventure was even worthy of a few radio and television interviews before we left.

Our branded clothing range went gangbusters. Owen had the wonderful idea of using contacts in London through whom he'd printed t-shirts before. I felt like Rodney Trotter from *Only Fools and Horses* as I walked through the pub door one night carrying two suitcases stuffed full of Afritrex t-shirts, jumpers and hooded sweatshirts. Twenty minutes later we'd sold out.

Back at Owen's house that night we were considering a second run when he broke the unusual silence between us: 'Ben, I need to tell you something.'

'Sure, what's up?'

'Well... I'm afraid I'm going to have to fly out and join you in Morocco rather than leave on the 27th. I just haven't tied things up in London yet.'

'Really?!' I was shocked but still 100 per cent sure everything was on track. After all, we'd both invested three years in getting this far. There was no way Owen **wouldn't** make it.

'That's okay, buddy. Why don't we book your flights to Marrakech now, then I can pick you up from the airport?'

'Great idea,' Owen replied, still adamant he'd make it.

Maybe he was trying to convince himself more than me. Did he really think he'd come? Was it just a cover for not having saved enough money? Only Owen knows what was going on inside his head at that stage.

Forming an expedition team

I've learned the hard way that forming a cohesive team takes more than just good friendship. The successful completion of any adventure or expedition relies on strong, professional alliances from everyone taking part.

- Ensure all members of the team are 100 per cent committed to the project.

- Produce full contract documentation covering roles and responsibilities, duration of project and remuneration.

- Review all contracts before departure and make any alterations where required—things do change.

- Employ people for their specific skillset and empower them with their own roles and responsibilities.

- Know the weaknesses of both you and your team, and fill any gaps.

- Get to know your team outside of the work environment.

- If it's your own expedition, don't expect your team to work late into the night like you.

- Encourage feedback, both good and bad, and remember to reward good work.

- Celebration is a short-lived activity. Take the time to live in the moment and remember what allowed you to cross the finish line.

- Trust your instincts and go with them.

- Be careful when employing friends—mixing business with pleasure can be a minefield!

I spent Christmas Day 2007 saying goodbye to friends and family. It would be an entire year before I saw most of them again. The hardest was hugging my sister Becky and her young family. I struggled to hold back the tears as I walked away from their house for the last time. I didn't want to be the uncle who was never there for them as they grew up.

I also remember my friend Fuzz turning to me and saying, 'You're bloody mad, Ben; you'll die in Africa. It's full of crazy people with knives and guns'.

Not the most reassuring thing to hear, but it did bring home the gravity of what I was about to undertake. In England my loving parents would be my rock, always just a phone call away, ready to help out with whatever stupid situation I got myself into. But this was different. Once I left the safety of the motherland, I was on my own.

Colonel Mustard was waiting in the driveway, packed to the gunnels. Dad and I had checked everything one last time. He'd invested months of hard work helping me to get to this stage, and was as eager and nervous as I was to make sure everything was prepared.

'Ben, I want you to know that we're right behind you all the way. If, heaven forbid, Owen doesn't make it, then we'll support you financially to get you home. This expedition could make you.'

The hairs on the back of my neck stood up when I heard those words.

'Thanks Dad.'

I climbed into the Land Rover and pulled the door shut, pausing to write the vehicle's mileage in permanent marker on the doorframe: 157 840 miles were on the clock at the start. Who knew what it would say by the time I got back next year.

The cold December night steamed up my windscreen as I drove through the frozen English countryside to my local pub in Petersfield. By the time I arrived, 20 minutes later, the heater had just about kicked into gear and brought life back into my numb fingers.

The warmth of the reception from my friends was overwhelming and I spent an hour saying goodbyes, shaking hands and collecting good luck mementos for my journey.

I spotted Owen and my good friend Sam chatting away across the crowded pub. It was only a few hours before that Sam had decided to join me for the drive south to Spain. From here he'd catch a flight back home and leave me to take on the early part of the adventure alone. I was unbelievably happy to have a friend along for the first leg.

Owen seemed sheepish and hesitant to talk. I thought nothing of it and pulled him close in a final farewell hug.

'See you in Marrakech, old boy!' I shouted, turning to wave to all my wonderful friends braving the cold outside the pub. The Colonel started first time, Sam jumped on board and we were off.

It was the last time I'd see Owen for a year.

CHAPTER 2

Afritrex

As the last ropes were thrown down to the Spanish dockworkers, my link to European soil was severed. I was leaving the relative safety of my home continent for a land of border crossings, endless paperwork, poverty, tyranny, heat and mosquitos — and of adventure, extraordinary experiences, sunshine and beaming smiles.

For years I'd been dreaming about this moment. Africa was less than an hour's sail away. I'd be immersed in it very soon.

There's something hugely significant for me about this stretch of water. It's only 30 kilometres from Spain across the Strait of Gibraltar to the Moroccan coastline, roughly comparable to the English Channel at the narrow end, but in terms of travel logistics the two stretches of water are remarkably different. A border is not just a border.

Crossing to Calais brought back memories of my school exchange trip, aged 12 — crammed in the back of a coach, steamed-up windows, sweeping through the pouring rain past commercial shopping estates. We were English envoys in a foreign land. Ours was the most bland of destinations with as much character as a Best Western hotel.

Sailing between countries is one thing; sailing between continents is another altogether. I felt like an old-fashioned explorer heading off into the great unknown. Leaving behind the relative safety of Europe and consciously taking a step into the 'Dark Continent' to test myself, the Colonel and my intricate plans.

1. Mount Toubkal, 4167m
2. Marrakech Marathon, 42km
3. Mount Cameroon, 4040m
4. Comrades Ultra Marathon, 90km
5. Knysna Marathon, 42km
6. Mount Kenya, 4985m
7. Mount Kilimanjaro, 5895m
8. Nairobi Marathon, 42km
9. Ras Dashen, 4543m
10. Home to Petersfield marathon, 42km

Crossing the border

It took just 35 minutes to cross the Strait—enough time to grab a drink, run to the toilet and head outside to snap a few photos. From the viewing deck I watched Europe recede in our wake as the mountains of North Africa rose up to greet us. The rugged landscape of Morocco was beckoning. I'm the sort of traveller who doesn't leave too much to chance for at least the first 24 hours in a new country. I'd read all about what to do, how to behave, the right line to queue in, which window to stop at.

I wasn't sure what to expect as we neared the Moroccan coastline; maybe a little less industrial, less European, less familiar. As we cruised along the seawall into the port of Ceuta, it didn't seem like so much of a transition. There were still signs I could read, company logos I recognised.

And then something a little different appeared. Were those men clambering along the outside of the seawall? Why on earth were they risking their lives on that precarious concrete pier? It dawned on me that they must have slipped over high security fences, past a security cordon and were attempting to board the container ship moored alongside.

They were would-be immigrants, fugitives—and this was their last despairing shot at leaving behind the hardships of their broken lives in Africa for the streets of Europe paved with gold. Would any of them make it without being found, to steal off the ship in Spain and somehow make it across Europe to the UK, perhaps hidden in or under a truck?

The harsh realities of life on a continent ravaged by war, drought, poverty and disease had pushed these people to this point, risking everything for a chance of a better life. And I was heading straight into it, head on, full steam ahead to find out what they were running from.

* * *

There's a little bit of Europe left in this part of North Africa: 18.5 square kilometres, to be precise. The Spanish enclave of Ceuta sits at the northern tip of Morocco and makes the transition between continents easy—almost too easy. Border control is cursory for Europeans. No passport stamp, no paperwork, no need to sign anything or pay anyone. Surely it wasn't going to stay this easy?

My reprieve is short-lived, however. Six kilometres beyond the port Colonel Mustard and I arrive at the border between Ceuta and Morocco.

'As-salamu alaykum.'

'Bonjour, mon ami.'

'Hello meester. Come with me. I help you, I help you!'

A smashed-up Land Rover lies abandoned at the side of the road, hopefully not an omen.

As I drive towards the security fence, the reality of *foreignness* hits me. A hundred eyes are watching. Overloaded trucks fill the air with noxious diesel fumes, cars looking like they've reached the end of the road form wavy lines off into the distance, all pointing towards the windows of authority. The commotion of a North African border hits me for the first time.

Everything I've read about suddenly comes alive. What the hell should I do first? Think back to those hours spent scouring the internet, Ben! I need insurance, passport stamp, carnet de passage stamp, yellow fever certificate check. 'Look for the window on the LHS, avoid the fixers, look assertive and don't ever let your passport or carnet out of your sight,' offers the Africa Overland Forum.

As I edge the Colonel forward I feel oddly secure inside the cab, my point of calm in the chaos. It's a taste of what is to come later on the expedition. The Colonel will be my retreat, my trading post, my office, my sanctuary, and literally my window into another world.

My relationship with the Colonel isn't just that between a driver and his car. Over the past three years I've got to know him in intimate detail as I've rebuilt and repurposed him. No longer just a Land Rover, he is quite literally my house, where I'll sleep, cook, eat, shower and work. He is my best friend and my lifeline.

So far I've ignored the offers of help thrown at me from afar. I feel as though I need to fend for myself. Searching back through the grey matter, my basic language skills choose a good time to resurface. I'm in North West Africa and if I can't speak Arabic, then I can resort to the next best thing — my modest knowledge of French.

Morocco has been influenced by Europe since the 15th century. The Portuguese, Spanish and English all showed interest in controlling the country, but it was the French who took charge in the 1800s, ruling by colonial fiat until they finally relaxed their grip a century

and a half later. This history has left a distinctly French feel to many parts of the country. It also left a language I can just about muster.

I find the window I've been looking for: *Assurance*, recognisably close to the English *insurance*, giving me an A+ in my first language test. *La langue française est très facile* — French is easy, sort of.

It's here I have my first lesson in border diplomacy. My goal is to get myself and the Colonel from one country to another with all the essential paperwork and stamps and with minimum fuss, and to pay nothing more than the standard fees. I'm determined to offer no financial bribes, to pay no additional charges and to not give in to overzealous officials.

'*Bonjour monsieur, ça va?*' I spout as I arrive, thrusting my hand under the window.

'*Oui?*' comes the less-than-friendly response. There's no effort to return my handshake. This guy probably sees a dozen of my kind a week. Adventurers wet behind the ears, bouncing with excitement, ready to take on the world.

Luke the lifesaver

I spent the first week of my African adventure with my aunt and uncle from Spain, who'd driven across to join me. Together we toured the gorges and mountains of the Rif Valley and the Middle Atlas Mountains, venturing as far as Erg Chebbi, one of Morocco's largest sand dunes.

Life on the road had no routine and no restrictions. We could venture where we wanted, masters of our own destiny. Morocco was full of welcoming people, fascinating food and dramatic landscapes, and felt like a very foreign land.

My limited French language experience dated back to school. Unfortunately that was a long time ago and I was seriously out of practice, but the more I tried, the more I surprised myself. If you immerse yourself in a country where you don't speak the native tongue you've got two options: don't bother trying, and miss out on forming relationships; or give it a go and enjoy some of the funniest, most bizarre and wonderful experiences you can have while travelling.

To make Afritrex a success over the next 12 months would require a huge level of commitment. I was responsible for looking after the Colonel, all the travel documents that were essential for getting us

around the continent, and of course myself. And if I was serious about running five marathons over the next year, then I needed to stay as fit as possible. Sitting behind the wheel for long hours every day wasn't the best way to stay healthy and fit enough to climb mountains and run marathons. I needed to seize the moment whenever an opportunity arose to get out of the cab, don my running gear and cover as many kilometres as I could.

When we finished driving at the end of the day, we'd track down a suitable hotel or auberge where Jenny and Colin could stay. I'd find a corner of their car park for the Colonel and then raise my five-star luxury roof tent, preferably out of sight of prying eyes. Travelling through Morocco in the middle of winter meant it was pretty cold when I awoke, a crisp white layer of frost often coating my flysheet.

It was the perfect time to get outdoors and train. Without doubt the hardest job of the expedition was dragging myself from the warmth of my sleeping bag in those first few weeks, but I knew that if I didn't use the early hours of the day to train I'd get into the lifestyle of the relaxed traveller rather than of the adventurer on the move.

I climbed down the ladder from my roof tent and looked up at the vast panorama stretched out before me. In the distance the white peaks of the High Atlas Mountains thrust up into the crisp, clear sky like serpent's teeth roughly hacked from the horizon. The rocky road we'd taken late in the day wound up from the valley below, passing the stone hotel hewn into the cliff face.

I shivered momentarily as a cold breeze brushed over me. I needed to move or I'd be tempted to dive back into my tent. Putting one foot in front of the other, I moved slowly at first then quickened my pace until I was in full flight. The first few steps of a run are never easy, especially when the temperature is just above freezing.

I ran up the road, following a small stream that began in an ice-covered pool and petered out into a dry gravel bed, all in the space of a few kilometres. As I climbed up the valley the frost became heavier until I arrived at the snowline, feeling pretty stupid for leaving the tent in a pair of shorts. My 12 km run gained over 1000 metres in elevation, and by the time I got to the village my legs were feeling it. With the second of my challenges, the Marrakech Marathon, just over a fortnight away, I was already having doubts about my stamina.

My first challenge was only a week away: to ascend Mount Toubkal, the highest of the Atlas Mountains, at this time of year covered in thick

snow. Having never before donned crampons or used an ice-axe, I'd have my work cut out learning the skills I'd need to get to the summit.

By the time I got back to the Colonel the morning had kicked into life. The sun's rays flooded the gorge, filling it with a warm, orange glow. My return was downhill all the way and my fingers and toes were chilled to the core, but it felt great to be alive.

We spent the day exploring the area, driving through deep, narrow gorges barely wide enough for the Colonel that opened out into wide, fertile river beds and down through long, sweeping valleys. That night I stopped beside another hotel set next to the river. My tent was up and I was fixing one of my headlights as a group of local kids gathered around to watch and giggle as I worked. After a while they got bored and drifted away, until there was only one young girl left. She started a conversation with me in French, to which I did my best to respond.

I'd prepared for times like this when I was planning the trip back in the UK and I had a supply of cheap sunglasses and bottles of bubbles to give away as I saw fit, gifts for kids I'd meet on the way. She took the bottle from me, unsure of what to do with it, so I demonstrated.

Her eyes lit up when I blew the first bubbles into the air. I handed them over and she tried. She skipped off happily blowing bubbles all the way home, excited beyond belief with her new toy. Twenty minutes later she arrived back with a small black bag in her hand, full of fresh mint for my tea — a Moroccan tradition.

My time with Jenny and Colin was drawing to a close. They had to return to Spain and I had to prepare for Mount Toubkal. We decided to part ways in Marrakech the next evening, only a few hours' drive away. It would give me a chance to stock up on supplies for the climb and to meet one of my best friends, Luke, on holiday in the country with his mother.

Owen had been due to fly into Marrakech the same day, but I received an email from him explaining that work commitments meant he'd have to postpone for another fortnight. It looked like I'd be tackling the first two challenges alone.

Luke and his mum joined us for our final dinner at one of the bustling restaurants in the old town's central medina. After a few beers and a hearty dinner, Luke and I talked about Owen's no-show and my next few days.

'I'll climb the mountain with you, Ben!' Luke suggested, showing great bravado. I laughed out loud at the ridiculous idea. Fitness isn't really Luke's thing, and climbing a mountain really wasn't something I could see him doing.

'I'm serious. If you're going to do it and Owen's place is paid for but he's not coming, then screw him — I'll do it.'

He seemed deadly serious.

'Well, in that case we leave tomorrow! It's a day's drive to the basecamp at Imlil where I'm meeting my guide. You can use all the gear hired for Owen.'

* * *

Luke is with me the next day, his commitment holding firm from the night before, as I drive towards the snowy mountain range in the distance. We wind our way up the steep, twisting mountain road, around wandering donkeys, dogs and goats, and arrive in the sleepy town of Imlil.

'You're telling me that neither of you have used an ice-axe or crampons before?' our guide Alex quizzes us, looking perplexed.

'Nope, but they can't be that hard to use, surely?' I reply, hoping our optimism will carry us through.

'You'll be fine, as long as you can walk with your knees apart.'

Our climb from the village to the summit of Mount Toubkal, at 4167 metres above sea level North Africa's highest peak, is relatively easy. We trek up through valleys past smaller and smaller Berber villages and stop for the night at Neltner Refuge, high above the snowline. Once the sun drops below the horizon the temperature plummets, the open fire inside offering the only warmth on a frigid night.

With sunrise a palette of purple then blue then orange light fills the sky. It's out of this world. After a hearty breakfast Alex, Luke and I set off for the summit.

We huff and puff our way through the first few hours, slowly gaining altitude. The effects of the thin air take their toll on Luke more than me, but he's done incredibly well to keep up so far. Then as the peak comes into sight it's like someone stuck a rocket down his trousers: he breaks into a full sprint and races all the way to the metal summit marker. Luke, the non-athlete, has beaten me to the top.

Challenge number one of Afritrex is complete! Owen isn't there but it doesn't matter; at least there's *someone* to share the experience with. Before we set out Luke and I were just good mates; now we're brothers.

* * *

A few days later I was back in the warmth of Marrakech, my legs fully recovered. With a week to go until the marathon there was little more to do than relax with Luke and his mum, wander the souks and watch the world go by.

I stopped at an internet café and checked my email. There was a message from Owen and it wasn't good news. It was time for some tough decision making.

Having him along as my expedition partner was based on three years of planning, training and saving together. Right up until that last week in the UK there was no doubt in my mind he'd be coming along for an astonishing year on the road, after which we'd return to the UK having fulfilled a lifelong dream.

I started to have my doubts when he didn't make our departure date from the UK, and they increased when he postponed his arrival in Marrakech, but something inside of me still believed he'd make it. Committing so much to a project and then not being part of it seemed inconceivable.

Owen's message told me he was still having problems with his company in London and he couldn't just get on a plane and leave. I'd have to continue without him for now and he hoped he'd meet me in Ghana for my birthday in March.

I was sad, disappointed — and furious. Poor Luke had to deal with my venting over lunch, complaining about the broken promises and how tough things would be for me towards the end of the trip. I'd have to tighten my belt significantly if I was going to make it back to the UK without serious debts.

Later that afternoon Luke turned to me and said, 'Ben, would you like me to join you through to Ghana? That way, you've got someone with you. I can put my jobs on hold back in the UK and I think we'll have a great time.'

I was blown away. 'Luke, I would love it more than anything. The last week has been amazing, so why not? Let's go on this road trip across the Sahara together!'

Taking a risk on the spur of the moment

Taking a risk and stepping outside your comfort zone is difficult for most people. A spur-of-the-moment decision to take a leap of faith and leave the security of everyday life behind proved to be one of the best decisions Luke ever made — he'll be the first to tell you that!

I used to be the king of procrastination, researching everything to the nth degree. Being brave enough to trust your intuition and roll with the consequences isn't easy, but it opens your mind to another way of thinking.

- **Don't procrastinate**. Go with your instincts.

- **Find a quiet place to make a stressful decision**. Time, space and solitude away from the pressure allows you to think more clearly.

- **Be brave**. Resolving to take a leap of faith and drive round Africa was one of the best decisions I ever made.

- **Collect the information necessary**. Bad decisions come from a lack of knowledge. Where possible, learn about what you're getting into before you fully commit to it.

- **Prepare for any outcome**. Think the different options through and prepare for the worst.

My feet were in a pretty bad way after Mount Toubkal. I'd brought a pair of hiking boots with me from the UK, ones that I'd worn on many previous treks and that fitted my feet perfectly. Unfortunately they couldn't be used with crampons, so I'd had to borrow a pair from the trekking company at the last minute and they were far from perfect. The blisters they gave me didn't heal in time for the marathon.

So when the morning of the marathon arrived I wasn't in the best shape to start the race. After a late night with Luke playing dominos and cards over a bottle of red wine I finally staggered to bed around midnight. The next morning I left him at the hotel and made my way to the start line for the 7 am start.

For 42 kilometres I hobble my way around the city circuit. It's a great event to be involved with, and countries all over the world are

represented, but I really have to dig deep to get across the finish line in less than four hours. It certainly isn't my fastest ever time, but that doesn't matter. Challenge number two completed.

An oasis in Nouakchott

'So where the hell is it?' asked Luke, starting to doubt the Lonely Planet guidebook.

We'd hit the outskirts of the city long ago, and for more than an hour had weaved our way through hectic rush-hour traffic that seemed to consist almost entirely of green Mercedes taxis from 1970, and donkeys. This, I realised, was where Europe's luxury marque comes to die. After eight hours of driving, we'd finally arrived in the Mauritanian capital of Nouakchott and were driving up and down the same street trying to find the only youth hostel listed in the guide.

'Are you sure we're in the right street, Luke?'

'Positive.'

'Well, there's definitely nowhere to stay there,' I said, referring to the boarded up concrete block we'd pulled up in front of. 'We'll have to find somewhere else.'

Luke took the initiative by winding down the window and launching into his best broken French.

'Ah monsieur, est là quelque part pour rester ici?'

The man clearly didn't speak French.

'Do *you* speak English?' came his surprising response.

'Yes, we bloody do! We're trying to find somewhere — *anywhere* — we can stay for the night. Have you got any ideas?'

'Follow me.'

And with that the English-speaking middle-aged Arabic gentleman grabbed a beaten-up old bike that had been leaning against the wall, beckoned to us and made off along the main avenue. It was yet another example in this raw and rugged land of someone unhesitatingly going out of their way to help.

Five minutes later we arrived at the bolted, forbidding gates of an auberge. Where the hell has he brought us? I wondered. I knew at once it was going to be far too expensive for our measly budget. My eyes locked onto the empty space in the middle of the yard.

'Can we park the Land Rover here and use the roof tent instead?' I asked the owner, expecting a gruff refusal.

'*Mais oui*. The water tap is here, the shower in here and if you need it…the washing machine here. Please come and meet my family when you are ready.'

Luke and I looked at each other, wondering. Was this too good to be true? No, it was just another demonstration of the hospitality this city offered. We'd moved from a scene of disorienting chaos into an oasis of calm, security and relative comfort.

Once we'd had showers (bloody fine ones too) and cleared the dust and dirt off our bodies from days of travel through the world's largest sand desert, we wandered into the auberge proper and sat down with our host. In the background a television chattered. Egypt had just beaten the Ivory Coast in the semifinal of the African Cup of Nations and emotions had been stirred.

The next morning we prepared to leave the comfort of the auberge car park, but only after I'd treated the Colonel to some TLC. It had been scorching hot driving through the desert over the past few days; add to that the blinding sand and dust that constantly blew across the road, and you had perfect conditions to grind away at all the Colonel's moving parts. I greased the final nipple on the prop-shaft and pulled myself from under the Land Rover. Mohammed, our gracious host, was there to greet me.

'So you leave us today?' he asked in his French-accented English.

'I'm afraid so. We have to be in Senegal by tonight.'

We said goodbye to Mo and his family, thanking them profusely for their hospitality. Then we plotted a route out of the city and hit the road south.

Life on the road

With two challenges out of the way and the next one more than 5000 kilometres away — in Cameroon — there was plenty of time to focus on the experience of travel.

The route I'd chosen would take us down the Atlantic Coast through Senegal and into The Gambia before turning east inland to Mali and Burkina Faso, avoiding the more problematic countries of Sierra Leone and Liberia. Having a vehicle as distinctive as the Colonel would stand out too much in those countries where roadblocks and hijacking were rife.

On a satellite image of Africa the vast red-and-orange area of the Sahara covers most of the top third of the continent. To the south,

the sand and rock give way tentatively to green where rainfall (albeit intermittent) allows agricultural land use. It also marks the boundary between Arab and black Africa, as contrasting as day and night, and delineated on the west coast by the Senegal River.

The dusty city of Nouakchott was now more than 300 kilometres behind us. We'd spent the entire day driving down the uninspiring strip of bitumen called the Autoroute Rosso towards the border with Senegal, the final leg of our Saharan adventure.

'Which way do you want to go, Luke? We either take on the chaos of the Rosso ferry and probably end up getting ripped off, or drive 100 kilometres through the beautiful national park?' I asked.

'Do I even have to answer that? Let's take a relaxing drive!' Luke replied.

Three hours later we drove across the barrage bridging the Senegal River at the end of the first leg of our journey. It would be the last I'd see of the Sahara until I reached Sudan in nine months' time.

Negotiating the 'system' at border posts had become a practised routine. Everything—from what paperwork I needed and which window to queue at, to how much to pay and to whom—had seemed alien when I first arrived in Morocco. I was more confident now, prepared for the officials' questions.

Transporting a vehicle around the continent requires a passport not just for you but for your car too. The *carnet de passage* (a temporary import document) I had for the Colonel was the second most important document I had after my passport. It needed to be stamped in exactly the same way, once on the way into a country and once on the way out.

Preparing to leave Mauritania and enter Senegal, Luke and I walked to the customs window with our sheaf of papers. There were the usual taxes to pay, a visa to purchase and, as we'd just crossed the river, a toll for using the bridge — to be paid in the local currency, the CFA franc, of which we had none.

Overhearing our slightly anxious conversation was a tall gentleman wearing what appeared to be an official uniform. He wandered over and offered to help, telling us he'd happily escort us to a cash machine and bring the money back in the morning when he returned to work. Alarm bells were ringing through my head louder than the dogs barking outside. Was I going to be stupid enough to fall for this obvious scam? Hell no!

It didn't make sense. If we were to drive with him into the city, they'd have to let us into the country. So whether he did or didn't pay the money for the toll was no concern of ours; we could simply continue on our way.

Corruption and smuggling are rife at border posts and as a result I'd developed a healthy suspicion of anyone who hung around them looking shifty. It had become part of my African mindset. The more time I spent in these places, the more I began to watch my back, and I really didn't like it. It felt so different from the person I'd always been: willing to give someone a go. I felt it was time to reverse my thinking.

'Okay. We've got nothing to lose. Why not?'

The official behind the counter stamped our gate pass and waved us off. Time to drive into our next country. Senegal.

Mr Song 'n' Dance

Our tall 'guide' climbed aboard and pointed towards the gate in the distance. 'Head that way. I'll take you into the city,' he said, leaning forward from the back seat. 'Do you like music?'

'Hell yeah!' Luke replied. This guy knew his weak spot already.

'Let me take you to see my friends. They play in a band here and I think you'll like them. Call me Mr Song 'n' Dance! Now put your radio on so we can listen to some tunes.'

This total stranger was now calling all the shots, and we had no idea who he was. I looked across at Luke, who was grinning from ear to ear. Oh well, sometimes you've just got to relax and go with it.

The sun was starting to set as we drove through the outskirts of the city. It was a Friday night and people were out in the streets. But the people had changed, along with the way they dressed. Their skin was darker and their clothing much brighter and more eccentric.

Mr Song 'n' Dance directed us around the back streets to avoid the police roadblocks. Once we'd organised the money, we headed to his house for an introduction to his family — all 20 of them!

The looks on the kids' faces were hilarious. Their Friday night was thrown into disarray when a bright yellow Land Rover rocked up on their doorstep with two Europeans inside. More music was playing on the stereo inside, Senegalese beats and traditional drumming filled the air and everyone, including the kids, was dancing and tapping their feet.

'Come and join in,' said Mr Song 'n' Dance, dragging me by the hand to the centre of the room so I had no choice.

Anyone who knows me knows I simply cannot dance. Two left feet would be an understatement. But for some weird reason, the situation didn't require rhythm or style, just the desire to get involved. There was no embarrassment here, no one judging how well you could dance and if you were in time or not.

So there I was in a room with a tall man and 10 kids dancing around me as I busted shapes on the dance floor, much to their amusement. I looked across to Luke who was sat in the corner.

'Come on Luke, what's wrong?'

'No, no, nothing. I can't dance here, Ben!' he replied, too embarrassed to get up and join in.

'Neither can I — look! You got two feet; you're human aren't you? Well then you bloody can,' I said, grabbing him by both hands and dragging him up to join in my dancing delirium.

Ten minutes later I was done — hot, sweaty and exhausted but ridiculously happy. Mr Song 'n' Dance was laughing from the side of the room along with the rest of his family. My fears of being hijacked or robbed had long gone, my belief in the human spirit revived.

'You like my music, Mr Ben? Good, but it's time for us to leave now, I want to take you to meet my friend Ibou. He lives on the beach and you can stay there for the night.'

We hopped back in the Colonel and Mr Song 'n' Dance directed us through the dark, music-filled streets. Stray dogs and kids playing football in the darkness ran for cover; the sound of music and the smell of weed filled the air.

Saint-Louis is 320 kilometres north of the capital, Dakar, and is a beautiful old French colony that's split into two parts — the dusty, urbanised mainland and the heart of the old colonial city, which sits on a narrow island and a long sand spit running parallel to the coastline. An old steel bridge over the Senegal River separates the two sections.

Once we'd cleared the police roadblocks and crossed the bridge the road wound through the old city, into the main square and past rundown colonial buildings. In the darkness it felt overpowering, the ethereal presence of times long gone overlaid by the clamour of an African street. We kept driving until the road turned from tarmac to compacted sand, a dusty track running alongside the beach.

'Stop there,' said Mr Song 'n' Dance, pointing at a wide space next to a low wall. 'You can park here for the night.'

The sound of drums echoed in the distance as I locked the Colonel's doors, checking everything twice. We kicked off our shoes and walked out onto the dark, sandy beach. The fire that flickered in the distance appeared to be the source of the music, and we were heading that way.

'Ibou, this is Mr Ben and Mr Luke,' said Mr Song 'n' Dance with a smile. 'I have told them all about you as they love music. Will you look after them tonight and make sure they are safe? Oh, and neither of them can dance,' he added.

'Salut, my friends. Please come and relax with us. There is fish on the fire and I see you have cold beer,' referring to the freshly bought bottles in Luke's hand, our first in two weeks. As an Islamic republic, Mauritania doesn't have a readily available supply of the good stuff.

The light of the fire revealed an idyllic setting. Palm trees towered over our heads, the sandy beach dropped away to the surf, the smell of cooking fish filled the air and Ibou's friends played djembes together in perfect time.

Our evening in the company of new friends was sublime. We drank, smoked and relaxed. Luke learned to play a new instrument while I ate fresh sardines from the fire. At 4 am we retreated to the roof tent — full, happy and high.

A road less travelled

I had a month to go until I had to be in Ghana. My birthday was on March 6, which coincided with Ghana's Independence Day. The day after Luke would fly back to the UK and Owen would finally arrive to continue the adventure. We had a big party to look forward to, but first we had to get there.

From the beachside bliss of Senegal we travelled south to The Gambia, another country now freed from colonial rule. The only remnants seemed to be the old English ladies who patrolled the streets trying to pick up the local men. We stopped overnight at Sukuta Lodge, an overland camp in Banjul, where we bumped into a fascinating German named Charlie, who had spent 25 of his 60 years working for the German Special Forces. That evening he told us stories of his life from far and wide — some believable, others a

little less so. His most important revelation was of a little-known road from Senegal into Mali, one that's not on the maps but would give us the most adventure of the expedition so far. We'd need food and water for seven days and fuel for at least 1000 kilometres.

I pored over the map with Charlie, marking out his proposed route, which appeared to cut through mountain ranges and cross open desert and a number of small rivers. If we wanted adventure then this was going to provide it!

The clock was ticking on the next of my marathon challenges, the Comrades Race in South Africa in June. It was still a few months away, but Charlie warned me that if I didn't make it through Cameroon and the Congo by early April, the rains would have turned the roads (or tracks) into a muddy, impassable quagmire.

As we waved goodbye to Charlie and hit the road, his words rang loudly in my head, the shortage of time pressing me into action once more. We drove along the Gambia River, following it upstream to the town of Mansa Konko. The straight dry track gave me a chance to get outside and train while Luke drove behind. The temperature gauge in the Colonel read 42°C and every kilometre was a struggle, but I fought on knowing the longer I put off training the more difficult it would get.

Some of the looks I got running through the villages were unforgettable. What the locals thought about this gangly white man running down their street with a yellow Land Rover in hot pursuit I'll never know! I tried to run at least twice a week to give myself a fighting chance of making the finish line of the 87 km Comrades Race. Driving across a continent isn't the easiest way to stay fit!

At the border back into Senegal we had one of the most amusing episodes of the journey so far. We had discovered that it's common in Gambia for people to ask for your address, and at first we were happy to oblige. After the hundredth time, though, it became a little tedious. Still, when one of the border guards, complete with AK-47, asked me yet again, I simply couldn't refuse — he was just being friendly after all. So I handed it to him on a piece of paper, which he gladly took, before looking me directly in the eye saying, 'Thank you for giving me your address. I love you,' which took me totally by surprise.

I looked across at Luke who was desperately trying to contain his laughter, then looked back at the guard and said, 'And I love you too, my friend,' with as much sincerity as I could muster. The guard waved

us through without blinking an eye. I'm not sure which one of us meant it more.

Charlie's route was remote and challenging. We were reduced to first gear for long periods, crawling over rocks the size of bowling balls. With one or two it wasn't so bad, but when the entire road was made up of them it slowed us down to the speed of a tortoise.

At times the road followed an old railway line, giving us a definite direction. At others there was no path at all and we bush-bashed our way through grass as high as our windows, across sand- and dust-filled plateaus and over small mountain ranges. I watched the compass and GPS intently, keeping our position on the laptop as best I could. This wouldn't be a good place to break down or get lost.

Towards the end of day four we raised the tent under a huge baobab tree, made a fire and settled in to enjoy a hearty dinner. The next day we finally picked up a track that led to a shallow river, the border between Senegal and Mali. There was no official border post so we made for the village police station instead, conscious we'd entered this new country illegally. Outside the station sobering photos of the burned bodies of drug smugglers adorned the walls.

We had no need to worry; the policeman on duty was friendly, spoke English and stamped our carnet and passports without question. That night we stayed in a small hotel room and enjoyed a cold beer. Over the past few days we'd certainly taken a road less travelled.

From here our journey to the northern border of Ghana took us to Bamako, the Malian capital, and the wonderfully named Ouagadougou, the capital of Burkina Faso. Luke and I played many games reciting it over and over again in different accents.

Luke, in his wisdom, had been reading the guidebooks and found what sounded like an oasis of calm on the coast to the west of Accra, the capital of Ghana. With two days to go until my birthday we still had more than 700 kilometres to travel to the promised land of Big Milly's Backyard. It was here we planned to spend our last few days together before he flew out and Owen hopefully arrived.

Ghana's telecommunications network is one of the fastest and most modern in West Africa. The same cannot be said for its roads. From Ghana's second city, Kumasi, to Accra is a distance of 250 kilometres along some of the most potholed, broken and congested roads I've encountered. Add raging humidity, countless flies, non-existent road

signs and street sellers who don't take no for an answer, and the last three hours of our trek to the coast felt like days.

Winding through the back streets of Kokrobite we had only GPS coordinates for reference. We finally rolled through the gates of the backpackers' just after midnight to find a party in full swing. Welcome to Big Milly's.

At Big Milly's

After two exhilarating but exhausting months on the road, the sandy beach at Kokrobite was welcome respite. Luke and I had travelled more than 7000 kilometres together without stopping for more than a couple of days to relax and take in our surroundings. Luke was due to fly back to the UK in a week so it was time to kick back, enjoy a celebratory drink and look back at the time we'd spent together crossing West Africa.

With March 6th both my birthday and Ghana's Independence Day there was reason enough to throw a party. Every Friday night at Big Milly's the locals celebrate with a massive live music and dance performance, so why not combine all three? We sat on the beach drinking cool, sweet cocktails and dipping our toes in the surf, watching the world go by.

The party started early that afternoon and continued late into the night. At its peak there were more than 200 locals, travellers and staff dancing, singing, partying and celebrating together, with fire twirlers, snake charmers, drummers and musicians all having the time of their lives. We watched from the bar for a while before eventually joining in and dancing until we were the last ones standing.

I retired to my tent feeling very much the worse for wear and fell asleep in the heat and humidity of the night with the doors of my tent wide open. The next morning I went for a walk along the beach to try to clear my foggy head. The Ghanaian coast is almost perfect, with palm-fringed beaches, tropical waters, cranking surf and brightly coloured fishing boats pulled up on golden sands. I say 'almost' perfect, as even paradise has its shitty bits, quite literally.

Along the beach fishing villages spill right to the water's edge. When the boats arrive back everyone comes to the beach to help haul in the nets and assess the day's catch. It's a wonderful sight. What's not so wonderful is the lack of sanitation, as there's no sewerage

system or running water. When someone needs to take a crap they head to the edge of the ocean, drop and squat. The high-tide line is not something you want to tread in at all. I only hope that in the future something is done to turn 'almost' into 'absolutely' perfect.

It was time to say goodbye to Luke. Spending eight weeks together in the close confines of the Colonel, we'd laughed, cried and laughed a shitload more, but his life back in the UK had been on hold for long enough, and the responsibilities of his son Roofus and work had to be attended to.

Our drive to the airport was a happy one. We'd grown closer than ever. When the situation arose, Luke stepped up and helped me out during those difficult first few weeks on the road. As his parting shot he signed the door of the Land Rover in permanent marker 'Lucky Luke'. I felt like I was the lucky one.

It was time for the next chapter of Afritrex, the long drive south to South Africa. I stopped off at the local internet café on the way back to Big Milly's to check my email for Owen's flight details the next day — and was hit by another bombshell.

Happy birthday you old sod. Last days of youth … you probably don't remember them any more …

I am getting a little desperate here. My bank have set back the date for a response until Wednesday the 12th March. I would need seven days to get ready after that — implement things on this side etc. I am not sure how this impacts on your plans but I understand you will not wait on me. You will go and I will chase.

Lagos, Douala? Libreville … most of Fucking Africa is gone. This is what I have planned to do all my fucking life. Looking at your route breaks my heart. I will catch up with you in one of these towns.

I love you and I am sorry to have disappointed you so monumentally Ben …

You are my sunshine buddy — the only thing keeping me going right now.

After everything we'd been through — the *years* of organisation, the continually postponed plans and the promises made — this was the straw that broke the camel's back. I had to accept Owen was no longer part of the expedition and I'd have to go on without him. The email broke my heart, as it had his in writing it. My best mate and expedition partner was stuck in a situation he couldn't get out of. I felt terrible for him — but I had to go on.

I also had to accept that travelling alone through central Africa in a private vehicle wasn't a good idea. My only option was to pack the Colonel into a container and ship it from Ghana to South Africa, then fly down myself to meet it a few weeks later. It was more important to arrive safely at my next marathon than not to arrive at all. I'd miss out on Mount Cameroon, but there were other mountains I could climb.

The next day I drove to the office of the shipping company, booked my space in the container, signed the forms and returned to Big Milly's feeling dejected. For so long I'd dreamt of driving through the rainforests of Africa, crossing the Equator and arriving in South Africa under my own steam. Instead I'd fly over it all, looking down from above, thinking about what could have been.

I drained my beer and turned to the barman, Solomon, to order another. It was my last night in the Colonel's roof tent before Cape Town. Until then I'd stay at the backpackers', train as hard as I could and bide my time.

'Hey Ben, are you still wanting to drive to Cape Town?' Matt, the manager, asked from the other side of the bar.

'You bloody know I am,' I snapped, more than a little disgruntled. 'Stop taking the piss!'

'I'm serious. You'd better chat to that guy in the big yellow truck that arrived today. I think he wants to go that way too.'

'*No way!* ... Solomon, hold that beer, I'll be back very soon.' I leapt from my bar stool and wandered over to the Dutch-registered yellow MAN truck parked in the corner of the yard.

Knock, knock.

'Hello. Anyone in there?'

After a moment the door opened and out popped the shaved head of a rather rotund, semi-naked man.

'Sorry ... I was sleeping. How can I help you?' he said, rubbing his eyes, dressed in only his underwear.

'My friend Matt tells me you're keen to drive to South Africa. Is that true? I'm going that way myself but don't have anyone to travel with!' I replied, not wanting to sound desperate.

'Sure thing,' his ridiculously relaxed answer came back. 'Why don't we do it together?'

* * *

Meet Kees, a Dutchman who has travelled most of Asia and Europe in his big yellow truck with his dog Bindi. He doesn't make plans, just

goes with the flow of the moment, making him quite possibly the perfect travel partner.

I couldn't quite believe my good fortune. On the eve of shipping the Colonel south, quite literally at the eleventh hour, one of those sliding door moments occurred.

That night my jubilation was tempered just a little by the error of my ways on the night of my birthday. Falling asleep with the doors of my tent open in a country rife with malaria had not been a good idea. The antimalarial drugs I'd been taking for the past few weeks, since arriving in the 'zone', were close to useless on a body weakened by alcohol. I'd literally left the door open for mosquitos to fly in, drink my blood and inject me with their poison as a delayed birthday present.

It hit me around 2 am, when I woke sweating profusely while at the same time shivering uncontrollably. As I clambered down the ladder I lost my grip and fell onto the sand below. Wendy, the owner of Big Milly's, saw me from across the yard and ran over to help.

'Are you all right, Ben? I saw you fall. My god, you're soaking wet. Are you feeling okay?'

'Urghh no, not really,' I spluttered, barely able to speak. 'I've got a splitting headache and I feel really weak.'

'I know the symptoms well, my friend. I think you've got malaria. Come with me. We need to get this sorted now.'

Wendy frog-marched me towards her office and handed me six tablets; two paracetamol and four Malarone, instructing me to take them immediately. Living in Africa gives you the experience to recognise the signs and deal with it straight away — if you're lucky enough to have the right medication. If not, it's very easy to become one of the thousands who die every year from this devastating disease.

By next morning I was already starting to feel a little better. The headache and sweats had gone but I was still weak, and it took a few more hours until I felt human again. I was extremely lucky to have caught it in its early stages, all thanks to Wendy.

The next few days were a hive of activity. I cancelled the container, serviced the Colonel, visited numerous embassies for visas and even recruited two more people to join us for the trip; an Australian girl from the Gold Coast called Alex, and Kerry, a wonderful man from Hong Kong I'd met in a hostel in Bamako a month before. We were all set — two vehicles and four people ready to take on the adventure of a lifetime.

Then things changed. *Again.*

We were due to leave Big Milly's two days later, once we'd collected our visas, when another overland vehicle rolled into camp — a Nissan Patrol with Patrick, his girlfriend Sarah and brother James on board. They'd left the UK a month earlier, were also heading to South Africa and were keen to join us. No sooner had that conversation finished than a family of six Canadians loaded with huge backpacks walked through the gate.

The Watkins family had just arrived in our world. They had first hit the road in 2005 and had backpacked their way from Hong Kong across Asia, into Europe and now Africa on a tiny budget, using public transport. Maggie and Brandon and their children Ammon, Skylar, Bre and Savannah were a bundle of fun and energy. Maggie and Brandon's decision to take their kids around the world in this way was one I admired greatly. Ammon, the über-intelligent one, was the brain behind their journey, constantly planning and reading, absorbing as much as he could about the destinations that lay ahead.

Bre and I got on well, her love of fitness and active approach to life our obvious connection. We spent time together running along the beach and swimming in the surf and hit it off from day one. Savannah, the youngest of the group, was a mysterious one. She was creative, intelligent and artistic but often hiding behind a book or writing in her journal, and seemed to resent every second spent away from her home in Canada.

Within 72 hours of my speaking to Kees for the first time, our travel convoy was up to three vehicles and 12 people (Skylar was headed back home to Canada) from five different countries. How things had turned around from the despair I'd been feeling so recently!

I left a little part of me at Big Milly's as I drove out the gates for the last time. It had become my temporary home, where I'd experienced a full range of emotions. But now was the time to move my Afritrex adventure forwards.

Let's go, comrades

With the Colonel leading the convoy, we moved along rather well over the next couple of weeks. My average speed had been reduced to 80 km/h to match Kees's Big Yellow Tortoise, but our 'safety in numbers' policy was working. We passed through Togo, Benin and

Nigeria with few problems, bar an incident or two with corrupt police and a couple of failed tax-jackings from the 'Sticker Boys', one of Nigeria's more persistent but badly organised roadside tax gangs.

Their scam is to throw a plank of wood full of nails in front of your vehicle, forcing you to screech to a halt, at which time they surround you and demand payment for using 'their' road. The first time it happened I wound down my window a few centimetres and reasoned with them for what seemed like an hour, until they finally let us pass without making a payment. The second time I was ready for them and drove onto the grass verge straight at the guy holding the plank of nails. He dropped it and ran for cover and our convoy drove past to cheers from the vehicles behind. Luckily the potentially serious consequences had been avoided, but my clutch leg shook for a good few minutes after!

The bureaucracy of Nigeria was the most pervasive I'd experienced in Africa. From the moment we crossed the border there seemed to be roadblocks every few kilometres with 'officials' from every government office, including the police, customs, bomb squad, health department — even veterinary checks. More often than not it was to simply sign a form, but on several occasions we were asked to make a 'donation' of anything from our clothes to our antimalarial tablets.

The most bizarre incident had to be when Patrick and I were told our steering wheels were on the wrong side of our vehicles. His Nissan and my Land Rover were both right-hand drive, coming from the UK, whereas Kees in his Dutch-registered MAN truck was in the clear. After much heated debate Kees came up with the idea of moving them from one side to the other. When the officials saw us pull on our overalls and thought we were serious, they backed down, eventually letting us through.

Dealing with officials and borders

National borders can throw up some of the most stressful and testing situations in the world of travel. The language barrier, prehistoric administration systems and incomplete paperwork, coupled with a constant fear of being ripped off, can create anxiety in the hardiest traveller.

These tips should help to make dealing with officials and borders that little bit easier:

- Try to arrive at the border post in the morning.

- Greet everyone with a warm smile and a handshake.

- Try to greet people in their own language.

- Don't wear sunglasses—it's often considered very rude.

- Be confident and in control, but not bolshie.

- Never try to rush officials—it will only slow them down.

- Always keep your passport and important papers in sight.

- Don't offer financial bribes of any sort, even if asked to.

- Ensure your papers are valid and have sufficient pages for any visa labels.

- Don't accept assistance from other people.

- If you do have to change money at the border, convert only a small amount. Be aware of the current exchange rate but don't expect to get it. There will be a commission charged; this is how these guys make their money!

One of Africa's 'worst roads' lies just over the border in Cameroon. I'd read all about the Ekok-to-Mamfe road in forums and on websites while planning Afritrex and was looking forward to it with a mixture of fear, excitement and trepidation.

The 68 km unsurfaced muddy track really is a road from hell. Deeply rutted from years of abuse, it's a mixture of long holes filled with water, and deep muddy tracks that could swallow a car. During all of my years of travel since, I have never seen a road as challenging as this one.

The Colonel did surprisingly well, its narrow track fitting between the mud walls that towered above it. Patrick's Nissan didn't come off too badly either, losing only the wheel arches against the unforgiving sides as he powered through. Kees's 11-tonne MAN truck, however, fared a little worse. Through continual use by heavy trucks the camber of the road veered steeply away to each side, meaning that staying dead centre was essential. One wheel out of place would suck a vehicle down and over the edge into the bog-like drainage ditch.

Kees struggled to keep the Big Yellow Tortoise on track, throwing his steering wheel from side to side as he fought both traction and gravity. The next part happened in slow motion: with all four wheels spinning furiously, the truck slowly lost speed and slipped uncontrollably into the ditch. It was stuck fast.

It took us nearly three hours in the hot, humid, muddy conditions to free it. Some of us dug away the mud while others lay branches in front of the wheels for traction.

'I don't know what these three buttons are? Something to do with diff-locks I think,' Kees said with a smile. Until now he'd never needed or used them. 'Should I press the magic buttons?' he asked.

'Just make sure everything is turned on or engaged,' Patrick advised. The day was fast disappearing and we had to get out now or admit defeat and stay here overnight.

With one last effort, Kees pressed the buttons and inched the truck along until finally the winch cable was close enough to anchor to a large tree. The grip from the wheels and force of the winch finally hauled the Tortoise free from the muddy channel. At last we could be on our way.

* * *

On the Cameroon coast an active volcano pokes up from the surrounding lush forest. Mount Cameroon is my next challenge. Lying just north of the Equator and rising out of the humid tropical rainforest, it tops out at 4040 metres above sea level on a bare summit that is cold, windy and occasionally brushed with snow.

My starting point for the climb is the small village of Buea at 800 metres above sea level on the eastern flank. Somehow I've managed to persuade all 12 of the group to take on the challenge with me, some more reluctantly than others. On day one we climb the steep, abrasive volcanic slopes to the overnight camp at just over 3000 metres.

When my alarm goes off the next morning most of my companions elect to stay in the warmth of their sleeping bags rather than join me on the slog to the summit. Five committed trekkers (Brandon, Bre, Patrick, James and me) set off into the mist and gloom that hangs over the upper slopes, our guides leading the way.

We reach the summit two hours later. It's hard to believe the wet, cold and windy conditions here. Having wilted in the 36°C heat of the day before, we are now shivering at zero degrees, albeit

4000 metres higher. Then the clouds part for a few minutes, offering views of the coastline below and the island of Equatorial Guinea off in the distance. I make a satellite phone call to Mum and Dad in the UK to confirm that challenge number three is completed before we scramble back down to the overnight hut.

Our luck holds

With sore bodies and the odd black toenail, we drove to the beachside town of Limbe. It was time to plot the next chapter of the Afritrex adventure. There were only five weeks to go until the Comrades Ultra Marathon in Durban, and to get there in time everything would have to work our perfectly on our journey south — including visa applications, border crossings and of course (always unpredictable) road conditions.

The Cameroon capital of Yaoundé was our next destination as the embassies of the next three countries we hoped to travel through were all located there. Four days, and a lot of handshakes later, we had 12 passports loaded with fresh visas all ready for the next 2500 kilometres of our adventure.

We were travelling well together, forming friendships, and the odd relationship was starting to flourish. Kees and Savannah seemed to be hitting it off, spending more and more time locked away in his truck, her brother, mother and father banished to their tent outside every night.

Bre and I were getting on well too. The friendship we'd formed from the start had blossomed into a relationship. We were having fun, without a care in the world, new experiences and challenges hiding around every corner.

During my years of preparation for Afritrex back in the UK, I had often daydreamed about the expedition, letting my mind wander to far-off places. I'd find myself somewhere in that vast continent, driving down a road, winding through rolling green hills to a destination I knew nothing about. The realisation of that dream as we crossed the Equator in the rainforests of Gabon reduced me to happy tears.

Our journey through central Africa was happening a few weeks later than I'd originally hoped, but luckily the annual rains were late too. Normally by this time of year intense thunderstorms would have rendered the roads impassable, closing down the already muddy

logging routes for a number of months. Our path to Brazzaville, capital of the Republic of the Congo, was ridiculously easy, with only minor detours and obstructions along the way.

We arrived on the banks of the Congo River in good spirits. We'd made it this far safely; now for the war-torn countries of the Democratic Republic of Congo and Angola, a notoriously difficult country to get any sort of visa for. According to my internet research, only two transit visas had been issued in the past six months. It was going to take all our diplomatic skills to get around this little obstacle!

First we had to get across the second largest river in the world. The ferry service between the capital cities of Brazzaville and Kinshasa normally operates several times a day. However, heavy rains meant the swollen river was washing large quantities of flotsam downstream, creating dangerous conditions for the ferries. All ferry services had consequently been indefinitely cancelled.

We waited patiently for four days with no change in the situation, until finally the Port Manager decided it was time to start selling tickets again. A huge backlog had built up while the ferry had been out of service. Queues of people desperate to get home stretched around the port. The line for vehicle tickets was much shorter; with only two trucks in front of us, our early arrival at the port that day was to pay dividends.

The ferry carrying our three vehicles and the two trucks left half full and with only a handful of passengers on board. The rest of the crowd were crammed onto two other, alarmingly overloaded, vessels that looked ready to sink.

The trip across the Congo River was superb — a vast reach of brown water with very little traffic and a few palm-covered islands in the middle. The heavy rain of the past few days had broken away sections of the bank upstream, creating dangerous obstacles for the ferry, which intermittently slowed its engines as the propellers cut through the reeds until they powered free.

With another major obstruction out of the way we made good time on decent roads to Matadi, home of the Angolan embassy.

We arrived feeling optimistic that the letters of approval we'd been given by the Angolan ambassador in Accra would be enough to ease us past the considerable bureaucratic obstacles to the granting of our visas. We spent the next two days in interview rooms and filling out forms before our visas were finally delivered.

I was reminded how fickle and unpredictable African immigration procedures can be. We'd applied for 30-day tourist visas so we could spend some time exploring one of Africa's less-visited but more beautiful countries. When the official behind the counter handed back our sheaf of passports, turned and abruptly closed the door, I knew there was a problem: they'd granted us only seven-day transit visas.

We had 2000 kilometres to drive on some of the worst roads on the continent. We'd have to cover at least 300 kilometres each day to make it to the Namibian border in time or face a daily fine of $100 per person for every day we ran over. Unlike Cameroon — where mud had been our biggest enemy — decades of war in Angola had literally blown apart the bitumen roads, leaving gaping craters that reduced road travel to a crawl.

No amount of arguing or bargaining would change the officials' mind. Every hour we sat around complaining was eating into the time we had to cross the country. We had to move, and fast.

We had no idea what to expect as we crossed the border into northern Angola and followed the road south towards the coast. But it was bad. What once had been a level bitumen highway was now a broken mass of rubble. It was quicker driving on the dirt track that ran parallel to the road, which was now suitable only for donkey-drawn carts.

By the time we reached the coast at the end of day one we were shattered. A day bouncing around at 30 km/h is as tiring for the passengers as it is for the drivers who have to remain constantly alert to the road ahead. We had no idea how we were going to make it in the six days that remained.

The next morning, 20 kilometres south of N'zeto, a wonderful African surprise appeared: a perfect new tarmac road stretched ahead as far as the eye could see, reviving our spirits and giving us the push we needed. Chinese mining companies have transformed some of the poorest countries in Africa by gifting them good roads from the mines to the ports. There are just very few people with vehicles to use them!

We made good time to the capital, Luanda, an old Portuguese enclave. We marveled at the colonial buildings that line the foreshore around the harbour. With the oil and mineral wealth that's tied up in the marina, if you squinted slightly you could imagine yourself in a city in the south of France.

The long drive south was fairly uneventful; good roads meant good progress. The transition in the natural landscape was the most noticeable change. We'd left the mountainous, equatorial rainforest behind us and were now driving across vast plateaus of savannah. Had the civil war in the 1970s not killed most of the wildlife, the country would still offer a safari destination to rival those of Kenya and Tanzania on the opposite side of the continent.

The Namibian border arrived quicker than I'd expected, and on the final day of our seven-day transit visa we crossed into country number 20 of my Afritrex adventure. I'd conquered my fears and made it through deepest, darkest Africa. Behind us lay some of the toughest countries to drive through in Africa. From here on (at least until we reached the north of Kenya in a few months' time) the roads, visas and communication should all be a lot easier to deal with.

Partings

Windhoek, Namibia's capital, was a return to easy living. Water ran clear from the taps, the beer was always cold and my Visa card worked in the first cash machine I tried. It was good to relax into a more Western lifestyle again — but I knew I'd miss the challenge of real overland adventure before too long.

It was here our group of 12 hardened travellers would go our different ways for at least the next six weeks. It was going to be tough breaking up after such an intense time on the road together. Bre and I had grown close, but the Watkins family would head to Cape Town with Kees in the Big Yellow Tortoise, while I was making for Durban with Alex on board, following Patrick and his crew on the final leg of their journey back to Pietermaritzburg. Kerry decided he rather liked Windhoek and chose to stay and explore it by himself.

The Comrades Marathon was only a week away and I still had to reach and cross South Africa, and acclimatise to the humid conditions on the east coast of the country. Having lived in Port Edward on and off for six years, going to Durban felt like going home. I had a renewed spring in my step that I'd surely need for my next challenge.

* * *

Arriving at the start line in Durban city centre in the dark of night, I feel nervous — not because of the usual hawkers and homeless drunks who patrol the streets at 5 am, but because of what lies ahead. I'm

facing the biggest physical challenge of my life: 87 kilometres uphill to the city of Pietermaritzburg.

The furthest I've ever run before is a normal marathon—I've completed a few, but that's less than half the distance. My training has fallen well short of what I'd hoped, with only a few runs squeezed into the last six months of overland travel. It's time to push my limits.

The first 20 kilometres seem to fly by, with the darkness limiting my view to the plodding feet up ahead of me. Then as the sun throws its warm rays into the sky the magnitude of what I'm attempting starts to take form: an endless line of runners is strung out over the hills ahead, winding its way towards an unseen destination.

A Durban day in the middle of June isn't cold, and by the time I reach the halfway mark the sun is beating down with punishing ferocity. With drink stations every 1.5 kilometres I make sure I take at least three sips of water each time, concentrating on keeping hydrated as best I can.

The Comrades Marathon has its own Big Five—that is, five big hills that all runners know and fear. Approaching the last of these, Polly Shortts, the field slows to walking pace and by the time I arrive at the summit, with only seven kilometres to go, I know I'm going to finish.

Sensing the city ahead, I up the pace. My legs are definitely feeling the 82 kilometres I've already run, but they still have something left in them. Entering the Flora Mile, the final stretch into the stadium, I give it everything I've got, breaking into a sprint for the last few metres. I turn and take a photo of myself as I cross the finish line, having shattered all my expectations and wildest dreams. Challenge number four is completed in 10 hours and 20 minutes.

The next of my 10 challenges, the Knysna Marathon, isn't far off. I have three weeks to recover before I need to start running again. In the meantime Alex and I decide it's time to hit the road. Our route takes us inland to the mountain kingdom of Lesotho. The Colonel slips and grips his way to the top of the icy Sani Pass, where we marvel at the snowy view across the Drakensberg Mountains while enjoying a glass of warm mulled wine.

The Knysna Marathon is a cinch compared with the Comrades a few weeks before. The winding course through the forest offers stunning views out over the river and bay before finishing on the waterfront. Alex cheers me across the line waving her glass of wine in the air. She has started celebrating without me!

I've reached the halfway point of Afritrex on many fronts: five challenges are behind me, I've reached South Africa and it's six months since I left home. From now on, my compass will mainly be pointing north.

Marathons, Mugabe and mountains

It was time to start the long journey home. It would be tough leaving behind the country I'd fallen in love with almost 10 years before. It seemed like an age since I arrived in Cape Town for the first time at the start of my work with Mumm Champagne. When I flew between the UK and South Africa and looked out of the plane window I'd think to myself, one day, Ben, you'll drive those roads.

There were six months left until Christmas Eve, the date I'd set for my return to the pub in Petersfield where I'd said goodbye to most of my friends. There were two friends I'd see well before that, Josie and Rachel, who'd decided to fly out and meet me in Johannesburg for a road trip to Mozambique.

After a brief reunion with Bre and her family and Kees in Cape Town, Alex and I hit the road again to meet the girls. It felt incredible to be so free. We toured the highlands of Swaziland before dropping down to the tropical waters of the Indian Ocean to swim with whale sharks, drink beer and make merry.

My next challenge was to be the Victoria Falls Marathon in Zimbabwe. The country was in political and economic turmoil, and with only two weeks to the event, the organising committee had to make the drastic decision to cancel it. President Robert Mugabe and his cronies were just making it too difficult for foreigners in the country.

When I was planning Afritrex I'd rigorously researched the continent's marathons, timing my entire expedition around the five I'd found. Now with one missing I faced the prospect of not fulfilling my sponsorship commitments. What was I to do?

'I've got an idea, Ben,' piped up Rachel, as I sat fuming on the beach. 'How about you run the last 42 kilometres back home into Petersfield as your final marathon?'

'You know what? I think you've got something there. That's exactly what I'll do!' I felt instantly buoyed by the idea.

Mozambique was a huge shift of mentality and circumstance. Alex had come to the end of her adventure with me and flew back to

Ghana to be with her friend Matt. After six months' travelling Josie flew back to the UK. Rachel and I had a week left to explore northern Mozambique and Zambia before she'd leave for home too.

I kept in touch with Kees and the Watkins family through email as they continued their travels in the Big Yellow Tortoise, still unsure of their destination. The family were determined to keep travelling as long as their funds held out.

When I first met Kees in Ghana his goal was to get to Cape Town, where he'd sell the truck and fly home. Now he'd made it but he still had paying passengers on board, and he knew I'd be driving back to Europe, so he thought we should link up for another adventure together — 10 000 kilometres up the east coast and along the north coast of Africa together. The Big Yellow Tortoise would soon be back.

Rachel and I set off for the Zambian border, our goal to spot as many of Africa's Big Five as possible. It felt wonderful to be back in the country I'd visited seven years before on my trip to view the solar eclipse. All evidence of the floods and refugee camps from that time was long since gone. Mozambique is a stunning country full of wonderful people, idyllic beaches, spicy peri-peri sauce — and, sadly, landmines, a relic of the 15-year civil war that lasted until 1992.

We'd stopped overnight at the Cahora Bassa dam and were driving back to the highway from the service road when there was an almighty SMASH! Turning and looking out the window, I spotted a young boy in a red t-shirt running away from the road with a catapult in his hand. My foot jammed my foot onto the brake pedal and the Colonel shuddered to a halt. I looked over my shoulder at the rear side window, which had been completely shattered.

Without thinking I jumped out of the Colonel and gave chase, racing across the bush-filled, scrubby landscape after an assailant I couldn't yet see. I had no idea what I'd do if I found him; I had to get there first. Then my sense returned with a thump.

What the hell was I doing racing through the countryside of a land still peppered with landmines from the years of war?! I stopped and gingerly retraced my steps through the dirt to the Colonel conscious that at any moment I could become a big bang on Rachel's horizon. It was only a boy doing what boys do, having some fun. Yes, I'd have to replace a window, but it was better than trying to replace a foot or leg!

Our Big Five wildlife mission was pretty successful (all except the leopard) by the time Rachel's African trip came to an end. We

drove into Lilongwe, the capital of Malawi, heading straight for the backpackers' where Kees and the Watkins were staying. Bre ran up to me with open arms. It was great to see her—and Kees and all of them—after so long.

With Rachel's departure in September, it was time to get Afritrex rolling again. In the next two months I'd be attempting three of my challenges; climbing Mount Kenya and Mount Kilimanjaro and finishing up with the Nairobi Marathon at the end of October.

Rather than follow me on my wild-challenge-chase around east Africa, Kees and most of the Watkins family decided to head off on their own adventure, a slower one along the coast. Bre and I headed inland, along Lake Malawi into Tanzania and then along Lake Tanganyika to the border of Burundi through some of the most dramatic and beautiful country of the trip so far.

Verdant, steeply terraced slopes laden with crops led down to cool mountain lakes as we drove the back roads of Burundi into Rwanda. Very few tourists pass this way and the tracks are unsurfaced, broken and remote. It's easy to imagine the time when early European explorers trekked through these parts charting early maps of the region. As always my modern version, the faithful laptop and GPS, was mounted on the dashboard to keep us on track.

Rwanda and Uganda passed by my window far too quickly. With a race on to get to the next challenge there wasn't time to stay and explore them properly, but I promised myself I'd return sometime in the future. Their landscapes, people and extensive history are etched in my mind forever.

After crossing the border into Kenya, I faced my next challenge—the ascent of Mount Kenya, the second highest in Africa. The mountain has two peaks, Point Lenana (4985 m), which involves an intense trek to the summit, and Batian (5199 m), which can only be climbed using ropes and requires comprehensive climbing skills to reach the summit.

Discretion being the better part of valour—after all, I still had no technical climbing skills—I opted to trek up Point Lenana. I'd booked my guide a few weeks before, after another overlander recommended him to me. Robin met me in Nanyuki, the starting point for our ascent. Bre, on her family's tight budget, opted to sit this one out and stayed in the comfort of the camp.

* * *

It takes three days to climb to the summit and back. The trek starts on the lower slopes of the mountain, passing through thick forest vegetation where elephants roam. They take us by surprise on a number of occasions, erupting into voice as they crash off through the bush.

On the second day the drop in humidity with our continued ascent makes the trekking easier. The landscape reminds me of the Scottish Highlands, covered in heather and boggy marshland. We arrive at Shipton's Camp, our overnight hut, early in the afternoon, then sit and watch as the sun disappears from view, plunging the valley into darkness and releasing the chill of the night.

At 3 am my phone vibrates next to me, deep in my sleeping bag. It's −8°C outside and I'm reluctant to leave the warmth of my cocoon. Robin hands me a thermos of hot tea and says we have to leave to make the summit in time for sunrise. Back on the hiking trail progress is slow — fast enough to keep warm but not to produce sweat.

'*Poli poli*, Ben. *Poli poli*,' Robin repeats over and over — 'slowly, slowly' in Swahili.

We catch and overtake the long line of head-torches stretching up the steep slope in front. Most of the people in the hut with us overnight left well before us, but with Robin's good fitness and my love of hard training we cruise past.

The lack of oxygen at altitude is starting to tell. My breathing becomes more laboured, but with only a few hundred metres to go I power on. At 5.45 we summit Mt Kenya in time to witness the most spectacular sunrise. To the south, and over 300 kilometres away, the peak of Mount Kilimanjaro pierces the clouds, casting a shadow over the land below. In 10 days' time I'll be right there on the roof of Africa.

After high-fives, hugs and photos, Robin and I turn and head back down the mountain. The descent is supposed to take two days, but as I'm always up for a challenge, I ask Robin if we can try to do it in just one. After racing 28 kilometres and descending 2500 metres, we make it back to the car in a little over 11 hours, much to Bre's surprise.

Challenge number six done and dusted.

A week later we drive into Arusha, the starting point for the ascent of Mount Kilimanjaro. James Beaton, a good friend from the UK, has flown out to join me for this, my next challenge. A seasoned trekker and climber, James arrived a few days early in order to properly acclimatise.

We take the Machame Gate route up the mountain and spend four days slowly gaining height before dropping back down at night so our bodies get used to the altitude and lack of oxygen.

On the eve of day four we camp at Barafu Hut, where overnight temperatures drop to −8 °C. The crystal-clear night erupts in stars, the Milky Way stretching across the entire sky. With no wind it's a stunning but frigid place to enjoy dinner. By 6 pm we're wrapped up warm and fast asleep.

The soft sound of snow on the tent wakes me just after 10 pm. There's no point going back to sleep now as we'll be starting our ascent in a little over an hour. It seems strange to be camped on the Equator in the middle of Africa in such arctic conditions.

The cloud clears quickly as we trek towards the bottom of the scree slope that leads to the summit. I remember looking up last night, wondering how steep it really was. Now, with the long line of head-torches stretching their way up, the incline becomes more evident.

For four hours we zigzag our way up the frozen scree, one foot in front of the other, *poli poli*. The air is becoming thinner all the time, James and I breathing heavily even though our legs are doing very little work.

The final 150 metres to the top of the slope really take it out of us. We have made it to Stella Point, 5750 metres above sea level. But our relief at getting this far is curtailed by the bitterly cold wind that sweeps in to greet us. To keep warm we keep pushing on to the summit across hard, snow-covered ground. It's a gentle walk over the final 150 metres to Uhuru Peak, the highest point on the African continent. The first signs of dawn are starting to appear on the eastern horizon.

With a spring in my step, I march to the wooden sign at the highest point, 5895 metres. At that moment I am the tallest person in all of Africa. Check off Afritrex challenge number seven.

As soon as I remove my hand from my glove to take a quick photo I realise it's a stupid thing to do; with the temperature around −25 °C, the wind instantly numbs my fingers.

My friend Char, who died in the Asian tsunami disaster, climbed to this same spot when she was 16 years old. I build a stone cairn in her name and leave a photo of the two of us under one of the stones as a personal memorial.

James comes over and we have a big man-hug and begin our descent, stopping off to photograph the glacier of blue ice that's

thousands of years old. Huge cracking sounds come from it as the sun's rays warm its core. It's estimated that by 2033 all snow and ice will have gone from the summit. I'm glad to have made it there in time.

Eleven hours after summiting we arrive back at the car park thoroughly exhausted but elated. It's been a huge undertaking and our bodies are drained, but with only minor blisters and one black toenail I'm in pretty good shape for the Nairobi Marathon in a week's time.

We take a quick trip to Dar es Salaam and recover on the beach for a few days. Then I drop James at the airport for his flight back to the UK and collect Mum and Dad, who arrive the same day. After eight months away it's fantastic to see them. With a full vehicle, we drive to the border into Kenya and west to Nairobi.

The city sits in a natural bowl 1600 metres above sea level and is home to some of the most polluting diesel buses on the planet — not exactly perfect atmospheric conditions in which to run a marathon.

By Saturday morning I feel ready for the race and join 3000 other runners at the start line. Looking around, I find I'm surrounded by gazelle-like athletic runners from Ethiopia, Kenya and Tanzania, the epicentres of international long-distance running. With my short frame and white body I feel totally out of place, but I'm not here to win. My goal is simply to get to the finish line!

Crack! We're off. The pack surges forward and I'm dragged along for the ride. I quickly drop off the pace, concerned that I won't make the halfway mark at this rate. It isn't long before I'm running alone.

The route for the marathon makes it one of the most mentally challenging and boring I've ever run. After a quick city circuit the course leads out onto a dead-straight two-lane highway (complete with traffic) for eight kilometres to the airport before turning down the opposite side back into the city — twice. By the time I make it back to the outskirts I'm done in, my legs tired, my brain shattered. I just want to get across the line.

Entering the stadium for the final lap of the track I just about muster the energy to cross the line. It has taken me a little over four hours to get there, nearly two hours behind the winner, but the time is incidental. To me it's another victory, and I've ticked off challenge number eight. Only two to go!

Tactics for completing a marathon

Many people have completing a marathon on their bucket list, but it's not something you can just get off the sofa and do tomorrow. In my view the challenge is 40 per cent physical and 60 per cent mental. If you have adequate training *and the right frame of mind*, then you can easily complete one.

To get your approach right, here are a few of my tips to getting across that finish line:

- Don't just think it, do it. Book that place now!

- Have a training plan that starts at least three months out and try your best to stick to it.

- Make hills your friend. Repetition work is painful and boring but *really* good for your overall fitness.

- Increase your distance every week by no more than 15 per cent.

- Mix it up a bit. Try sprint work and long distance runs; get on a bike or in the pool — it's great for aching legs.

- Get a decent pair of running shoes fitted at least a month before the race by a specialist running shop. Buy one size up from your normal shoes as your feet will swell.

- Taper down. The last week should be relaxing, not brutal.

- Eat well before the race, food you're used to. Personally I'm pasta all the way! Don't overfeed the night before, and carb-load for at least three days before the event.

- Don't get dragged along with the pack at the start — you'll regret it towards the end.

- Stay hydrated. Take small sips as often as possible and don't miss a feed station just because it's busy. You can walk occasionally!

- If things get tough focus on getting to the next corner or the next kilometre mark rather than on making it over the finish line.

- Never say never—you can, and you will get across that line.

- Enjoy it. You're about to achieve something incredible…
and it may be your last!

Bandits, dust and decisions

Nairobi was both a happy and a sad place, with a reunion and a farewell. Kees and the Watkins family arrived at the camp, and Mum and Dad's short visit to Africa came to an end. The last leg of Afritrex was about to start. Only two more challenges and five African countries lay ahead.

The road leading north from the Kenyan capital was a good one — well surfaced and wide, with expansive views of the surrounding countryside — all the way to Marsabit.

It was here the 'second worst road in Africa' began. Running for 250 kilometres to Moyale, on the Ethiopian border, this unsurfaced road made mostly of rock, sand and dust is bad in the dry and horrific in the wet. It also goes through the heart of 'bandit country'. Weirdly enough I was looking forward to it after the ease and monotony of the last 10 000 kilometres!

Safety in numbers had been our theory up until now and we were going to stick to it. Other overlander websites had recommended a police escort, but we couldn't find any in town, so we chose to go on alone.

The road's condition hadn't been improved by a torrential overnight storm, which had turned the good sandy parts into long muddy sections that the Colonel and the Big Yellow Tortoise slipped and slid their way through. After a day of bone-shaking corrugations, tyre-destroying rocks and muddy diversions, we arrived in the border town of Moyale. There'd been no sign of bandits, just a few Maasai herding their goats and sheep. We'd made it.

Ethiopia was a revelation for me. I arrived in the country with visions of drought, death and famine brought on by memories of Bob Geldof's Live Aid in 1985. Our journey through the southern part of the country, where we drove past lush, green pastures and high rolling meadowland, changed all that.

The last of my mountain challenges was Ras Dashen in the Semien Mountains, 1000 kilometres north of the capital, Addis Ababa. Bre and I left the others behind on our own three-day mission. I was up against the clock again, knowing that the only barge we could take across Lake Nasser, in the north of Sudan, would be leaving in 10 days and we had to be on it. Otherwise we'd have to wait another week for it to return, which would have serious implications for a Christmas Eve return to Petersfield.

* * *

At the Simien National Park office I find my guide, an old gentleman by the name of Nana. It's forbidden to climb the mountain without a guide in case you are attacked by bandits! Nana comes with his own rifle, albeit a very bent one.

I impress on the park warden the urgency of my situation, and that, if possible, I want to reach the summit and get back in two days, not three as are normally taken. He passes on my message to Nana, who doesn't speak a word of English. I'm not sure he fully understands. I figure I'll just have to see what happens.

I am on my own for the climb. Bre stays behind with the Colonel, happy to sit back and relax with her book. Nana and I take off loaded with 18 kilos of food, camping gear and water. I have to carry everything with me, as there are no overnight shelters or shops on the way.

To get to the summit of Ras Dashen requires two separate ascents, the first of which takes you over Ethiopia's second highest mountain, at 4200 metres above sea level. It's a hard trek, the air is thin and once you reach the first summit you drop down over huge rocks and along dusty mule tracks until you reach the valley floor at 2800 metres.

The first day goes well; we cover a good distance and complete some huge ascents. We drop down into the valley, losing 1400 metres in altitude, to where I think we'll be staying the night, but the day isn't over. There's still another 500 metres to climb back up before the small village where we're to camp appears. The day's exertions have taken their toll and my thighs are starting to cramp, something I've never experienced before.

My alarm goes off at 5 am. I roll over and shake Nana, who's asleep beside me. Our ascent in the darkness is by head torch and we

slowly wind our way up through the fields and villages that extend up to 3800 metres, the fertile soil and warm daytime temperatures providing ideal growing conditions. We reach a rocky slope leading up to the peak with the sun just breaking the horizon, and after a three-hour ascent gain the summit by climbing hand over hand along a precarious wall.

I take Nana's rifle so he can scramble up the final ledge, then he turns and pulls me up to join him. At 4543 metres above sea level we've reached the top of my final Afritrex summit and we embrace. It doesn't matter that we speak different languages. We don't need words to convey what we are sharing.

With a huge day still ahead, we hurry down the mountain, stopping at our overnight camp to devour breakfast, having left on an empty stomach. I take the chance to refill our water bladders from the stream that runs alongside, drop a couple of water treatment tablets in and shake them around. They won't get rid of the cloudiness, but at least they'll kill any water-borne disease floating downstream from the grazing livestock we've passed.

Somehow, though, I've misjudged our food needs. With breakfast gone we have only one out-of-date army ration pack left to share between us for the whole day, and with over 2000 metres still to climb we need every calorie we can get.

We set off for the valley floor below, dropping 500 metres in less than 20 minutes before starting the climb back up the second highest mountain in the country. Both the flies and local children are now awake, buzzing around as I sweat my way up the steep track.

'Salām, hello, salām,' they repeat over and over until I reply. My body and mind are exhausted and sociability is the last thing I feel up for. When I look up from my trudging feet the children's eyes sparkle at me, full of life, and it brings me out of my weary daze.

With 200 metres of the 1400 m climb to go, I go into shutdown, with nothing left in the tank. Nana looks as tired as I feel. We've both pushed too hard after too little sleep with not enough food; it's time for my last ration pack.

Sharing my plastic camp spoon we take it in turns to shovel down the bangers, beans and mash and wash it down with cloudy water. It doesn't take long for our new fuel to take effect and energy to return to our tired bodies. The top of the pass is close and as we clear our third summit of the day a herd of mountain ibex dart for cover.

The final 800-metre descent to Bre and the Colonel is another heavenly experience. I've completed the toughest of my physical challenges, and as the sun breaks through the misty mountain range ahead groups of gelada baboons with bright pink backsides, and more ibex, welcome us home.

* * *

My next challenge wasn't physical but rather logistical. The race was on to get to the northern border of Ethiopia, cross Sudan and reach Lake Nasser in time for the waiting barge. Kees was ready and waiting for us in the castle-filled town of Gondar, so after a quick sightseeing tour we hit the road west.

The international news about Sudan was full of horror stories of killing, kidnapping, war and destruction. The fighting factions of a country torn apart by conflicts over oil and land meant the west was a no-go zone for foreigners, especially those in very conspicuous bright yellow vehicles.

We took a route up through the east of the country, away from Juba, the Janjaweed and other potential problems, to the capital, Khartoum. Our destination, the Blue Nile Sailing Club, is a favourite for overland travellers with its campground on the bank of Africa's most famous river.

Khartoum offered another great example of how different real life can be from what we read in the press. On our way into the city through the morning traffic, people waved, smiled and sparked conversation through my open window.

'Hello meester, you know where you're going, yes?' one guy asked.

'*As-salamu alaykum*, how are you today, sir?' another enquired.

It was good to see wide smiles, which I happily returned. When we'd finally set up camp for the night, I checked my email and noticed two messages from addresses I didn't recognise. They were from two different people who'd spotted us driving through the city, taken down my website details from the side of the Colonel, and sent an email offering help and a place to stay if we needed it. I was absolutely floored by this African hospitality.

After a morning spent filling in forms, we could finally move again. We had 1000 kilometres to drive to the waiting barge and by all accounts the roads were good for the first 500 kilometres and horrendous thereafter. Dust as deep as your ankles and as fine as

talcum powder would mean slow, filthy, frustrating progress. Having the GPS and laptop for navigation meant I was always the lead vehicle, so Kees really wasn't looking forward to it.

At the end of the day so much dust had blown up from the Colonel in front and seeped into the Big Yellow Tortoise that you could write your name on the dashboard with your finger. Kees looked like he'd been working down a mineshaft, his nostrils, eyes and ears full.

When we set camp that night Bre and I talked for a long while about what the next few days held for us. In my mind the end of Afritrex would naturally spell the end of our relationship. While we'd had some incredible experiences together on the road, we were both returning to our own lives in different countries. We'd both get back into our old routines and our time together would enter the history books — or so I assumed.

Once back in Cairo, my plan was to continue to the Mediterranean coast, turn left and west into Libya then on to Tunisia. From there I'd catch a ferry to Italy, leaving a 'short' drive back through France to the UK.

I had no idea what I was going to do back in England. The last five years had been all about this expedition. I had no firm plans beyond the final marathon into Petersfield. The rest of my life was up in the air.

Once back in the UK there'd be no one to share the stories of travel and adventure with. My friends would quickly grow tired of my harping on about 'this amazing road' and 'that incredible view'. Maintaining my relationship with Bre meant I could hold onto the last threads of Afritrex for as long as possible, even though the expedition was well and truly over.

My mind was all over the place. Do I keep the relationship going, hopeful it'll survive in the long run over a huge distance? When would I even see Bre again? I needed to talk it through with someone. Someone who would understand the situation and give me some clarity.

Rachel. She'd met Bre, she'd know how realistic the idea of a long-term future together would be.

Walking away from our camp in the middle of the Sudanese desert I powered up my satellite phone and called her.

'Ray, can you hear me? It's Ben.'

'BEN! Wow, how are you? Where are you?'

'Actually I'm in the middle of the bloody desert. I need your advice. I'm at a crunch point and don't know what to do.'

'Sure thing, Ben. Is this about Bre?' she replied, already picking up the concern in my voice.

'Yes, exactly. I've got strong feelings for the girl and we've been through loads together. Do I finish the relationship? Or give it a fighting chance and bring her back to England with me? I just don't know if it'll work out for us?' I temporised, not knowing what I was asking or what Rachel could offer. I just needed to get it off my chest.

'From what I saw you had fun together, but whatever you decide you'll have to stick by it. Just ask yourself, if you bring her home with you, will it work out?'

I thought long and hard about what to do before finally deciding to give it a go. I remembered Jay's words: 'If you don't go, you'll never know.' Later that day I sent an email to Sami, our Libyan visa-fixer, and added Bre's application to the list.

The barge was waiting for us at Wadi Halfa as planned. Kees and I drove our trucks on and waved goodbye to the family. Only the drivers could travel on the barge; the family would have to travel on the passenger ferry that left later that day. So we'd all meet up again at Aswan in Egypt.

With two days of downtime on the barge I took stock and thought about the final two weeks of the journey. The next day I checked my email using my BGAN satellite system and found a reply from Sami — our Libyan transit visas had been granted.

I could see the finish line. It was two weeks to Christmas Eve and I intended to be in the pub in Petersfield to celebrate with friends, just as I'd promised almost a year before.

A race for the border

Leaving the chaos and calamity of Cairo behind we'd done all we could to prepare for the Libyan border. It was rumoured to be one of the most problematic on the continent, and with time running out before we had to be in Tunis to catch the weekly boat to Italy, nothing could go wrong.

Sami confirmed the date we'd need to be there to meet him and the government guide who would remain with us throughout our

drive across Libya. He'd have our transit visa with him, which had a fixed start date and was valid for five days (just enough time to get across the country). We'd got the Arabic translation stamp of our passport details, as requested.

We handed over our temporary Egyptian number plates and moved to the next window. Exiting a country where every sign and form is in Arabic was proving difficult, but together we were making progress. All that remained was a stamp on the *carnet de passage* and on each of our passports and we could leave Egypt behind, and enter Libya.

'Okay. Done. You can go now,' the English-speaking official barked from behind his counter.

Another country successfully crossed. We drove through no-man's-land, past a few whitewashed, bullet-ridden buildings and up to the high barbed-wire fence marking the border with Libya, country number 35 of the trip.

'Papers,' another welcoming official growled.

'Where is your translation stamp?' he demanded, sliding the passports back to me.

'Um, this is it right here,' I said confirming the page they were open on was correct.

'This is not an *official* stamp from your embassy. You need to get one before you can enter our country.'

There was no arguing. What I firmly believed would be an acceptable translation stamp on our passports had been issued by an Egyptian government translation agency, not our individual embassies. I had screwed up big time.

It was now 5 pm and we were stuck in no-man's-land with no way of entering either country, our Egyptian number plates and visa papers having been revoked only 30 minutes before. It was time for some quick thinking.

After some fast-talking back on the Egyptian side, I walked out to Kees and Bre armed with the paperwork we'd needed. We'd been given a two-day extension on our original visa by the understanding official; just enough time to race back to Alexandria, get the correct stamps and race back again. The problem was, the clock was already ticking on our five-day Libyan transit visa. It was going to be mighty close. Now was not the time for a breakdown.

We left the Big Yellow Tortoise at the border and all jumped into the Colonel. There aren't many situations in which you would expect a 25-year-old Land Rover to be the fastest vehicle available, but this was one of them.

After driving for 21 hours across 1500 kilometres of mind-numbing desert we arrived back at the Libyan border with three passports containing the 'official' translation stamps. I have never since taken on a drive of that magnitude, and never will again. For the last 200 kilometres of the journey both Bre and Kees were fast asleep and I was left to battle the sleep demons alone. With the windows wide open and the radio blasting I got us safely back to the last Egyptian town of El Salloom.

The detour meant there was no way we could get to the port of Tunis in time for the ferry to Italy. After everything I'd been through on the road over the past year — 60 000 kilometres of mud and broken roads, hectic borders, exhausting marathons and mountain summits — one simple oversight meant I'd miss Christmas at home.

The drive across Libya took three days. It would have been wonderful to spend a week or more there exploring the lunar landscapes of the northern Sahara and the magnificent Roman archaeological sites, but time didn't allow for it.

Our government guide Ali sat quietly in the back, never saying much unless we spoke to him. We did stop at Leptis Magna, an hour outside of the capital, Tripoli. The ancient ruins of one of the Roman Empire's most prominent cities stand on the edge of the Mediterranean, where the Wadi Lebda meets the sea. Arriving in the centre of Tripoli, Ali told us the traffic was heavier than usual — something big was happening. We waited patiently at the traffic lights, with a long line of cars backed up behind, for nearly half an hour as the police and military presence grew. We were a little uncomfortable and the Colonel was drawing more looks than normal. People evidently thought we were part of the action.

A long line of military vehicles drove by at speed. Some had huge machine guns mounted on the roof with eagle-eyed gunners

ready to fire on anyone who stepped out of line. The situation felt incredibly threatening.

'Ali, do you have any idea what's going on?' I asked.

The military vehicles were followed by a shiny black Mercedes, then another, and another — 18 in all, every one identical.

'What you are seeing is Mr Gaddafi moving through the city. Nobody ever knows which car he travels in. It is much safer that way in case somebody tries to assassinate him.' Ali had extinguished his hash joint and was our tour guide again, proud to have encountered his 'Great Leader'. Three years later Gaddafi would be dead.

We waved goodbye to Ali as we crossed the border into Tunisia and started the final leg. It was now Christmas Eve, the day I had planned to be home. We spent the night at a tourist resort, splashing out on a little bit of European luxury so we could celebrate together, but my heart really wasn't in it.

The disappointment of missing out on Christmas at home with my family and the realisation that Afritrex was almost over were too much. With all the jubilation I'd felt over the past year it didn't seem right to be holed up in this tacky resort for the finale.

With two days to go until our ferry left, there was no rush to get to Tunis so our pace along the toll-road (our first since South Africa) was pedestrian. Our surroundings were turning European very quickly: the tarmac roads were wide and immaculate without a pothole to be seen and the shop at the Shell service station was stocked full of brightly coloured drinks, crisps and chocolate. Everything we could have wanted was there. Kees and I stood and stared at the shelves dumbfounded by the choice.

We were back in the world of multinational corporations, complete with their robots behind the counter. No longer could we spark up a conversation with the shopkeeper, whiling away the time, bartering for the sake of it. Everything had a sticker with a price you had to pay. I missed Africa already and we hadn't left yet.

Finally the ropes were cast off and as the ferry cruised away I looked back at Africa getting gradually smaller. The sun slowly disappeared behind the city skyline. Africa had finished with me — and for now, I'd finished with it.

Essential technology for life on the road

Whether I'm running an expedition from inside my Land Rover or on a kayak, I like to share my experiences with my digital audience. Here's my must-have technology to help document a life of adventure.

Tools

- MacBook Pro 15" with keyboard cover and case
- LaCie Rugged Drive x 2—for backup and media dump
- iPhone 5S with battery case
- Garmin Montana GPS—with map database
- Nikon D7100 with several lenses—HD video
- Nikon AW110—rugged and waterproof without a case
- GoPro Hero3 with mounts—for underwater ease
- Manfrotto Carbon 190 Tripod—lightweight and sturdy
- Rechargeable batteries—think of the environment
- Inmarsat Satellite Phone—last resort in remote places
- Cable bag—with one of everything
- Handheld compass
- Lonely Planet books
- Paper maps of region—great for scribbling on and sharing
- Leatherman Wave multi-tool—remember not to carry it on the plane

Social media channels

- Website (www.bensouthall.com)
- Facebook
- Twitter
- Instagram
- Flickr

Travel apps

- Navionics—ultimate iPhone GPS for life on the water
- Snapseed—best mobile photo editing software
- GoPro—leave that battery-chewing screen behind
- XE Currency—for up-to-date world exchange rates
- Word Lens—live translation service using the camera
- Motion X—GPS mapping service can be used offline

The last marathon

In the span of 12 months, I'd circumnavigated the African climate, passing through wet and dry seasons, from cold to hot and back again. As I boarded the cross-channel ferry from Portsmouth to Le Havre at the start the adventure I remember thinking, thank god I'm leaving the rain behind. Now I was back in the cold of a European winter all I could think about was how quickly I'd left the heat of the desert behind!

I couldn't wait to see my friends and family after so long. My niece and nephews would have grown up so much. But I wasn't especially looking forward to my return to England on that bone-chilling December night. The festive season reminded me of icy roads, numb fingers and log fires, rather than the deep-red African sunsets I'd become used to.

It was the end of five years' planning, a year on the road and a lifelong dream. The end of the best year of my life—or so I thought.

I spent my first night back on English soil at my sister's house in Guildford. The next morning I'd have to get up at 6 am, climb into my running gear and complete the last of my 10 Afritrex challenges.

I hadn't given a lot of thought to the temperature at that time of the morning, but when I stepped outside in my lucky marathon shorts the bite of the frosty morning hit me.

'This isn't Africa? What the hell am I doing?' I shouted to Dad, Colonel Mustard's new driver, who would shadow me along the route.

It took nearly four hours to complete the course that Dad had meticulously measured out the day before.

The route took me through the lanes of Surrey and Hampshire and finally into the high street of Petersfield. As I ran down the road people were cheering from both sides, I could see the faces of my friends who'd waved me off from the same spot a year before. I turned the final corner into the market square, completing the last 42 kilometres of my 65 000 km adventure on foot.

A huge gaggle of friends and family were there to greet me, together with a group of journalists from local newspapers and television.

After a year away, having just run a marathon in freezing conditions, I now had to stand up and deliver a coherent interview in front of the cameras. This wasn't the end of my adventure, but the start of something new. My expedition had been a source of motivation for many people. They'd followed my blog and website from the comfort of home as I toiled through 'the most dangerous continent in the world'. Using the power of a beaming smile and a firm handshake, I begged to differ.

* * *

The euphoric high of my homecoming was short-lived. I'd returned home to the gathering gloom of the global financial crisis. I was heavily in debt with no job lined up, and the cold and darkness of winter just added to my feeling of discontent.

In Africa I'd built a companionable relationship with Bre that filled the void Owen had left. Now, back in the UK, it seemed to be my only link back to a happy place and a life of adventure on the road. In the last few weeks of Afritrex, Bre split from her family and joined me as I headed for home through North Africa. For her, life on the road was a never-ending dream, funded by her family, but after four years of travelling together, their dream was also drawing to a close.

When you spend years of your life planning, saving and preparing for an expedition that delivers incredible adventure and new experiences on tap, the vacuum left behind afterwards leaves you feeling empty and listless. I felt like a yacht with no wind, struggling to steer and find direction, unsure where life would take me next.

My head was a mess as I tried to adapt to normality. Afritrex was a motivating force that had driven me forwards; now it was over

my momentum was gone. I needed something new to inspire me, something to look forward to. But where would I find it?

Neither of us knew what the next few months had in store. Bre was keen to get back to her friends in Canada after being away for so long, and I could only see as far as the next few months, paying off the debts I'd amassed.

After the exertion of the final marathon back into Petersfield on a frigid New Year's Eve it was time to catch up with friends to welcome in 2009. My best friend Jay wanted to hear the stories of life on the road, so instead of the usual night of debauchery in the local pub we accepted his offer of dinner with a group of my closest friends.

As a last-minute attempt at fancy dress, Bre and I donned our African-batik shirts and joined the party. Everyone was in fine spirits, buoyed by a few bottles of wine, the conversation a reminder of what I'd missed for so long. The night was just what I needed, a chance to relax, unwind and share stories from the last 12 months.

I was feeling the difference between life on the road and life back home. Without my realising it the experience had subtly changed who I was as a person, and now I was back home things weren't fitting as well as I'd hoped. But being honest about who I was and where I saw my future with Bre was something I shied away from. She was my link to Africa and I was scared to let go of that dream. Bre's flight to Vancouver was booked for the first week in February. At that point I'd say goodbye to her indefinitely, unsure of when, or if, we'd see each other again.

CHAPTER 3

Applying for the 'best job in the world'

With the Afritrex fanfare over and Bre heading back to Canada, I forced myself back into the world of work in order to pay back some of the money I owed Mum and Dad. And given all the pain and heartache Owen had caused me over the last year, his offer of a few days' work to start me on the road back out of debt was well timed.

It started with 'that' advert

Luke also threw me a lifeline with a week of work at his film-location business. On the morning of January 11, 2009, we were driving up the A3 towards Croydon, South London, with his girlfriend Emma. This particular drive is, for me, the epitome of everything that is soul-destroying in life: commuting to London on a Monday morning, with thousands of other grey-suited workers, grinding along in nose-to-tail traffic in near-darkness with drizzle falling.

We were chatting fitfully when suddenly Emma plucked a folded page of newspaper from her pocket and said, 'Ben darling, I've found the most amazing job in the newspaper and I was going to apply for it but I think *you* stand a much better chance of getting it than I do'. I was immediately curious.

'Let's have a look then,' I replied, taking it from her.

The full-page advert from the *Daily Mail* didn't look anything like a conventional job advert. There was no recruitment agency blurb or job specification, but instead it featured a photo of the view from a sunny wooden deck overlooking pure white sand, turquoise water,

palm trees and a tropical island way off in the distance. My eyes dropped to the text below:

Island Caretaker Wanted — Six Month Contract — $150K

I read on:

Responsibilities: Clean the pool, feed the fish, collect the mail, explore and report back...

As I absorbed the words, I thought to myself: this couldn't be a *real* job ... could it?

'Emma, I couldn't take this home with me, could I? I'm more than a little curious.'

'Of course you can! I don't think I'd stand a chance up against you anyway!' she teased.

I took that article out of my pocket at least five times during the day, reading it from top to bottom, going through the detail of what was expected from this 'Island Caretaker'.

My mind drifted away to this far-off place called the Great Barrier Reef. As a newly qualified diver, I'd heard about this mecca for underwater adventures. I also knew a huge amount about this marine wonderland through my love of maps and geography, but I hadn't been there. And now I really wanted to go.

After a long day working on the streets of Croydon with Luke, I got back to Hampshire that night exhausted. I headed downstairs and grabbed a bite to eat from Mum's infinitely stocked fridge before setting about my daily online job search. Event management? Maybe with a charity? Ideally based within 50 miles of my parents' house in Hampshire.

I trawled through the same mundane adverts that hundreds of other potential applicants would be reading. Too far away ... too little money ... too few qualifications ... boring — there was so little out there!

My mind drifted as it does when surfing the internet. Distracted, I started checking emails instead. There was a new message from Aunty Jenny in Spain. She often sends me links to articles from the *Guardian*'s website: interesting news pieces, articles about places I've been in Africa, and the occasional job advert.

I opened the link and sure enough, another job — but this time a very different one, and didn't it sound familiar? Island Caretaker for

the Great Barrier Reef. My tired memory kicked into gear. I rushed upstairs and rummaged through the pockets of my discarded jeans until my hand brushed against the *Daily Mail* newspaper clipping.

'Mum, have a look at this,' I said passing her the article. 'Emma gave it to me today and thinks I'd stand a chance. What do you reckon?'

She skim-read it, taking in the headlines and the enticing photo. 'Well, why not apply? It sounds amazing and you're more than qualified.'

I headed back to the study, sat at the computer and typed in the web address: www.islandreefjob.com. The response on the screen wasn't what I'd been hoping for: *This page cannot be displayed.*

Ugh. Had the job gone already? Was it just a hoax?

I would find out later how so many people around the world had visited the website that the server had crashed and the whole page was down. On that first day alone more than 400 000 people had clicked on the homepage to find out more about 'the best job in the world'.

I went to bed exhausted and a little disappointed. The promise of an exciting opportunity had evaporated before it had even taken shape.

The next morning I gave it one more go, carefully typing in the URL. To my joy the site was back up and running. The image of the tropical island paradise greeted me with the same unbelievable job still on offer.

Position vacant: Island Caretaker

Six-month contract AUD$150,000 package

Get the full job description here

Mum sat next to me. I clicked the link to find out more and together we pored through the fine print.

'They want someone to feed the fish, clean the pool and deliver the mail?' I said doubtfully. 'The only *real* work I can see is writing a weekly blog.'

'Well that's what it says, yes. Looks like they'll pay you pretty well and provide all transport and accommodation too. Can't be bad. You'd be silly not to give it a go, but I imagine there'll be thousands of other applicants, so don't get your hopes up too much.'

For the past 12 months I'd been doing the very thing this job requires every single day: writing a diary, taking lots of photos,

compiling short videos and uploading them to my Afritrex website. Would that give me a head start?

I'd already convinced myself I was the right person for the role. After all I was adventurous, loved travel and meeting new people, and I could write a blog and take a good photo when I put my mind to it. But how on earth would I prepare a résumé for a position like this? I had no experience as a caretaker, let alone one on an island. This could be tougher than I'd thought. I scrolled down the application page and read further.

> Want the best job in the world? If you enjoy new experiences and you can spare six months to enjoy life above the Great Barrier Reef, you're already in with a good chance. It's easy to apply.

> Step 1: Create a video application (in English and in 60 seconds or less) telling us why you're the best person for the job and demonstrating your knowledge of the Islands of the Great Barrier Reef.

> Step 2: Fill out a brief application form and upload your video. Remember to be enthusiastic, creative and imaginative.

Submit a video? Okay, this was going to take some work. Up until now I'd only recorded short, amateur clips of myself for my Afritrex website and YouTube channel. Nothing of the quality I'd want to provide for a job application. I'd probably need to learn how to edit as well, something I'd never attempted. My mind was all over the place. What would I talk about? How would I sell myself? Where could I possibly film it in the middle of the British winter?

I needed answers to all these questions, but with four weeks to go until applications closed I thought it would be best to sit back and watch some of the other entries before I set about creating my own. This would give me an idea of what the opposition was offering and help me make mine even better. I knew the photos and video I'd taken around Africa over the past 12 months would give me a leg-up. I had to use those assets to my advantage and combine them with a killer script.

My search for full-time work was turning into a fruitless pastime, so when my old boss George offered me a part-time job back at the Turf Centre I reluctantly accepted. When I left for Afritrex I swore I'd never go back, reckoning I'd prefer to chew off my own arm than return to a life answering phones and preparing delivery manifests. As I walked through the door on my first day back I promised myself

I'd find another job as quickly as possible; until then it was a means to an end.

February is a pretty quiet time for the turf industry in the UK. With frost on the ground almost every morning, the landscaping industry grinds to a halt. So between work chores I found time to watch the daily videos that had been uploaded by the other Best Job hopefuls from around the world, and so far I was pretty unimpressed.

A few videos seemed acceptable, but most were so badly put together I figured I *had* to stand a chance. I'm no Steven Spielberg, but I know if you're sending in a video as your résumé then creating something that looks professional is absolutely necessary. Seeing the quality of what had been submitted filled me with confidence. That night Bre and I started work on the script. We wanted something fun, factual and engaging that would grab the attention of the team at Tourism Queensland—but that didn't run for more than a minute. We also knew we had to get the video shot, edited and uploaded *fast*.

'They want a video explaining why you're the best person for the job, that shows knowledge of the Great Barrier Reef and above all is entertaining,' I read from the website.

'How about you jump in front of the camera at the start in a panic 'cause you've only got one minute to tell them so much about you?' Bre suggested in her usual energetic way.

'I like it! That's a great way to start. Then I want to show I'll try anything once, have travelled extensively and have the right credentials.

'We also need to think about where we're going to film it. There's no point denying it's the middle of winter, so let's embrace it and head outdoors. I've got a good idea where we can go too — Bramdean Common. There's loads of open space, and I've got a funny idea that might just attract the judges' attention.'

'Tell me, tell me!' she said excitedly.

'How about I dive into a freezing cold pond to show my commitment?'

'You are frikkin' mad but ... YES!'

That night I trawled the internet to find out as much as I could about Australia, Queensland and the Great Barrier Reef. The more I flicked through the websites, the more my desire to get there grew. Images of stunning beaches, rainforest, deserts and the greatest coral reef in the world were more than enough to whet my appetite.

Bre and I worked away like busy beavers constructing a script and production plan in preparation for filming the next day. I'd hop around like an idiot acting out the lines and Bre would be the camera operator.

The next morning I peeled back the curtains and a beam of sunlight pierced the darkness of the room. Any tiredness from my short night's sleep was erased by the excitement of the day ahead. Today I had the chance to create something special: my application video for the 'best job in the world'.

I wasn't pinning all my hopes on getting the job; the last time I checked more than 15 000 videos had been submitted, and with three weeks to go to that number was bound to rise. But with the images and video of my travels, my work experience and a cracking script, I thought, I must have *some* chance of making it through at least to the second round. Armed with Mum's tripod and camera, my script and a clipboard, Bre and I headed out into the cold morning air.

Filming 60 seconds worth of video doesn't actually take that long if you get it right first time, but I was struggling to deliver, or even remember, the scripted words. And the more I repeated my lines, the less natural they felt.

So I threw away the script, remembering just the bullet points I needed to cover, filling in the gaps with my own words. Suddenly it felt right. I could have a conversation with the camera instead. Once we'd got everything recorded, I played it back to check the sound and focus were okay (two of the most annoying elements of any video if they're not right), packed up our gear and headed to our final location, the local pond.

The script we'd written included the line 'I'm practically a fish myself'. My plan was for the video to include images of me swimming, snorkelling and scuba diving in exotic locations around the world. To add some comedy and fun I wanted to add a clip of me snorkelling in the cold of the English winter, in a suitably unimpressive location compared to the Great Barrier Reef — Swelling Hill Pond.

The temperature sat at 3 °C all day and the crisp white frost around the edges of the shallow, brown, leaf-choked pond didn't add to my enthusiasm. It had seemed like such a good idea back in the warmth

of my bedroom; but as I stood on the rickety, old wooden jetty that speared out into the water I quailed at the prospect of launching myself into the mire.

We had to get this shot in one. If I failed to deliver my line or Bre mucked up the filming, there would be no chance for a second attempt. I'd be covered from head to toe in cold, muddy water. Plus, I'd be freezing my balls off.

'Okay, so when I give the go ahead, check the framing, press the record button and follow me all the way into the water' I directed Bre.

'Sure thing Ben, just get undressed and do it!' she replied, chuckling.

I checked round for curious passers-by, dropped my trousers, threw off my warm jumper and instantly felt the cold envelop me. With a shiver running through my core I pulled the mask onto my face, checked my launch route one last time and went through the motions of my running dive into the uninviting water ahead.

'Just get on with it! I'm getting cold standing here!' Bre shouted across to me.

'How do you think I'll be feeling in two minutes' time! Are you ready?'

Her countdown cut through the cold, silent air. 'Three…two… one…go!'

'I'M PRACTICALLY A FISH MYSELF!' I yelled at the camera, turned, thrust the snorkel in my mouth and raced down the jetty, launching into the water with a perfect dive.

'Arghhhh, urghhhh, that's disgusting,' I gasped immediately after surfacing, bobbing amongst the pond weed, sticks and leaves stirred up as I hit the bottom. 'The snorkel split as I hit the water, meaning my mouth was wide open. I think I've swallowed half the bloody pond,' I spluttered, spitting out another mouthful.

Bre was beside herself with laughter. I must have looked ridiculous clambering out onto the jetty daubed in mud and leaves.

'Did you get the shot, Bre? That's all I need to know?'

'Ahahahaha, don't worry you won't have to do it again!'

The things I do for shameless self-promotion. Those judges better sit up and take notice of this ludicrous Pom!

Putting together the perfect application video

When I filmed my application video I had no editing experience and simply used a compact camera on a tripod. Getting through to the Top 50 out of 35000 entries meant I did something right.

I've now presented television programs for National Geographic, the BBC and most of the Australian networks, and still use the same approach today. Keep the following guidelines in mind when you're shooting your video:

- **Plan what you're going to say first.** Build a timeline with a start, middle and end.

- **Be an expert.** Research the position, cover all the requirements and refer to some unique facts.

- **Don't be a know-all.** No one wants to work with 'Mr Been Everywhere Done Everything'.

- **Be open minded.** Ready to try new things, push your limits? You need to be!

- **Use bullets points.** Scripting everything makes delivering it difficult; by using your own words you'll come across more naturally.

- **Focus on the four important filming basics:**
 - **Stability.** Make sure the camera is on a tripod/bean bag/wall.
 - **Sound.** Is the wind going to ruin your video?
 - **Focus.** Is it on the background or on you, the talent?
 - **Lighting.** Get out into the sunshine and try not to squint.

- **Don't read your lines.** Everyone watching will know what you're doing.

- **Use your eyes.** Focus down the barrel of the lens and don't get distracted.

- **Start strongly and finish stronger.** A good first impression is essential.

- **Mix up your scenes.** Change location for different shots so you're not in the same place all the time.

- **Don't be scared to edit.** It *is* easy and the end result will be much more professional.

That evening I set about creating my application video at my parents' house. Having never edited a video in my life, the task was huge. I had to learn and perfect the process of turning my raw footage into something that looked semi-professional. I used Microsoft's free program Windows Movie Maker, which is clunkier than a wooden horse. Once I'd figured out the basics, it wasn't actually as hard as it first seemed. The program's lack of technical sophistication was a blessing in disguise for me, an editing virgin.

The clock struck midnight as I attached my website address to the final frame of the video and clicked Save. With Bre's help, I'd managed to script, film and edit my video in just over a day. All that remained was to upload it, complete the application form and submit my entry.

The next day I drove Bre to the airport and said goodbye — no easy task. She was returning home to Canada after three years away. It was the end of our 10-month adventure together.

I spent the next few days wondering what to do with myself, again unsure of what path to follow. Long-term work at the Turf Centre certainly wasn't the direction in which I wanted to head. The travel bug had bitten me so hard that all I could think about was my next overseas adventure, but where to and who with?

Is this the email you've been waiting for?

My head was all over the place when I decided to visit Bre in Vancouver the following week. The job application had faded to the back of my mind. I was caught up in a new country, happy discovering another part of the planet.

As we walked through the downtown part of the city, my phone picked up a free wifi signal from one of the shops, *beep beep, beep beep*, signalling an incoming email.

I plucked it from my pocket, opened my inbox and read the new mail

'Is this the email you've been waiting for?' the subject line read. Another spam message to clutter my life?

As I scrolled down my gaze froze, locked on the small screen in my hand.

'What's up, Ben?' Bre asked.

I read on.

'Congratulations! You've made it through to the Top 50 for the Best Job in the World! From the Team at Tourism Queensland.'

'You are not going to believe this, Bre!' I spluttered. 'I'm through to the next round!'

'No way! I told you you'd make it through! What do you have to do next? Does it say?'

I read the email aloud:

> We request you submit a 300–500 word short story by 11th March. It should include a little about your background, previous employment, family, where you live, what is most important to you in life. If successful in gaining The Best Job in the World with Tourism Queensland, who will be joining you on your journey to the Islands of the Great Barrier Reef (partner and/or children and tell us a little about them) and anything else you would like to share about yourself.

Among 34 685 entries I'd managed to get noticed, and now I really stood a chance of taking the big prize. My ears were up, I had a sparkle in my eye — it was game on. Time to think outside the box. Every one of the 50 finalists would submit a document blowing their own trumpet; how was I going to stand out now?

So instead of simply writing a boring document, I decided to film another video. It was a chance to sell myself in a more interactive way by talking about my life, experiences, family and recent travels. Within 48 hours of receiving the email from Tourism Queensland I'd replied with another video, including a transcript just to stay inside the rules. I spent my last few days in Vancouver answering emails from the media and Tourism Queensland's office in London. The announcement of the Top 50 had been huge news around the world and the scale of the campaign had started to sink in.

One email was particularly interesting. The BBC wanted to film a documentary about the campaign and asked to interview me as soon

as I stepped off the plane back at Heathrow. They'd already filmed the three other UK finalists, Doug Stidolph, Holly Smale and Sarah Louise. The program would follow the recruitment process all the way to the final on Hamilton Island on May 4, *if* one of the UK finalists made it that far.

The story was big news on national television in Canada too. It featured as their lead story on the breakfast chat shows. I tuned in and watched two of the other finalists discuss their video entries along with their dreams and aspirations for the role, should they be lucky enough to win. Erik Rolfsen and Annie Chi not only had great videos but were pretty confident in front of the cameras too, both having careers in the media. I'd have to lift my game here to stand any chance.

My phone rang through the night as I took calls from radio stations back in the UK eager to talk to me.

* * *

After landing at Heathrow I headed through the green channel into the arrivals hall, scanning the mass of people waiting. I couldn't make out my parents' faces, so I walked on, dragging my wheelie bag behind me past the line of grey-suited, bored-looking taxi drivers holding up name signs. I finally spotted them, but they weren't looking for me, focused instead on the television camera in front of them, its bright light picking them out amidst the dull greys of the terminal.

Moving closer I saw Mum was talking to a woman, who was evidently asking her questions. Dad stood to the side, wearing his characteristic smile, preferring to take the back seat in a situation like this.

'Is that him?' the woman asked, pointing in my direction.

'Yes, here he is!', she said, turning to walk towards me, leaving the film crew behind. 'Hello Ben! How was your flight?'

'Hey Mum...Dad. How are you both? They must be the BBC. What did they ask and are they okay?'

'That's Agnieszka. She's the producer. She just wants to talk about your making it through to the final 50. You'll be fine!'

I strode across to introduce myself to the crew, but the cameraman was already halfway to me. There was no chance of a dress rehearsal as Agnieszka threw me the first question.

'Hello Ben. Welcome home. So why do you think you made it through to the next round of the competition, and how are you preparing for it?'

I had absolutely no idea. In fact I hadn't given it much thought at all. Maybe it would have been sensible to prepare some answers on my flight, but instead I just said what came into my head.

'Now I've made it through to the final 50 the serious work begins. They've sifted through the entries and now are left with the real contenders, and from what I can see ... I'm up against it!' I replied.

My brain kicked into gear. Being in front of the camera would become a way of life if I got through to the final. I needed to get my media skills right from the start if I was going to stand any chance of making the next cut.

'The three other finalists from the UK have already started their publicity campaigns to get through to the next stage. What are you going to do to raise your profile?'

Another probing question for which I had no immediate answer.

'I've got a bit of catching up to do now I'm back on home soil, but don't worry! I've got a few great ideas you'll see soon enough,' I declared confidently.

There's nothing like dangling a carrot in front of the media to leave them begging for more. Maybe playing to the cameras wasn't going to be as terrifying as I'd imagined. In fact, I was rather enjoying it!

My campaign—pulling out all the stops

Tourism Queensland (TQ), the organisation behind the promotion, had a plan—and a very clever one. Their role as the government tourism department was to market the state globally, gaining as much publicity and exposure as possible. More exposure meant more people visiting the state.

The Great Barrier Reef is one of the world's most recognisable natural wonders, the planet's largest reef and the only natural object identifiable from space. Tourism Queensland's objective was to bring the 600 islands, along with all their tourism operators and associated experiences, out from under the Reef's long shadow. Their challenge was to show off both the Reef and the islands in all their glory to a worldwide audience. But how could they do this effectively in order to stand out from the hundreds of other global destinations with similar credentials?

When the Brisbane-based creative agency SapientNitro was tasked with coming up with a campaign to promote the islands they floated

several ideas, but only one captured everyone's imagination: 'The Best Job in the World'. An international, high-profile competition would offer the winning candidate a dream job — as 'Caretaker of the Islands of the Great Barrier Reef' — throwing in a luxury home on Hamilton Island, a pay cheque of AUD$150000 and a six-month mission to explore (and promote) the islands of the Reef.

The role of Island Caretaker wouldn't be limited to the nominal housekeeping duties referred to, not very seriously, in the job ad, but would focus on continuing promotion of these iconic Queensland tourist destinations. The wave of international publicity created by the initial launch had to be maximised through continued publicity via television, radio and print media, along with the winner's use of their own social media channels.

Whoever ended up in the job needed to bring more to the position than just a caretaker's brown jacket and a stiff broom. He or she would need to be hard-working, tech-savvy and confident in front of the media, a marketing and public-relations expert and an ambassador for the Queensland brand. So was born the 'Islands of the Great Barrier Reef' campaign.

Round two of the application process required us to market ourselves in a blatant push for online votes. The theory was that if we showed a talent for gaining publicity for our own campaign, we'd be able to do the same when it came to selling Queensland.

At the end of the voting window three weeks later, the top 50 candidates would be reduced to 11: 10 chosen by TQ's staff based on the quality of their campaign, and the final position decided by the greatest number of votes.

I had no idea where to start in producing a marketing campaign for myself so again I took to the internet to check out the competition, their entry videos and what they'd done so far. People were really going for it, throwing everything they had into their application — from a professionally choreographed song-and-dance masterpiece to getting the New Zealand Prime Minister John Key and Coldplay frontman Chris Martin to help promote them.

Time was against me. I'd already lost a week to my fellow finalists by staying in Canada for an extended holiday, and now I was heading back to the Turf Centre full-time from Monday morning to try to reduce some of the debts I'd amassed.

I had to develop a campaign fast, but first I had to beat the three other UK finalists, as only one Brit would go forward to the grand final on Hamilton Island at the beginning of May, and I had only my downtime at work to concentrate on the campaign. The other three finalists didn't work full-time as I did, which meant they could focus exclusively on their canvassing, appearing on television, radio and in local newspapers to boost their popularity and votes.

The four of us were invited to a dinner in London so we could all meet. It was difficult to get a word in with everyone vying for the limelight. By the end of the night we'd sized each other up, discussed tactics and formed friendships, although perhaps more for the sake of appearances than anything else. A rumour even arose that one applicant was a mole sent over by TQ to check out the opposition first-hand before the next round of selections took place, but she firmly denied it.

My relationship with the team from TQ's London office grew stronger every time we met. I liked them and it appeared they liked me. Jane, Daisy and Liz offered support and guidance on how the other finalists from around the world were gaining publicity and votes.

They also told me the CEO of Hamilton Island, Glenn Bourke, would be visiting London in a week's time to meet us. The big day would involve a group interview in front of the cameras to see how we responded under media pressure.

I needed to get in front of Glenn before the other finalists met him. His flight was due to land on the Saturday night before we all met for the interview on Monday. That left me Sunday — this had to be my 'in'! Jane confirmed she'd speak to Glenn's assistant and organise our impromptu meeting. The pressure was on to produce a media stunt worth turning up for.

With a few days to go I pulled out the big guns, calling on friends and family to help me out. My plan was to hire an enormous 10 metre–high fish tank on the back of a truck, drive it into Trafalgar Square in central London and swim around in scuba gear for an hour surrounded by tropical fish — all to bring publicity to the Great Barrier Reef... and myself.

Reality soon kicked in, though. Firstly, the tanks were in constant use, booked up by dive shows around the country for at least the next month. Secondly, they were ridiculously expensive to hire and move around; and thirdly, renting even a corner of Trafalgar Square for

an hour would cost thousands of pounds. I had to scale my campaign back, just slightly. I was reduced to a children's paddling pool in a pub garden in Hammersmith on the banks of the Thames. Fortunately, my friends and contacts from the world of event management and Mumm Champagne came to the party to help out.

My big media event took place on Sunday, March 22, which happened to be Mother's Day in the UK. It was also the first decent day of sunshine for months, which meant people were out in droves walking the towpath with family and friends.

I needed votes to catch up with the other UK entrants, and lots of them. I decided on the face-to-face approach: if people met me in person I was hopeful they'd like me and take the time to vote for me online.

At 4 am on the day of the event I left my parents' house with a car-boot full of donated Mumm Champagne, my destination Heathrow Flower Market. Two hours later I had a car loaded with bubbles and 4000 daffodils, ready for the biggest giveaway I could afford. It was a blatant gifts-for-votes campaign but I was sure it would work.

I was going to give away free champagne and a bunch of flowers to all the mothers who walked past the pub. At the same time I'd hand them a pre-printed card with details of how they could vote for me. Dressed in a wetsuit and white dinner jacket, I was surrounded by generous friends who came to help out dressed as mermaids, turtles, Nemo and even a pirate.

Our garden party was in full swing an hour before Glenn's arrival. Inflatable palm trees, a pop-up bar, a huge paddling pool, free-flowing champagne and 50 friends in 'Vote for Ben' t-shirts guaranteed there was a buzz to the day. A huge 'Vote for Ben' banner Owen had designed was draped across the entire garden, leaving no one in any doubt as to why we were here.

I'm normally a fairly reserved person, but I knew that day's event would require me to step out of my comfort zone for the sake of shameless self-promotion. Every passing female who looked like she could be a mother received a bunch of daffodils, a glass of bubbles and details on how to vote.

Glenn turned up precisely on time at 2 pm. I'm not sure what I imagined when I thought of a typical CEO, but he was nothing like it. Dressed in casual clothes, sporting a bronze Aussie tan, he immediately walked over to introduce himself. We hit it off straight

away. His years as a world champion sailor meant he'd spent time at Cowes Week, where I'd worked with Mumm Champagne. Our offices even backed onto each other in 1996, although of course we hadn't known it at the time. It was proving to be a very small world.

With the BBC filming the event and a few newspaper photographers on site too, it was time to get on with my big finale. Grabbing a microphone in one hand and an inflatable airbed in the other I announced to the gathered crowd exactly why we were here.

'Ladies and gentlemen, thank you for turning up today as I continue my quest to become the Caretaker of the Islands of Great Barrier Reef. On this very fine Mother's Day, ladies please help yourself to some beautiful flowers and a glass of the finest champagne, but I ask from you one thing in return. Please head to the website www .islandreefjob.com and vote for me, Ben Southall!'

Out of the corner of my eye I could see my friends threading through the crowd handing out my flyers. People were using their smartphones to access the website and vote, there and then — it was working!

I had one more trick up my sleeve. A little showstopper for the cameras: a plunge into the freezing cold, not particularly pleasant water of the River Thames.

With the inflatable airbed under the arm of my immaculate white dinner jacket I pulled on my mask, stuffed the snorkel in my mouth and walked to the concrete steps that led into the uninviting water. With one mighty jump I leapt into the frigid brown water, established my balance and, after announcing that my next stop was Australia, paddled off down the river.

I could hear people cheering as I disappeared off downstream. A few hundred metres downstream I came ashore and started the chilly walk back to the pub, dripping in Thames mud.

Glenn was the first to greet me. 'You're bloody mad mate but well done, everyone loved it. I've got to head off but I'm seeing you tomorrow, I believe?'

'Absolutely, but I'll have had a shower by then I promise!' I answered through chattering teeth.

It had worked — a typically stupid public relations stunt that had got his attention, and a few votes too. I knew I was never going to get through to the final as the wild card with the most votes, but I had a fair chance as someone who is confident in the public eye and hard

working, and has a good sense of humour … or at least that's what I hoped!

I met the other three UK finalists and the team from TQ at the London Eye for a full day of interviews with the BBC, gathered media and Glenn. He headed straight to me, much to the annoyance of the others, greeting me like an old friend.

'Hello Ben, did you manage to get all the mud off you?'

'There's still some behind my ears — but most of it, yes!' I chuckled. From the puzzled faces around us, my opponents evidently wondered how on earth I knew Glenn already. I'd done my homework and it had paid off, giving me a head start on the others.

As Glenn said his goodbyes there was no telling what he was thinking. He was off to New York on the next flight, ready to meet the four finalists from the US and two from Canada. I could only hope I'd done enough.

There was no flashy business class flight for me the next day, just the dreary drive back to the Turf Centre office. Normal service had been resumed, for now.

Of course, I had to start thinking about what I would do if I didn't win. I was giving the competition my best shot, but as with everything in life, it's good to have something to fall back on if things don't go according to plan. I'd already started to think about my next overland adventure — maybe a drive in the Colonel from Alaska to Chile?

Always have a plan for the future

If you decide to commit everything to a project, expedition or campaign and things don't go according to plan, what are you going to do next? Rather than being left in the lurch, it pays to have a backup plan that you can focus on afterwards. That way you won't be left feeling empty and hollow if things don't go your way.

Throughout the Best Job campaign I was thinking as much about my next overland expedition as the final itself. If I hadn't won I'd have jumped straight into a new project.

Reading the wonderful motivational book *Who Moved My Cheese?* by Spencer Johnson gave me a great insight into dealing with change and planning for the future.

One of the major requirements of the future Island Caretaker would be to market and sell the experiences on offer in Queensland using the relatively new digital platforms of social media. I was used to writing a blog, updating my website and uploading photos and videos during Afritrex. I hadn't used Twitter and I wasn't too keen on Facebook either, but I needed to get with it. The other finalists were hugely active online, sending tweets every hour and updating their own personal blogs almost every day. I now realised these social media platforms could be used for my own promotion and marketing, not just to tell the world what I had for breakfast! My first ever tweet was as basic as it gets.

> **Ben Southall** 🐦
> @Bensouthall
> **voting for Ben** www.islandreefjob.com/bens
> 3:28pm - 16 Mar 2009

The BBC team shadowed each of the four UK finalists for an entire day, filming a day in the life of each of us. They had as much idea who'd get through to the next round as we did and for their documentary to work they had to assume we were all level pegging in order to build their back story of the eventual Top 11 finalist.

I was the last of the four to be filmed, so at that stage Agnieszka had spent a day with each of the other candidates and knew them pretty well. My day must have seemed pretty uninspiring; a 30-minute swim before work, a day of grind at the Turf Centre and a run in the evening. She pulled me to one side away from the camera and said, 'Ben, you're my bet to go through. Compared with the other three you've got much better credentials so I'll be with you the night of the decision.'

I was honoured she thought so highly of me, but I still had my doubts. We'd just have to wait and see.

The lucky few

April 2nd was D-Day, when the Top 11 finalists would be revealed. Those lucky few not only stood a great chance of getting the job but would also be flown to Hamilton Island in Queensland, Australia, for a seven-day, all-expenses-paid trip. This was a prize in itself—a week in a country I'd never been to before!

The day itself didn't feel that special, apart from the camera crew that followed me everywhere. I went to work, I came home, I went rock climbing and they were still there.

As I came down from my final climb of the night, Agnieszka informed me, 'Ben I've just had an email from TQ. It would appear they've changed the rules slightly. They've decided to make the Top 11 a Top 16 instead. They said the competition was too close to call'.

I wasn't pleased. 'How the heck can they do that?!' I exclaimed. 'We've done everything we can to promote their state and they thank us by changing the rules at the eleventh hour!'

Well, I'd beaten 34 000 people to get to this stage. An extra five couldn't be too tough, right?

A little after nine that night, my phone rang and the message 'withheld number' popped up on the screen. Could this be it?

'Hello Ben, I'm Peter Lawlor, the Queensland Tourism Minister,' he announced in a broad Australian accent. 'I'm just ringing to tell you that you've been successful with your application for the "best job in the world". You're one of the 16 finalists!'

'Thank you so very much,' was all I could muster in reply.

When the words 'Good on ya, mate!' came back, there was no doubting this was the real deal. I'd made it through to the finals.

Once the furore had died down I was able to look more closely at the remaining finalists, their application videos and skillsets. I wanted to get an idea of where my strengths lay and how I'd fare when crunch time came on Hamilton Island. From what I could see I was up against it. All 16 finalists came from the key markets for tourism in Queensland: New Zealand, the US, Canada, France, Germany, Singapore, China, Japan, Holland, Ireland, inter-state Australia and of course me in the UK. Every one of them seemed to have a strong following in their own country that was building internationally as the competition went on. This is exactly what TQ had banked on. They knew that for as long as the finalists from each country were still in the competition, that contestant's national press would continue to follow their progress, which meant free publicity, with images and film of Queensland broadcast to national prime-time audiences around the world.

With only four weeks to go until the final, I had some work to do. Up to that point, compared with the other finalists, my online presence had been pitiful. I'd posted a few blogs and started to use

Twitter more regularly, but I needed to prove myself to the team at TQ before I touched down on Australian soil for the first time.

I started to document certain aspects of my active life — the places I visited with friends, the running training I was doing, how long I swam for in the pool, all in an effort to build and engage my social media audience. I wanted to motivate people with my story.

Now that I was the sole focus of the BBC documentary, they needed the back-story of my life and how I got there. A long-weekend road trip down to Cornwall with friends was perfect for both them and me. We dived, sailed and socialised in front of their camera, and it also gave me fresh content to write about on my blog, while practising my presenting skills, above and below the water.

My following was starting to build, with hundreds of people trying to connect with me online through Twitter and Facebook. They were interested in my background and journey through life, asking questions about the competition and previous travels. There were even requests to come and stay with me on the island, should I win!

Queensland's state-wide newspaper *The Courier Mail*, which was extremely supportive of the Best Job campaign, ran an article on each of the Top 16 candidates in the run-up to the final, covering their history, education, experience and odds of winning. I didn't rate very highly at all, with a 33–1 chance of taking the title. Obviously they didn't have a lot of confidence in me.

I hardly slept the night before I left for Australia. As the first light of day crept through my window I jumped out of bed, packed the last few things into my suitcase and headed downstairs. Agnieszka and the crew were at the airport to welcome me, the camera already rolling as I walked through the door and said my goodbyes to Mum and Dad.

In the waiting area at the gate I met up with George Karellas, the finalist from Ireland I'd heard would be travelling on the same flight. We chatted throughout the first leg of our flight to Brisbane, both excited by what lay ahead but also aware there was a lot at stake over the next few days. At our transfer gate we bumped into Greg Reynen, another of the finalists, who was working in Singapore. I'd now met two of the people I'd read so much about back at home. Seeing them in the flesh for the first time was pretty surreal.

I slept for the entire second leg, the excitement of the last few weeks finally catching up with me. When next I felt the plane's wheels hit the tarmac I knew I'd arrived.

It was time to get my game-face on. To get through to the final I had to embrace the new digital space of social media. I jumped into it with both feet and quickly realised its importance in helping market and promote *me* as a product.

Using social media to your advantage

Setting up an account with social media channels such as Facebook, Twitter or Instagram is easy. In years gone by everyone wanted their own website, which cost a lot of money or time. Today you can use social media, create a blog or share photos and video to tell your story, promote your brand or document a journey.

How does it help?

- You can stay in touch with friends and family on the other side of the world. They share your life, and you can share theirs.

- If you're planning an expedition it's a great way to build an audience of like-minded people with whom to share information, links and contacts.

- You can inspire and motivate people by getting out there, doing it and sharing your story.

- Uploading your digital images and video to a social media site is another form of backup.

- I use TripAdvisor to research places before I go; absorbing other travellers' advice can often uncover little gems.

- When I'm not creating my own content I often share links to other sites that are relevant to my audience.

- Building your audience to a credible level will help get you noticed as an influencer, which in the long run can help you gain sponsorship.

- Find the people who inspire you and follow them. Just seeing what they post is enough to make me get up and get on with it.

- Never forget the first form of social media—forums. They are superb places to research, learn and ask questions.

The final contest

Kerri Anderson from TQ met us at the airport and escorted us to our bus. It was late in the evening and Brisbane looked alive and pumping. Driving through the city centre, life was spilling out from clubs, bars and restaurants. Having slept on the flight, there was no way I could rest now. I was in a new city in a new country — it was time to explore!

Once we'd checked into our luxurious rooms at the Stamford Plaza, Greg and I hit the streets. It was Friday night and people were everywhere. We wandered around aimlessly, soaking up the atmosphere of our newly adopted city.

I loved Australia's weather and vibe. I could see myself living here.

The next morning after breakfast we all gathered in a large meeting room at the hotel for our first taste of the Best Job brand. Each of us was handed a thick folder of printouts, a lanyard with our name on it and a stack of blue t-shirts sporting the words 'Best Job in the World'.

This was the first time we'd all been in the same room together and the buzz was exciting. Given that none of us had met two days before, everyone got on remarkably well. We were from different countries and different cultures but we all had the same goal.

Andrew Cameron-Smith and Alison Dwyer were the event managers, responsible for ensuring that everything went according to their tightly scripted plan over the next few days. They'd tell us where to be, at what time and wearing what; basically when we could take a shit. With the world's news media about to descend on Queensland, the Whitsundays and the Great Barrier Reef, nothing would be left to chance. Every camera shot would be thought through and premeditated, ensuring the best possible message and most beautiful images would be delivered to the watching world. When people thought of their next summer holiday they'd think of Queensland.

It was time for us to be 'unveiled' to the waiting media. Until now we'd been closely guarded, with security at the hotel turning away anyone whose name wasn't on the list. Now 16 excited people wearing matching blue t-shirts filed out into the hot Brisbane sunshine to the waiting press-pack.

'Hey Magali, come and stand over here.'

'Hailey and George, I want you there for a photo.'

'Clarke, Channel 10 wants to interview you.'

'Meiko, where are you? There's a crew from Japan want to talk to you.'

'Ben ... Ben ... Ben — that lady from the BBC needs you *now!*'

It was organised chaos. Accompanying each of the finalists were between one and five film crews from their own country plus newspaper journalists and photographers, along with the Australian media. Every move we made, every reaction and comment, would be analysed not only by the team of judges at TQ who would decide over the next few days who'd get the job, but by the gathered media too. We were now living *very* much in the public eye.

The next day we flew out — 16 finalists, 30 TQ staff and 40 members of the media, including of course Agnieszka and her BBC team. Since we'd arrived in Australia she'd taken a back seat, happy to film from afar.

I was surprised by how little rivalry there was between the finalists. We'd all been caught up in the mad campaign TQ had engineered to bring us together from around the world. There were only 16 people on the planet who could truly understand what we were going through. But instead of seeing each other as rivals we seemed to squeeze together like sardines in a bait ball being pecked at from all sides, and the more they pecked, the closer our group became.

The door on the Virgin Blue flight opened and a wall of tropical humidity swept through the plane. Hamilton Island.

'Now I want you to let the rest of the passengers get off first, then the film crews.' Alison's instructions came across the plane's speakers. 'We'll give them five minutes to set up and then the finalists will all head down onto the tarmac for a photo shoot outside the terminal building.'

Once the plane had emptied I looked around. The others were in their own worlds, gathering their thoughts for what lay ahead. No one knew what the next few days — or even the next few hours — would bring. We were told only of the next few minutes of our life, as events unfolded.

We crossed the tarmac to the arrivals area and the waiting media. A melee of sound again rose from the assembled press: 'Over here guys, stand here, look here, no this way, one more smile please!' their individual voices merging into one great clamour. We threaded our way past the photographers and the island staff who were there to welcome us, and straight onto the buses that whisked us away to the hotel without a moment to stop and take it all in.

'You've got 10 minutes to drop your bag in your room, then meet me back down here in reception and we're off to your first part of the interview process,' Andrew bellowed.

Thirty minutes later we were all dressed identically, issued with Best Job rash vests and board shorts in trademark Queensland blue. Our first task in front of the cameras would be a swimming test — to prove we could hold our own on an island, if that was our fate for the next few months.

I'd prepared for a water-based challenge back in the UK by swimming every morning before work, but I wasn't ready for what they'd prepared: you simply had to prove you could swim from one side of the pool to the other. This wasn't a test of our fish-like abilities, more one to uncover the human spirit inside you. How did you communicate with the person next to you? Did you help them as they struggled to put on their snorkel? Were you relaxed in front of the world's media? And could you deliver a juicy sound bite to the camera once you'd surfaced after your own attempt? The panel of judges — two directors from TQ and two recruitment specialists — sat in chairs at the end of the pool, clipboards at the ready.

The next morning it all got a little more serious, beginning with a psychometric test that was handed out as we arrived for what we thought was breakfast. Ill prepared and hungry, we sat down and completed the Myers-Briggs test so TQ could see inside our heads and find out more about us than we knew ourselves.

Having never applied for a high-ranking job or management position, I hadn't done one of these tests before. There's no fooling the system, though. Your responses to a series of carefully phrased questions give the judges a unique insight into what you are made of. It's like someone flipping open your head and looking inside — a scary idea!

With the personal examination out of the way it was back to reception. We learned that each day would expose us to one of the many tourist experiences on offer in the region, and each night we'd have a limited time to write a blog, select our best images of the day and upload them to the TQ Best Job website.

The winner of the role of Island Caretaker would have do to this at least twice a week so it was a logical way of finding the person best equipped for the task.

There was just enough time to grab board shorts and towels from our rooms before heading down to the marina, ready to board a luxury ferry to our next destination — the Great Barrier Reef.

The start of a love affair with the Reef

The boat was packed to the gunnels with the usual entourage from TQ, the finalists and of course the media. Throughout the rather rough journey, the journalists were free to interview any of us they wished and ask whatever questions they wanted.

I chose to spend this time observing the other finalists, trying to determine who my real competition was. Juweon Kim from South Korea was particularly good in front of the cameras. Having delivered the news on a daily basis back in his own country, Clarke Gayford from New Zealand was, too: professional, funny and a definite contender for the crown.

One finalist with a larger-than-life personality was Anjaan RJ from India, a radio DJ who lives every day as though he's constantly on air! It was hard to get a word in with Anjaan around, but his infectious smile and firm handshake placed him high in my popularity poll from day one.

The images I'd seen advertising the Whitsundays suggested continual blue skies, calm seas and sunshine, but on the day we headed out to the Reef the weather failed to follow the script. Heavy grey skies meant our first underwater experience snorkelling amongst the coral brought out little more colour than browns and greys, not the reds, purples and blues in the pictures. When I surfaced in front of the waiting television cameras it was time for a little artistic licence. Keeping my game-head on, I enthused, 'It's amazing the diversity you see down there — the tiny little fish living amongst the coral, and the bright colours that jump out at you.' It was only a little white lie.

Our transport back from the Reef was nothing short of epic, with a fleet of seaplanes and helicopters waiting for us on the nearby pontoons. We took to the sky in a cacophony of whoops and cheers. I was hypnotised by the Reef's actual colours and beauty, which appeared so much more dramatic than when I'd snorkelled there only an hour ago. The impossible blues and greens stretched far off into the distance; the enormity of the Great Barrier Reef was hard to take in.

On Hamilton Island that afternoon it was time to review the day's experience and deliver that story to the world — it was blogging time. We were limited to one hour and 300 words. A row of 16 faces concentrated on the screens in front of them, fingers tapping furiously at the keyboard. It was a tough challenge but it also felt good. For the past year I'd been writing a blog on my trip around Africa; now I was in Australia doing very much the same.

We were given no indication of how we'd fared; the blogs were simply posted online for the world to see. There was no voting or comments this time, unlike with our application videos. When I spoke to Mum later that evening from the quiet of my hotel room, she told me mine was the best, but of course she would!

Day two of the final delivered torrential rain from heavy black clouds that seemed to skim the surface of the ocean as I watched from my balcony. I was joined by a few cockatoos sheltering from the elements, or poised ready to steal the food from my room — I couldn't tell which. As I looked out over the Coral Sea I wondered if I had only a few more days here, or if I'd be lucky enough to wake up to this view every day for six months. Our tour of the Blue Pearl, the $3.5 million villa that came with the job, was set for later that day and I couldn't wait to see it.

A loud *caw caw* from one of the Whitsunday pigeons shook me from my trance. I had a final to win and I was determined to arrive on time, every time, punctuality being one of the key qualities required of an Island Caretaker, according to our sergeant major, Andrew.

We were off to Daydream Island, a neighbouring resort around 30 minutes by boat from Hamilton, for the next chapter of this adventure. By the time we arrived the rain had abated enough to walk without umbrellas, but the wind was still pumping across the water, whipping foamy whitecaps out of the dark blue waves.

Our activities for the day should have taken place on the water, but with the weather as it was sailing and kayaking would be impossible. TQ's events team had to think on their feet: how could they keep the interview process going in a way that was visually fun for the cameras? By stripping us down to our underwear and throwing us into the spa for a complete pampering, that's how!

The next couple of hours *would* have been perfectly relaxing had our treatment sessions not been open to the media. Instead of dozing

peacefully on the treatment table I had a different camera thrust into my face every 10 minutes and questions lobbed at me as I hid behind my eye mask.

'How do you think you're doing compared with the others, Ben? Are you enjoying your time in Australia? Who would you choose to be the winner?' I answered as best I could, not wanting to miss out on the pampering but always conscious of the cameras.

That afternoon, after a lumpy trip back from the island that saw most of the finalists regurgitate their lunch over the side, it was blog time once more.

I attempted to gather my thoughts. I'd done all I could over the past two days, tried to be a gentleman wherever I went, sparking conversations in my normal friendly way. The blogs I'd written were engaging and informative, the photos (although nowhere near as good as some of the others') were acceptable, and the work I'd done in front of the television cameras was natural and fun — not bad for someone who'd never done it before.

I slept well that night, without a worry in the world, knowing that if things didn't go my way with the big announcement the next day I'd enjoyed my visit to Australia and had some ideas on which direction my life would go next. Unlike some of the other finalists I hadn't bet everything on this being the job for me. I could see past the next 24 hours.

The moment of truth

The first flickers of dawn appeared in the sky above me as I laced up my running shoes on the road outside the hotel. A local had told me that watching the sunrise from Passage Peak, one of the highest points on Hamilton Island, was not to be missed. As this could be my last day on the island, I figured it was now or never. Forty minutes later I arrived at the summit to a picture-perfect panorama all around. The surrounding islands basked in the first light of a day that was very different from the one before. With hands on hips I stopped to catch my breath and take it all in.

In a few hours the Premier of Queensland, Anna Bligh, would be arriving on the island to announce the winner in front of the world's media. It would leave one person jumping for joy and 15 others rather deflated after so many months of hard campaigning.

My phone was vibrating into life. Owen was calling. I knew he was thinking of me even though I was on the other side of the world, much as he had done throughout Afritrex.

'Have you won, or did they decide to go for someone more suitable?'

'It's later today you idiot, but thanks for the call.' I said. 'Call me this time tomorrow and I'll tell you.'

'I think I'll find out before that,' he replied. 'It's all over the news here, Ben. You're a bloody hero and you haven't even won yet! I just wanted to say good luck.'

'You're not just trying to get a free holiday out of me, are you? You know you missed your chance last year!'

By the time I got back the resort was starting to stir, the smells of breakfast emanating from the kitchen. It felt good to have achieved something before most other people had even woken up.

The announcement was scheduled for 3 pm AEST, which left the rest of the day for individual interviews with the panel of judges, a final chance to stake our claim for the title. There was very little socialising between the candidates during the morning. Most opted to spend time with their own thoughts or on the phone home seeking reassurance that life would go on if they didn't win.

My interview was at 11 am. In keeping with the vibe at Tourism Queensland, it was an informal process, a relaxed chat on a sofa overlooking the ocean. The results of my psychometric tests were revealed. I learned that I lack confidence in myself, something I always knew.

When they asked who I thought should get the job if it wasn't me, there was only one person that sprang into my mind who could pull it off: Juweon from South Korea. He was professional, intelligent and confident in front of the camera, but without having read any of the other finalists' blogs or seen their photos it was hard to judge who'd be the best storyteller, one of the most important roles.

I walked out of the room with my head high. I knew I had done all I could. I'd had a laugh with the judges, submitted my blogs and tried to be the polite, well-mannered person my mother and father had brought me up to be.

An hour before the final ceremony we were introduced to Anna Bligh. Lots of people were pacing up and down in the Green Room as we entered the final 15 minutes. The timing of the announcement had

© Jennifer Campbell

Way back in 1997 long hair was cool, for girls at least. How did my Mum allow me to graduate from Kingston University looking like this?

© Margaret Southall

With less than a year to go until the start of our Afritrex expedition, Owen and I crossed the finish line of the 2007 London Marathon together in just under four hours.

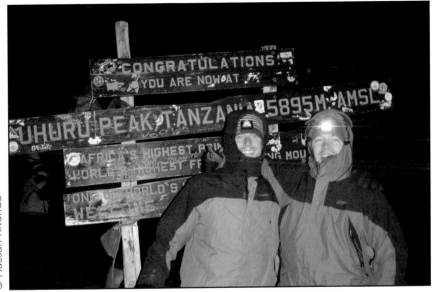

© Hassan Kitundu

Summit of Kilimanjaro—Afritrex 2008. Five marathons, five mountains. Standing on Mount Kilimanjaro, the roof of Africa, at 5895 m with my friend James Beaton.

© Margaret Southall

Afritrex 2008—the final challenge of the expedition was to run the last 42 km back into my home town of Petersfield, Hampshire...and immediately give an interview. A taste of what was to come!

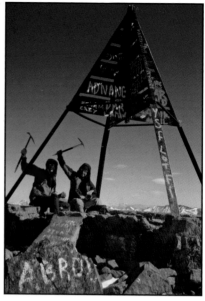

© Alex Heude

At the summit of Mount Toubkal in Morocco with Luke Marshall, my unlikely hero. The first of five peaks I'd climb that year.

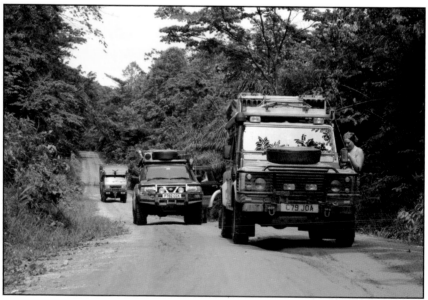

© Ben Southall

Taking a break on a flat spot driving along one of Africa's iconic roads from Ekok in Nigeria to Mamfe in Cameroon. It was 70 km of wet, rutted, muddy 4WD heaven.

Sixteen finalists from around the world arrive on Hamilton Island for the first time to vie for the position of Island Caretaker. We're all waving at the massive media scrum who were there to cover the event.

The eyes tell the story! After four months of campaigning, this is the moment I was announced as the Caretaker of the Islands of the Great Barrier Reef from 34 684 hopefuls.

It was straight into work following the announcement I'd won the Best Job in the World. In the 48 hours following I was interviewed over 100 times.

July 1 2009—Day 1 of the Best Job in the World as Anthony Hayes (CEO of Tourism Queensland at the time) hands me the keys to 'Blue Pearl'; my $3.5 m villa on Hamilton Island.

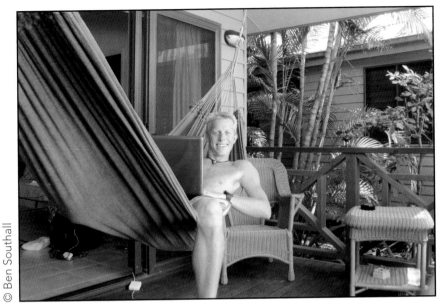

During the Best Job my office was wherever I opened my laptop. This is me watching the world go by from my hammock on Long Island.

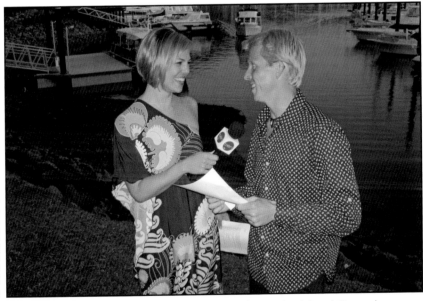

The Australian media covered my six months as the Island Caretaker extensively. I even had a go at reading the weather for Channel Ten—some of the Australian place names totally threw me!

During my world tour after the Best Job in the World finished I visited Taiwan and starred on one of their most popular television shows. They blindfolded me and made me consume stinky tofu, fried scorpions and bubble tea to gauge my reaction.

Sunrise over Whitsunday Island on an epic glass-out morning. We stopped here for two weeks during the Best Expedition to film and photograph the underwater world around the islands.

The 1600 km route of the Best Expedition in the World from 1770 north to Cooktown. Four months of adventure on the Coral Sea.

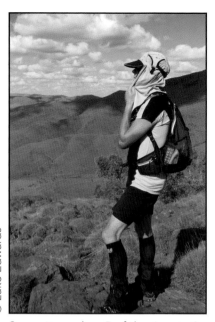

Best Expedition in the World 2011—along with kayaking 1600 km along the Great Barrier Reef, my mission was to document the activities tourists could do there. In this photo I'm en route to Bait Reef off the Whitsundays.

Summit number 5 of the Aussie 8 Expedition—Mount Woodroffe in South Australia. Heat, exposure and flies everywhere!

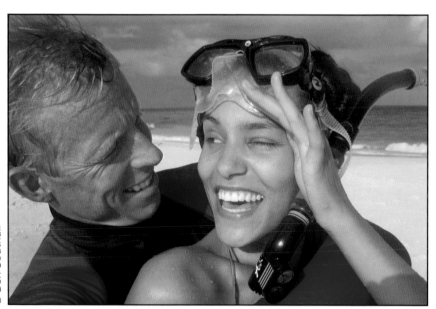

The Best Expedition wasn't all about hard work and kayaking! Sophee and me taking time out to have fun and snorkel the fringing reef around Mackay Cay in North Queensland.

been cleverly orchestrated to accommodate the morning news shows in Europe and the evening news in the US. My fellow finalists looked really stressed. I forced myself to think of something other than the here and now, focusing on my next expedition as a diversion. That drive from London to Singapore in Colonel Mustard seemed like a superb idea. How could I fund it?

'Okay listen up,' said Andrew, 'we're five minutes behind where we should be due to this satellite issue, but I want you all out on stage with Anthony Hayes (Tourism Queensland's CEO) to answer those questions we've rehearsed for the media, okay?'

This was it. Time to face the music.

Four months of relentless campaigning had been worth $180 million for Tourism Queensland. Four months of relentless campaigning from us, the 16 finalists, had so far delivered us a week's holiday in Australia. Was it about to bring me a new job and $150K?

We were led out onto the stage and turned to face the full force of the media. It was the first time they'd all been squashed together in one room. There were so many they looked like an advancing army, and they were aiming at us.

The venue was packed to the rafters: Tourism Queensland staff wearing navy Best Job t-shirts; the Oatley family, who hold the island under a long-term lease from the Commonwealth Government; even holiday-makers were caught up in the event. I saw Andrew give Anthony a nod, meaning the satellite had finally gone live — we were broadcasting around the world. It was time for the Premier to enter the room and do her thing.

'Ladies and gentlemen, the moment we have all been waiting for, the thing that has brought us all together, the opportunity to meet the successful applicant...'

I saw Agnieszka smiling up at me, one hand raised, her fingers crossed. I wasn't the only one who wanted me to get this job. If it went to someone else her documentary might never go to air.

Red lights flashed on the bank of cameras arrayed before us. A silence descended on the room, the buzz of the last few minutes subsided. I could feel my heart thumping hard in my chest.

'It gives me great pleasure to introduce the Caretaker of the Islands of the Great Barrier Reef... from the United Kingdom, BEN SOUTHALL!'

A huge cheer went up from the crowd and I froze, rooted to the spot. *Did I hear that right?* The 15 other finalists, my new friends, surrounded me, appearing to be as excited by the announcement as I was.

The Premier walked over and offered her hug too. Protocol was forgotten, and we embraced in front of the cameras and flashlights that lit up the room. I've never been one for formalities, anyway!

* * *

For the next couple of hours, my feet barely touched the ground. We'd been warned that whoever won would be busy with interviews for the rest of the afternoon. Congratulations poured in from all sides — handshakes, pats on the back, hugs, high-fives.

As TQ's newly elected spokesperson, it was time for me to deliver.

An impromptu interview area was set up where television journalists from each of the Australian networks could get their piece of the action. With deadlines for the evening news in a couple of hours they were the first in line.

Summer Burke from Channel 10 had covered the campaign since the beginning and her stories broadcast around Australia daily throughout the final.

'Can I just say, Ben, a massive well done and ask how does it feel to have the "best job in the world"?'

'Right now? After four months of hard work it's absolutely incredible to be the official Island Caretaker. I can't wait to get back out here to Queensland at the beginning of July to start the job for real.'

'And who will you be bringing out to join you on your adventure? Are your family going to come out and visit?' Summer asked.

'I imagine Mum and Dad will come out, and a good few friends from the UK too. Then of course there's my girlfriend Bre, who's in Canada right now fast asleep!' I said, glancing down at my watch.

As soon as I'd said those words, Canadian TV host Jeff Hutcheson, who was standing just out of shot, thrust a phone into my hand.

'Actually Ben, she's wide awake and on the phone for you right now.'

'What?! Bre? Hey, how are you? Guess what?' she cut me off mid sentence.

'I know you won — well done! I told you you'd win! So does that mean I can come and join you?"

'Of course you can! Listen, I have to go but I'll speak to you later on.'

Summer Burke took control again, with one last question: 'So Ben, what are you looking forward to most about the job?'

'Going home and telling my current boss I quit!'

Kerri Anderson was my TQ chaperone for the rest of the day. After some quick photos and goodbyes she whisked me up to the media centre ready for the first part of my job, the media interviews. Outside there were three cameras all pointing at a single chair — the hot seat. For the next five hours the interviews, lined up for every 15 minutes, came thick and fast with little or no break in between. From radio stations in Colombia to the CNN morning news in New York to the BBC in London, everyone wanted to ask me about my new job.

Kerri and her team were on hand throughout the chaos, offering food and water in case I was drying out or getting tired. I was so focused on doing the best job I could for my new employers I missed the sunset and night's arrival, the bright artificial lights of the temporary studio masking the end of the day.

As the evening wore on a few friendly faces stuck their heads around the corner of the set to say hello. Magali and George, my fellow finalists, stopped by to ask if I'd be coming along to my own celebration party. There were already 300 people there drinking and dancing, but I couldn't leave my seat — the interviews had to take priority.

As the world came alive and the working day kicked off in different time zones I appeared on their breakfast shows — first in the UK, then the east coast of America, then the west coast. I lost count of how many interviews I'd done but the TQ team seemed happy.

The clock struck midnight and I could hear the party in full swing. After six hours of back-to-back interviews I was done, but I had to be ready to go again at 5.30 am.

On day one the Best Job was already the busiest job in the world.

I arrived at the party to a hero's welcome, still dressed in my blue t-shirt. The other finalists and TQ staff had been joined by hundreds of well-wishers, from the island staff to holiday-makers, all keen to get involved.

After a quick beer and a hundred high-fives, I retreated to the hotel, set my alarm for 5 am and fell into a deep sleep.

Hey boss, I quit!

The financial side of the Best Job had never been important to me. Yes, I would be earning $150K over the next few months. But as far as I was concerned, the valuable part of the deal would be the experience, adventure and opportunities the new role threw up.

Whether I walked out of Queensland at the end of the contract with $100 000 or $10 really didn't bother me. I wanted to continue to get the most I could from my one chance on Planet Earth!

The baggage carousel kicked into life, waking me from my trance. In 23 hours I'd flown around the world from Brisbane to Heathrow Airport. I hadn't seen Mum and Dad since winning the contest. I'd been forewarned that there might be a few photographers waiting to capture that first embrace with my parents. Pushing my trolley through the door of the arrivals area I could see a gaggle of them in the distance. In front of them Mum and Dad waited, beaming from ear to ear. As I got closer the camera flashes started, drawing attention from the crowds of people stood around waiting for their own friends and family to arrive.

'Ben, over here!'

'This way now!'

'Look into the camera please!'

'And a big smile from the three of you!'

Is this what it felt like to be famous, followed around by photographers and reporters? What a change in lifestyle I'd experienced in the last few months. A year ago I was living in a roof tent on top of my Land Rover driving around Africa, and now I had a $3.5 million Australian island villa to look forward to.

With the photos out of the way I could concentrate on Agnieszka and the BBC crew. It had been a week since I'd seen them in Australia, and having been through so much together it felt like meeting old friends.

'Oh Ben, how well you did out there!' she said. 'How does it feel to be home with Mum and Dad?' she asked.

'It's fantastic! They're the most supportive parents anyone could ask for.'

My official role on Hamilton Island was due to start in eight weeks on July 1, but Tourism Queensland had asked me to quit my current job as soon as possible to fulfil the growing list of media commitments they had lined up for me.

It wasn't long before I'd be starting my second adventure of a lifetime.

Usually when you quit a job there's a fairly standard procedure to follow: your letter of resignation, a month's notice, you work through to that final day and walk out of the door ready to start your next adventure. Of course, it's rather different if the details of your new job have been all over the TV for the past week.

'Don't tell me, I already know!' George said as I walked through the door of the Turf Centre, a wry smile across his face, looking happier than I could remember ever seeing him on a Monday morning.

'Look Ben, I always knew you were destined for bigger and better things than I could offer you. So when can you work till?'

'Ideally the end of the week. Is that okay?' I replied, nervous he'd refuse. 'But you beat me to it, George. Can I just say one thing to you?'

'Go on.'

'Boss, I quit. I've got the best job in the world!' I'd been rehearsing the line since waking up that morning.

The next four weeks flew by. My departure from the Turf Centre signalled a new line of work, with new responsibilities I'd never been trained for. Tourism Queensland was keen to milk every drop from their campaign and readily accepted offers from media outlets around the country and Europe.

The radio, television and newspaper interviews didn't stop. At least once a day I'd chat with another media outlet somewhere in the world. I even had an entire day locked away in a radio studio in London giving BBC Local Radio interviews around the country, one after another.

My confidence in front of the camera was growing and I became accustomed to microphones being thrust into my face. I was enjoying my time in the limelight, happy to talk about my life to date, my African adventures and why I thought I'd been chosen as the Island Caretaker.

It was an interesting insight into the world of the media, who wanted to know everything about me, my background and especially why, out of everyone, I'd been chosen. There were a number of standard questions they all seemed to ask: How did you win? What are you looking forward to most? What do you think an average day will be like? How are you preparing to live on a tropical island? They were all questions I had no really honest answer for. Apart from the

blogging and media work I had no real idea what I'd be doing. And neither did Tourism Queensland — it was new ground for them too. The campaign had moved so fast that they had yet to work out what was to come afterwards. It would all be a wonderful surprise.

I put my selection down to a number of factors:

- My adventurous background and experience of travelling and blogging was the perfect combination they were looking for.

- As someone who loves the great outdoors, barbecues, the ocean and being very social, I have a Queenslander's take on life.

- And then there was the convenience of being English and of the right demographic. The UK is one of the key markets for Australian tourism. Employ someone from Britain and the audience who watch my journey may very well follow me to the Sunshine State.

CHAPTER 4

Life of an Island Caretaker

With 10 days to go until my job was due to start I began to say my farewells to friends, unsure exactly when I'd return. I felt sad to be leaving behind such a close, supportive group of friends who had helped out so much with my preparations and early campaigning. I wanted to share the experience with them. Since it would clearly cost too much to fly them all out to Australia, I decided at the last minute to throw a huge party instead.

My parting speech invited anyone and everyone to come and join me in Australia. All they had to do was pay for the flights — the accommodation was on me! I would sorely miss my wonderful friends.

Welcome to the world of television

A phone call from Tourism Queensland a few days before my departure threw another curveball and opportunity my way. They'd been approached by Beyond International, a television production company based in Sydney, who were interested in making a series out of the Best Job — with me as host.

Alanna Simonis explained that being escorted everywhere by a cameraman and sound engineer over the next few months could make life a little more restrictive, but the opportunity to promote Queensland globally was too good to pass up. And it would give me my first real presenting role. The series would be broadcast on the National Geographic Adventure channel and shown in 114 countries around the world. I thought about it for all of 10 seconds before gladly accepting.

I was told from the get-go that this series would be different. Beyond Productions were there to film an experience, not to try to create it. If they tried to over-manage what went on in my daily life as the Island Caretaker, it would detract from the experience — something the team at Tourism Queensland wanted very much to avoid.

My first shoot with their UK-based team was at my parents' house as I packed my bags ready to leave — not just once, but four times. First a wide shot, then a tight one on the zip, then one over my shoulder and the last one from the reverse angle. If this was going to be a taste of what was to come then maybe I shouldn't have said yes so easily!

Initially, having to relive every aspect of my life multiple times on camera felt awkward and rehearsed. I struggled to hold the same conversation with people several times over. As time went by it began to feel a little more natural, until finally I got used to the way creating television works.

On my last day in the UK I spent time with my sister Becky and her family. I had missed out on two years of my nephews' and niece's growing up, and now I was about to jump on a plane to the other side of the world and do it all again. But the one camera I do love jumping up and down in front of and have no problem talking to is my own webcam, and Skype gave me a window into their world wherever I was, so I could witness them growing up and talk to them from afar.

There was no rehearsal or retake required when it came to my farewell with Mum and Dad at Heathrow. While they were overjoyed about my new job, they were also sad to see their only son disappear through the international departure gate once again. But they'd be coming out in a few months' time to join Bre and me in our luxurious three-bedroom villa.

* * *

Through the plane window the weather in Brisbane looked distinctly better than it had been in London 18 hours before. Midwinter in the southern hemisphere delivered clear blue skies and sunshine I could hope for only during the summer months in the UK. I could pack away my warm jumper. I wouldn't need it for the next few months.

Bruce Wallace, Tourism Queensland's Communications Director, was waiting for me along with the Australian camera crew from Beyond Television Productions. Behind his camera the smiling face of Paul Henry peered from around the viewfinder.

'Hi Ben, my name's Paul. Can I ask one thing of you?'

'I bet I can guess what it is. Shall I go through my arrival one more time?'

'How did you know?' he laughed.

'When you've been involved in television as long as I have, you just know these things,' I replied dryly, giving him a wink so he knew I was joking.

I retraced my steps to the sliding doors (much to the bewilderment of the people who stood watching), turned, smiled and met Bruce for a second time.

While driving me into the city, Bruce outlined my schedule for the next 24 hours and the media commitments that had been lined up. I had the rest of the day in which to relax and try to beat my jetlag. Everything started in earnest the next day with Bre's arrival from Canada.

My early morning run along the Brisbane River was just what I needed to clear my head and I was back at the hotel in time for a hearty breakfast. On the way in the front door I spotted Channel 10's Summer Burke and her cameraman poised ready to interview me.

'Hi Ben, welcome back to Australia. Can we ask you for a few words?'

'Any chance I could go and have a shower first?' I replied, conscious I was dripping sweat over the polished marble floor.

'Oh go on, I just need a short grab for the lunchtime news. Are you looking forward to starting the Best Job and having Bre arrive tomorrow?'

There was no getting away from the cameras now. I'd just have to be prepared wherever I went. Welcome to the celebrity life — if only for six months.

* * *

The minutes ticked by. We'd been waiting at Brisbane Airport for Bre to arrive for nearly an hour. She'd stepped onto the Air Canada flight in Vancouver 18 hours earlier, full of anticipation for the adventure ahead.

I'd been hanging out with the film crew from Beyond TV for the past couple of days. 'Maybe she decided not to come?' piped up Bruce, who was there as my chaperone. 'After all, apart from a $3.5m villa, a tropical island and fat pay packet, what are you really offering the

girl?' he smirked. His Aussie sense of humour was growing on me — a little amused sarcasm with a twist of envy. It was something I'd have to get used to over the next few months.

Then around the glass divide she arrived, smiling and bursting with energy after the long trans-Pacific trip, weighed down with a backpack emblazoned with country flags, as overloaded as a Nepalese porter.

'Oh my god, this is like country number 72!' Bre managed to spill out in her first sentence to the film crew. Once a country counter, always a country counter.

The views along the Brisbane River from the tenth floor of the Stamford Plaza were incredible; the cityscape twinkled all around, the ferry pontoons below buzzed with life, picking up dark-suited commuters and disgorging hungry restaurant-goers. How was I suddenly here in a vibrant Australian city when just six months before I'd been shivering my nuts off in my roof tent atop Colonel Mustard on the side of the road in wintery France?

I'd arrived in Brisbane two days before Bre, meeting the team at the head office of Tourism Queensland, going through the procedures of writing for a government website and working out how I'd use all of the amazing technology I'd been issued with.

In Africa I'd got used to documenting my travels with a seriously rudimentary kit: a compact, waterproof camera that recorded low-res video and a Panasonic Toughbook that was perfect as a GPS but looked more like a prop from a Lego cartoon than a decent laptop.

In order to tell my story online through my blog and sell the Great Barrier Reef to the world through beautiful images and video, I'd need access to the right equipment. A few weeks earlier I'd been asked to compile a list of what I'd need to make it happen. My mind boggled at the opportunity — a DSLR stills camera, a video camera, dive housing, a GPS and of course a state-of-the-art laptop on which to edit it all. Since my office for the next six months would be beaches and islands, I wouldn't need a desk!

July 1, 2009, was to be my official start date as Island Caretaker and the day I took up residence in my villa, the Blue Pearl, on Hamilton Island. In the days leading up to flying north from Brisbane, it was all about publicity and promotion. Tourism Queensland understandably wanted to get every single dollar's worth of publicity out of me. Their campaign had received worldwide recognition, and I'd be helping them milk every last drop out of it.

Requests had been coming in from different media outlets all over the planet since I'd been announced as the 'successful candidate' (there were no winners or losers here, was the message; this was a serious job with serious responsibilities). All of them wanted to know what I was doing and how I was preparing for my six months on what many conceived of as a desert island.

As this was a government-funded advertising campaign, it was important for Tourism Queensland to keep the state-wide newspaper on side. John Wright, a journalist with *The Courier Mail*, had given extensive coverage to the 16 finalists in the build-up to the final, dedicating a half-page feature to each of us. John and I got on really well; he was an Englishman from the West Midlands (close to where I was born) who moved to Australia in the early seventies. We talked about home and made the promise that one day we'd drive to the northernmost tip of Australia together. (Still waiting on *that* adventure.)

Now it was time for *The Courier Mail* to run a personal profile all about me and why I'd won. And of course the article needed a decent photo to accompany it. Off Bre and I trundled with the newspaper's photographer to South Bank's Streets Beach — 4000 cubic metres of Moreton Bay sand and a chlorinated pool overlooking the Brisbane River and cityscape. It's great for screaming kids and stressed families and sun-worshipping backpackers.

'I want you to befriend a couple of hot girls in bikinis and sit down between them with your laptop open,' suggested the photographer. So off I went on a mission to recruit my 'extras'. From the corner of my eye I could already see Bre getting twitchy.

Walking across the sand dressed in my blue Island Caretaker t-shirt felt good, and uttering the words 'Hi, my name's Ben. I've got the best job in the world' was a privilege, and as a hot news topic it was also an easy sell.

'Sure thing; what's it for?' came the reply from the bronzed Dutch backpacker.

'The local newspaper wants to show me *at work*,' I replied.

'Oh! You're the guy who actually *won*?' came her response. It had fast become the way I was referred to — you're THAT guy.

Once we'd got the snaps needed it was back to the hotel to prepare for tomorrow's departure and the start of our big adventure. 'You didn't have to look like you were enjoying it so much back there, Ben,' groused Bre. Yikes. What was I supposed to do — *frown* in the photo showing off the perfect job and lifestyle?

Starting on Hammo

Every kid knows what it's like trying to fall asleep on Christmas Eve, waiting for Santa Claus to deliver. That's pretty much how it was for me the night before leaving for Hamilton Island — trying to separate my mind from the chaos around me, struggling to find that perfect dark space where nothing happens. My body was ready to quit for the night, but my brain remained active, my thoughts tugging me this way and that.

In the morning I raced through the shower, inhaled a bowl of muesli and checked out of the hotel in time for the first interview of the day. Summer Burke was back with her cameraman.

'What are you looking forward to the most?'

'How's Bre enjoying being in Australia?'

'What will you do when you get to the island?'

I couldn't figure out how to answer that last one. Who knew what was in store for me?

Our plane banked sharply as the city of Brisbane disappeared from view. With just over an hours' flight time to the Whitsundays, this was a last chance to do very little, apart from taking in the view as we tracked north up the Queensland coast.

Two months earlier I'd flown the same route with the 15 other 'successful applicants' and half a planeload of international media, heading to the finals circus. Cameras were flashing, interviews on the go, nervous anticipation and egos on show, everyone throwing themselves into the media spotlight, desperate to stand out from the crowd.

How different this flight was. Last time I hadn't looked out the window and seen the Great Barrier Reef below, stretching out to the horizon, a pallet of indescribably azure blues and greens. Now as I looked closer I made out individual islands, watched as the currents ripped through narrow channels, and was that — it couldn't be! — a humpback whale? Maybe not this time, but I'd be seeing them up close very soon.

My relationship with one of the most stunningly beautiful, ecologically fragile environments on Planet Earth was just beginning. For the next six months I'd explore it from the Torres Strait in the north down to Lady Elliot Island at its southernmost tip.

'Ben, have you got a second?' Alison asked, jerking me from my dreamy stupor. 'I just want to give you a little briefing on how we'll

manage your disembarkation.' Alison was part of the team I'd met during the final, responsible for managing the event to ensure it ran like clockwork.

Surely I'll just collect my bag, saunter to the door and exit, right? I thought wryly. I have been doing this walking thing since the age of two; I think I've got it down.

'We're expecting a fair turnout there, including the media who stayed on the island last night. You'll be the first off the plane so when we touch down the flight attendant will come and get you and escort you out. Cross the tarmac to the terminal building and we'll see you there.'

Our plane kissed the runway and with a mighty roar of reverse thrust we came to an abrupt halt on one of Australia's shortest commercial airstrips. I looked at Bre beside me, smiling like a Cheshire cat as she caught her first glimpse of our home for the next six months.

'Well here we go! Don't worry about the cameras and questions, just smile and enjoy the ride,' I whispered in her ear, trying to calm her nervous excitement.

As the plane pulled up outside the terminal I could see the reception committee on the tarmac outside. One of the Virgin stewardesses made her way across to my seat and shyly asked, 'Mr Southall, would you mind if we had our photo taken with you before you go?'

I climbed out into the aisle, posed for the photo and pulled down my bag from the overhead locker, then passed Bre hers. This was the moment I'd been waiting for — my arrival on Hamilton Island.

'Come on let's get out there, we're holding up an entire plane!' I said to Bre, turning and walking out of the plane door and down the steps to the tarmac below.

Our arrival at the tiny terminal building was pure rock star. Big banners reading 'Welcome Ben — Island Caretaker' hung from an overhead gantry, film crews thrust microphones into my face, camera flashes momentarily blinded me and everyone was clapping.

All I can remember thinking is, but I haven't actually *done* anything yet. Wasn't all this fanfare perhaps a little premature? A wry smile came over my face; I did enjoy the limelight. Two years ago I couldn't even read out the raffle tickets at a Christmas coffee morning at the Royal Star & Garter without tripping over my words. Now I was

giving press conferences and interviews to a global audience. Being thrust into a new role like this filled me with a confidence I never knew I had.

'Don't worry about your bags, Mr Southall. We'll take care of them. Here are the keys to your buggy — it's parked over there,' said the island concierge, pointing at what could be any one of at least a hundred identical buggies in the parking area. Hamilton Island has few cars, relying on buses and golf buggies, and there's something tropically brilliant about that.

With Bre by my side and the film crews following close behind, we walked towards the buggies. It quickly became obvious which was mine: a huge Best Job in the World sticker on each side left no doubt. There'd be no sneaking around the island over the next six months. Promotion and publicity were the name of the game. With film crews from France, England, National Geographic and each of the Australian news networks following my every step, ensuring the brand of Tourism Queensland was front and centre in every shot was the most important job I had. *I* was now the product that needed placement. My face had become recognisable and it was up to me to be the best ambassador I could. I'd need to be on my best behaviour at all times.

As I drove away from the airport, 10 buggies followed closely behind. Bre was hanging out the side of ours whooping at the television cameras as only Canadians can, and I realised with sudden embarrassment that I had no idea where I was going. Fortunately Alison and Andrew from the Tourism Queensland team were on hand almost immediately, pulling alongside in their own buggy.

'Do you know where you're going, Ben? You look a little lost!'

'I have no idea!' I bellowed back at them.

'Follow us then.'

We took off as fast as the little electric buggies would go. With the world's press following like a bunch of lemmings, I could just see tomorrow's headlines:

Best Job Ben Can't Even Find His House

or

Lost on Hamilton Island, and It's Only Day One!

Five minutes later we'd climbed the Great Northern Highway, descended One Tree Hill and arrived in Coral Sea Avenue outside the Blue Pearl. I had to perform my perfectly 'natural' arrival at the house

several times so the cameras could capture it from every possible angle.

Bre had only seen the house on the Tourism Queensland website. During my last visit, when all 16 finalists were given the tour, it had seemed like an unachievable dream — a huge house you might visit but you would *never* live there. Now we were moving in.

'Oh my god, it's incredible!' Bre screamed, running from room to room, opening each door in turn to see what lay within. The camera crews loved her pure unbridled wonderment at the size and grandeur of the Blue Pearl. For the past five years she'd been living in backpackers' hostels and the cheapest hotels on her parents' worldwide adventure. Now it was her time for the penthouse.

The view from the main balcony was majestic: a wide panoramic outlook across the ridiculously blue waters of Fitzalan Passage to the shore of Whitsunday Island, no more than a few hundred metres away, which was covered in lush tropical hoop pines that dropped down to the water's edge.

Below our balcony the ground fell away sharply. A steep track wound through the foliage, emerging again where the rocks stopped and the ocean started. I caught a glimpse of a turtle in the water below as it popped its head up momentarily to take a breath. For a moment I forgot about the furore behind me and stared off into space, soaking up the atmosphere of this new world. In the distance a yacht under full sail heeled over, the wind powering it through the ocean swell. The buzz of a light aircraft drifted overhead, no doubt ferrying holiday-makers to Whitehaven Beach, tucked away somewhere on the island that lay before me.

'Ben! Have you seen the size of the spa downstairs?' Bre belted out, the cameras in hot pursuit.

'I know; isn't it awesome? There'll be time to jump in there later, I'm sure.'

Alison cut the conversation short. 'Ben, I need you to come with me; we've got a few interviews we need you to do.'

'What about me? Can I do any?' Bre interjected.

'I'm afraid not, Bre. These are for the news teams about Ben's first day doing the Best Job. If you just wait here we'll be back soon enough. They just want a few photos in the spa, on the bed, in the buggy. You know — the usual PR stuff.'

Bre loves the spotlight and enjoys attention. Taking a back seat didn't come naturally to her. I could see her take the comment hard.

Balancing work and personal life

From day one I knew the eyes of the world would be watching how well I performed as the Island Caretaker and naturally I wanted to do well. A self-enforced hard-work ethic meant I was glued to my laptop late into the night, creating the content I'd promised to deliver, but it did have some negative effects on my relationship in the early days. Learning to manage the two was key.

- **Physically separate work and home.** Designate a space in your home as your office. Even if it's an alcove or a corner of the garden shed, having to make the effort to travel to it means you can better differentiate between work life and home life.

- **Always stop for meals.** Be strict with yourself about when you take lunch and dinner. The most important meals of the day are those taken with loved ones. It's much healthier to take a break from your computer and eat somewhere else. It clears your head, which is good for your thinking, and it also means you don't get crumbs all over your desk.

- **Know your rhythm and work to it.** Are you an early bird or a night owl? Use your most productive time of the day to tackle the toughest jobs, rather than pushing them back. I think about these when I'm out for a morning run then attack them the moment I get home.

- **Unplug for a while.** I treat my iPhone like my manhood: it's rude to get it out at the dinner table. Treat time out with friends and family as sacred time, when only the people you're with matter.

- **Try to enforce internet-free Sundays.** Make this the day of the week when all internet use is banned—no laptop, tablet or smartphone if at all possible. Don't take your smartphone to bed; our brains need rest and relaxation to produce innovative ideas.

- **Prioritise the email torrent.** These days we're expected to answer emails immediately, which is often impossible. We need to prioritise! When I open my inbox at the start of the day I sift through, flag the most important and reply to them first during my 'email window'—an hour in the morning and another in the afternoon. Mobile devices are great because you can reply with a one-liner rather than an essay. Make sure you leave 'sent from my iPhone' at the bottom to justify your brief answer.

- **Make time for a holiday.** Be it a night, weekend or fortnight away, nothing is better for a relationship than getting away from the coal-face, forgetting about work and relaxing together. And don't you dare check your email!

The *busiest* job in the world

Alison led me back into the house to start another afternoon of hard work. Each of the journalists and film crews that had travelled to the island had been allocated 30 minutes with me on which to build their story. I spent the next few hours recounting the last 10 years of my life to reporters and television hosts, again and again. I described the work I'd done after leaving university, what it was like living in a Land Rover in Africa, why I was riding an ostrich in my application photo, and whether my family would be joining me here on the island. By the end, I felt like they knew more about me than I did!

There was also a serious side to each interview. Why had I been chosen over 34 684 other people? How would I take the story of Queensland to a global audience? And why hadn't an Australian won the job?

Although I told the truth in each interview, I also kept my answers a little guarded to protect myself. I hadn't been the perfect citizen while growing up in the UK—who is during their youth? If the story of a certain big night out back in the nineties got out it wouldn't have done my reputation, or Tourism Queensland's, any good. Also, I'd observed that the press can take a perfectly decent answer and spin it 180 degrees if they choose to. Sensationalism sells more papers.

After a couple of hours we'd finished the newspaper interviews and it was on to the television stations in time for the evening news reports. We jumped onto the buggies again and headed back up to One Tree Hill, leaving Bre and the house behind. A backdrop of 74 stunning islands clearly beat the inside of a luxury house.

Each of the three main Australian commercial television networks wanted a live interview for the evening news slot. Emma Croft, TQ's ruthlessly efficient Corporate Communications Manager, worked from a finely tuned schedule detailing who I'd be talking to and when.

First up was a live link to Channel 10 news in Sydney. Ten minutes later it was out with their earpiece and in with Channel Nine's. Another 20 minutes and Channel Seven in Sydney were talking to me on air. When the sun set behind me I was too busy to notice, focusing dutifully down the barrel of another camera as I told the world what it was like to have the 'best job in the world'. And just when I thought my day was drawing to a close Emma said, 'Okay, the UK's just starting to wake up. We've got a couple of satellite links set up for the breakfast shows over there. Lindsey will look after you'.

One Tree Hill is a beautiful vantage point to watch the sunset from and a magnet for holiday-makers. Every evening a bar is set up and the quiet car park fills with golf buggies as people arrive to sit on the grassy slopes, cocktail in hand, and watch the sun drop behind the distant mainland. So the television cameras naturally drew a few curious looks, and I stood out like a beacon as the bright floodlights illuminated me. I could hear low voices in the crowd: 'Isn't that the guy who won the greatest job in Australia?' and 'That's the lucky Pommie bloke, isn't it?' At that moment, I realised how much of a success the campaign had been.

An hour and three interviews later Lindsey finally called it a 'wrap'. We'd finished all the TV work for the evening, but there was still a long way to go before I could wind down and relax.

'How are you doing, Ben?' Emma asked.

'I'm good. I could do with the toilet, but I'm happy to carry on until the work's done.' The adrenalin from all the live television interviews was still running through my body. 'So what's next?'

'Back down to the house for now. We've got a few radio interviews lined up for later in the evening but they're not for a couple of hours. Here're the numbers you need to call and the time slots. In the

meantime, you may as well get your first blog post up. People are already asking where it is!'

I'd been up since 6 am, travelled halfway across the state, given back-to-back interviews for the last four hours — and still had more work to do before I could wind down in my new house. Well, it was what I'd signed up for, and I knew as I looked around how lucky I was. Not many people have an office as majestic as this, perched on the side of a hill on a tropical island.

Back at the Blue Pearl, Bre was fast asleep on the sofa, the jetlag finally catching up with her. I hadn't unpacked my bags or done any grocery shopping since we'd arrived, and we had no food in the house. Luckily Alison had thought ahead and left an all-Australian welcome hamper for us, including macadamia nuts, cornflakes and a pot of Vegemite.

Tucked in the corner of our expansive lounge at the Blue Pearl was a tiny desk that would serve as my office-at-home for the next 182 days. There was just enough room for a laptop, the printer and a few reference books. I was used to writing my blog in the confines of the Land Rover, so having even a small dedicated workspace was bliss. I could stick my Great Barrier Reef map on the wall, charge up the multitude of camera batteries I'd be using and even have something as organised as an inbox for the first time in my life. An hour later I'd written the first blog for my website www.islandreefjob.com and got ready to upload it for my waiting global audience to read.

I plugged in my USB internet stick and watched as the signal flicked between one bar and nothing at all. That's when I realised there wasn't a good enough signal to hold a connection, let alone upload photos and videos. The Best Job was about being at the forefront of technology, telling my story across social media and digital platforms in real time, yet here I was in my luxurious island villa and I couldn't even send an email.

There was no spot in the house where I could use the internet or conduct a coherent telephone conversation. The only place I could connect was hanging off the side of the balcony with my left leg in the air! I spent the next couple of hours back on top of One Tree Hill giving radio interviews, reading emails and uploading my blog in the dark.

My inbox was chock full of messages from friends and family around the world, but I hadn't the time to reply to them. One email

that needed my attention contained my itinerary for the next few days—all 33 pages of it. As I read through, each day seemed more incredible than the last. I'd be living the life of a high-flyer in some of the most exotic places in Queensland, starting off with a trip to the Great Barrier Reef, then to Hayman Island, before flying down to meet Premier Anna Bligh in Brisbane later in the week for a photo shoot.

Every day was scheduled down to the minute—where I needed to be, with whom and what I should be wearing. If I thought the last 24 hours had been ridiculously busy, then the next few days would be even more so.

Dealing with the first day on the job

The first day of any new job can be tough, whether it's the best job or the worst job in the world—and I've had both! Giving a good impression is paramount to setting the tone for the rest of your working life.

- **First impressions count.** Deliver a big smile and a warm handshake, just as you would when arriving at an African border post! Positive body language and a tidy appearance make a huge difference.

- **Listen more than you talk.** Every day is a school day. It pays to open your ears more than your mouth so you can learn as much as possible, then hit the ground running. Don't forget to ask lots of questions.

- **Feed your brain.** Being fit and healthy on the inside shows on the outside. A good breakfast will keep your brain fuelled until lunchtime.

- **Remember their name.** When you meet someone for the first time either say their name back to them in conversation ('It's great to meet you, Rachel') or say it to yourself several times so you remember it.

- **Say hi to the boss.** Drop by their office and introduce yourself. Not many people do, and it can make a huge difference!

- **Find a mentor.** Keep an eye out for a colleague you think will be a good mentor. It's good to have someone you can turn to for advice and run your ideas past.

- **Don't be late.** Make a good impression from day one. Aim to leave home 15 minutes earlier than you need to. You won't arrive flustered and sweating, which is never a good look.

From outhouse to penthouse

My role as Island Caretaker was to travel the length of the Great Barrier Reef sampling every experience it had to offer — from the luxury of a six-star villa to remote beach campsites to the buzz of a backpacker hostel — and 'report back'.

Those first few days on the job really opened my eyes to a world of travel I'd never before experienced — one focused on utter pampering, exquisite food and total immersion in life's finest luxuries. My holidays had hitherto been adventures in which I was always on the go and more or less 'roughing it'. Lying back on a sun lounger, soaking up the sunshine and sipping a cold cocktail simply wasn't *me*!

The first stop on my itinerary was Whitehaven Beach. Seven kilometres of pure white silica sand and one of the most iconic locations in Australia, Whitehaven adorns the front cover of a thousand brochures. Our take-off from Hamilton Island in a seaplane with two film crews packed into the rear was incredible. As we banked heavily, I could make out our house suspended on the side of the cliff below. Bre loved every minute of it and let out a 'whoop!' each time we changed direction. Ten minutes later we landed on the crystal-clear waters that lapped one of the world's most beautiful beaches, and waded ashore.

Our arrival must have looked pretty interesting to the tourists on the beach. While there's nothing unusual about arriving in a seaplane, when 10 people clamber out carrying camera tripods, reflectors and film gear, it gets a bit of attention! It was like the set of a Hollywood movie was being unloaded.

We'd arrived at the unofficial home of the Island Caretaker. The images that had been broadcast across the world throughout the Best Job campaign had shown a tropical island paradise complete

with sandy beach and waves quietly lapping the shore. It was time to capture the dream again.

Summer Burke was still compiling her piece about my first few days on the job and we were here to film the final part that would wrap it up. 'Can we maybe have you splashing about in the water, Ben? Bre, if you could to the same.'

'Sure thing! How about I do some backflips or cartwheels?' Bre asked.

'Ahhh yeah. Maybe when we've finished this part, if that's okay?'

Once we'd filmed all the water shots, Summer and I wandered along the beach for the interview. Her cameraman was a few steps behind and focused on Bre, who'd started doing gymnastics down the beach. After a quick run-up she threw herself into a flip and came down hard on both heels — the rock-hard sand was unforgiving.

'Yeooooww!' Bre gasped.

I ran over. 'That looked painful, Bre? Are you okay?'

'I don't think so... my feet are pounding. I've definitely done something bad.'

'If I carry you up the beach, will you sit down and rest for a while until we get this final interview out of the way?'

'Sure thing, Ben. I'm sorry. Maybe one flip too far...'

'Don't worry about it. We'll get you to a doctor just as soon as we can.'

By the time we arrived at Hayman Island, a 20-minute flight away, Bre's ankles had turned a light shade of blue, the bruising seeping through to the soles of her feet. Luckily there was a doctor on hand to strap them both up and provide her with the crutches she'd need to get around for the next few days.

It wasn't the best introduction to one of the most luxurious islands in Australia, but it only slowed her down for a day or two.

* * *

During that first week the crew from National Geographic had lingered on the sidelines everywhere we went. Their role was to capture every awesome experience above, on and below the water for the next six months. By the end of our adventure together, their team had produced six hour-long episodes that would be broadcast around the world, with me as host. I got to know them during our

first Best Job trip together — to visit Lizard Island. It was also one of the trips on which Bre was able to join me.

Lizard Island

The four of us stared out of the window in awe at the colours of the reef below as we made the final approach to the island. We'd flown two hours north from Brisbane to Cairns, before boarding a second flight to one of the most remote and luxurious resorts in Australia.

The hotel staff walked us to our rooms, dropping James and Jason off at the workers' dongas (in this case a pre-fabricated shed) on the way to The Pavilion, where we'd be staying for the next couple of nights. Perched on its own private rocky headland, the view from the glass-fronted villa was epic. Sunrise would peek out through the glass from the right, and sunset to the left. In front of us a private plunge pool, a four-poster day bed and our own private boat for exploring the ridiculously clear and warm water.

It would have been the perfect place to relax and soak up the world with the one you love. But since arriving in Australia Bre and I hadn't rediscovered the chemistry we'd enjoyed in Africa or Canada. The tension between us, combined with my media workload, meant we were slowly drifting apart. Most of the time we managed to keep up a happy front, which isn't that much of a challenge when you're enjoying such wonderful experiences. We dived with huge potato cod at the famous Cod Hole and took a helicopter flight over the Great Barrier Reef, its electric colours silencing us all.

One morning I headed out before sunrise for a run. I find this to be the most amazing time of the day, as golden rays of sunlight erupt over the distant horizon, bathing everything in a warm iridescent glow. Ten kilometres later I arrived at Cook's Look, a famous landmark on the island, and read how in 1770 Captain Cook had stood on the same spot during his search for a channel out through the treacherous network of coral reefs. I tried to picture myself on that early explorer's ship, navigating the oceans of the world with no GPS or maps. These were true adventurers, setting out across unknown seas to chart and map what they found, unsure if they'd ever return.

Something stuck in my mind that morning atop the island. I made a mental note to myself to buy a book about Captain Cook and read more about his voyages of discovery. I didn't imagine it

would lead to my own expedition around the Great Barrier Reef two years later.

I shared one unique Best Job experience in the company of South African–born adventurer Mike Horn.

Mike's Pangaea Expedition, a four-year educational project to sail around the world in his icebreaker yacht, happened to stop off in Cairns when I was there. And one of his main sponsors happened to be my old employer Mumm Champagne, which was hosting a gourmet lunch celebrating his arrival, which I happily attended.

The lunch was number three in a series of seven held in unique and stunning locations to celebrate the beauty of the natural world. We flew to Undine Cay, a tiny sand island around 40 minutes by helicopter from Cairns, where a team of eight people had constructed a bright red marquee. Beneath it, a table for 16 was set, along with a kitchen for Michelin chef Mauro Colagreco and more champagne bottles than people.

Mike and his team arrived 20 minutes later, their 35-metre yacht anchoring just off the coral cay.

You have to close your eyes and picture the scene: a perfect day with blue skies; a flat calm tropical ocean; a bright red marquee; a yellow helicopter and a huge luxury yacht alongside. One of James Bond's villains couldn't have pulled it off better.

I confess to downing a few glasses of champagne that day. When you're offered the entire cellar of one of the most famous champagne houses in the world you don't refuse, even if you don't especially like bubbles. Suffice to say the food was exquisite, the company (mainly journalists and sponsors) eccentric and the location perfection.

A ride with an outback angel

I was able to entertain my love of all things aeronautical once more in the care of one of Australia's most experienced pilots, Bill Bristow. Bill is the CEO of Angel Flight, a charity that coordinates non-emergency medical flights for regional Australians. Tourism Queensland, which knew how much I loved overland travel, and that I'd never visited the Australian outback, thought it was about time I took a break from the islands and the ocean, threw on an Akubra (a traditional Aussie cowboy hat) and tasted the red dust in the west of the state.

Parked up outside the hangers at Hamilton Island airport was a mean-looking machine, a silver and grey turbo-prop Pilatus

PC-12 aircraft, one of the sexiest looking planes I'd ever seen. Climbing on board, and looking around the cabin area, it struck me that this was exactly the way film and pop stars travel: air-conditioned luxury with acres of sumptuous leather. I made myself comfortable in the co-pilot's seat, adjusted my headset and listened intently as Bill made his flight plan clear to the control tower. We taxied to the northerly end of the runway, turning into the brisk headwind ready for the off.

With a simple push forward of the throttles we powered down the runway, gaining speed with every metre until Bill pulled back on the controls. We rose silently and effortlessly from the runway, climbing sharply into the sky. Ten minutes later we reached our cruising altitude of 10 000 feet, levelled out and set a course due west for the outback town of Longreach, some 700 kilometres away.

Bruce Wallace from Tourism Queensland was there to meet us in a four-wheel-drive for the start of my outback adventure. Hundreds of kilometres of driving around remote towns...with 25 other vehicles all covered in sponsors' stickers! I was thrown in at the deep end and given the chance to try everything from whip-cracking to sheep shearing to mustering on horseback.

The people of the outback were some of the most hospitable and genuine I'd met. They welcomed us into their daily lives with open arms and showed us how tough life could be in areas of the country that hadn't received rain for more than two years. It was a stark contrast to the life on the fertile coastline I'd grown used to and showed something of the diversity of this Great Southern Land.

The power of networking

One of the key skills of the job was being able to integrate and socialise with people from all walks of life, from a sheep shearer to the State Premier. Walking into a room full of strangers can be daunting, but if you take control of the situation, you can walk back out having made new friends, contacts and even business deals! Networking can be the key to success—it's not always what you know but who you know!

- Set yourself a target before entering the room, such as 'Today I'll talk to five complete strangers'.

(continued)

The power of networking *(cont'd)*

- Go prepared to listen, not preach. Be a good listener and encourage others to talk by asking open questions.

- Take a pocketful of business cards to every event.

- With any card you receive write notes on the back about your interaction with that person.

- Ensure you contact that person the next day—just a simple email connecting with them online.

- Keep your online profile up-to-date in case someone looks further into who you are.

- Networking doesn't have to be at a formal event. It could be as simple as a shared coffee or lunchtime run—anywhere out of the office where you can discover the person behind the business card.

Sailing on a piece of history

Hamilton Island is a prestigious yachting destination with a stunning yacht club, a wonder of modern architecture that looks across Dent Passage. Every August more than 150 yachts gather in the marina for the island's biggest event: Hamilton Island Race Week, during which these ridiculously luxurious vessels take to the waters around the island for seven days of inshore racing.

With my experience working for Mumm Champagne I knew what to expect: intense action on the water, dazzling events on shore, mingling with a social set who don't mind inviting you along if you're up for a laugh. All I had to do was find a boat, and as a well-known face on the island that wasn't difficult. James and Jason, for National Geographic, wanted to film me getting involved on deck—the usual stuff: hoisting sails, grinding a winch, steering a vessel worth more than I'd ever earn.

Glenn Bourke, the CEO of Hamilton Island, offered me a trip on *Wild Oats XI*, a 100-foot supermaxi ocean racing yacht owned by the Oatley family, who also leased the entire island. It was an opportunity not to be missed.

Spending a few hours on the water in average conditions gave me a sense of what this boat could do in a strong breeze; we were hitting speeds of 20 knots with only 15 knots of wind. Unfortunately my role on this flying machine was limited to taking photos. Each member of the crew had built their skills over years of training to win their place. I needed something a little more manageable, so I wandered along the pontoon later that afternoon in search of a vessel that might offer me a chance of getting a bit more 'hands on'.

'We'll let you on board as long as you bring a bottle of rum and no bananas,' a burly guy called from the deck of a big, fine-lined racing yacht.

'Do you mind if these guys come too?' I called, pointing at James and Jason following behind me.

'The more the merrier! Jump on. I'm about to do a crew briefing,' came the response. 'I'm Bruce Absolon, owner of *Spirit of the Maid*.' And just like that we'd been recruited as members of the 10-person crew that would sail this 65-foot yacht.

At the start line of a yacht race, the milling boats can shave past each other so closely that it seems like an accident waiting to happen. Eighty 30-foot yachts plus some larger ones, including several 120-footers, were all jostling for position in the tight confines of Dent Passage — it's beyond me how collisions were avoided.

Bruce stood at the helm expertly manoeuvring his sleek vessel through the chaos while shouting obscenities at the other skippers. 'I'm on a starboard tack, get out the way! How am I supposed to get through there? Back off!' he roared.

It was the same on board all the yachts, the sound of skippers baiting each other resonating across the water. I was happy just to soak up the atmosphere and wait for my time to get involved in the action.

Our main opposition was another of the old Whitbread boats, *Merit*, which I'd watched take second place in Cape Town back in 1997. James was jumping about trying to film every angle of the race while at the same time maintaining his balance. On more than one occasion it looked like he'd go overboard as the boat changed tack.

BOOM! The start cannon fired and we were off, cutting a course south towards Pentecost Island, 15 kilometres to the south.

As the pack spread out things calmed down on board. Even Bruce seemed quietly focused, happy to let the crew do the hard work while

he concentrated on our heading for the next mark. Standing alongside him I adopted my role as TV presenter. With six episodes of our series to film over six months, being out on the water was just the sort of content we needed. I couldn't believe my luck. Back when I worked for Mumm I could only dream about life on a yacht racing around the globe, and now I was on board one of those vessels. The job had been packed full of unique, astonishing experiences, but this had to be the best so far.

Bruce seemed happy to let me steer the boat, so for the next hour I followed his instructions closely, conscious that a decent finishing position was at stake.

To say I got the full experience of what it's like to race one of these boats would be a lie. They need 15 knots of wind just to get moving and are more suited to life in the Southern Ocean, where storms propel them along at breakneck speed, pushing both crew and boat to the limit. As we sailed south to Pentecost Island what little breeze we had slowly died, our great start all but wiped out as the hundred boats behind us slowly caught up, until they too were becalmed. We had at least stopped in one of the most expensive and beautiful parking lots I've ever visited — the Whitsunday Islands on a picture-perfect day, for everyone but sailors, that is.

A long-drawn-out, windless afternoon on the water didn't offer a huge amount of yacht racing excitement, but I really didn't care. We made it back to the marina in third place in our class, secured our shorelines and headed straight to the bar for a celebratory soda water.

Flying a chopper

Six months of adventure around a state as large as Queensland (more than twice the size of Texas) meant a fair bit of flying. Most of the trips included at least one ride in a helicopter to get the lay of the land. We flew in lots of different types, including a Squirrel over the rainforest, an R22 in the outback and a Bell Ranger over Hamilton Island. But my favourite was the highly manoeuvrable aeronautical luxury of the four-seater R44.

Every fortnight, a new email would arrive from the team at Tourism Queensland with my next itinerary attached. I'd spend the next hour flicking through it for the highlights, celebrating with Bre the wonders

of the 'job'. One day I was blown away to see that helicopter flying lessons were scheduled for my next week in the Whitsundays. My fear of heights was for a time outweighed by sheer excitement. I was itching to go by the time I arrived at the Whitsunday airport hangar. As always I was chaperoned by a cameraman and reporter, there to capture another 'average day at office'.

Carefully following the instructions of my instructor Des, I pulled back on the stick and held on tight. Slowly our silver bird lifted its payload clear of the tarmac and we were airborne. It was only when I turned to look at Des that I realised he'd been flying it the entire time. I'd simply been holding onto the controls as he moved them!

Fifteen minutes later it was my turn for real. Des talked me through the basics before handing over complete control. It took a few minutes to notice I was gripping the stick so tightly my knuckles were white.

'Just relax Ben, you'll find the sweet spot. Just feather the stick until she starts to turn ... there ... that's better.'

It was a splendid feeling controlling the helicopter as I turned over Whitsunday Island and Whitehaven Beach. For 40 minutes I flew us over the islands that I'd already explored by kayak, seaplane, speedboat, sailing yacht and even stand-up paddle-board. Flying a helicopter isn't easy though. Everything works just fine when you're up in the air, but try landing it. Cyclic, throttle, rudder, collective — there are just too many things to concentrate on at once for a newbie like me. Our final few metres were pretty hairy with the tail bucking and writhing all over the place. I was sure the rear rotor would hit the ground given the angle we came in at, but Des was there to save the day, bringing a collective sigh and deep-felt thanks from the Sky News team sitting behind me.

'You might have the best job in the world, mate, but you're not the best pilot in the world,' the relieved cameraman murmured in my ear as we crossed the tarmac to the hangar. Hey, he wasn't wrong, but at least I gave it a go.

Diving the SS *Yongala*

Living on the Great Barrier Reef gave me the chance to dive its entire length from the Torres Strait in the far north, only 35 kilometres from Papua New Guinea, to Lady Elliot Island at the southernmost tip.

Losing two friends on diving holidays had given me an irrational fear of going underwater for any longer than my own breath would allow me. I still hated the idea of scuba diving when I set out for Afritrex in 2007. It was only when I got to Malawi during that expedition that I had the opportunity to overcome those fears in the calm, fresh waters of Lake Malawi. I'm glad I took on my fears and gained my Open Water certificate. If I hadn't, I'd have missed out on some of the most breathtaking dive locations on the planet. You can't fully appreciate life underwater on a coral reef until you pull on a scuba tank, descend to the bottom and breathe bubbles with the marine life that lives there.

In the first few weeks of the job I dived in a number of different locations around the Whitsundays. My confidence was slowly growing. Once I'd registered my twentieth dive, Tourism Queensland asked if I'd like to take my diving to the next level for my advanced certification on the 110-year-old wreck of the SS *Yongala*.

To say I was a little apprehensive would be an understatement. My palms were sweating, my stomach churning and nausea was washing over me as we headed down to the beach in Yongala Dive's troop-carrier. I kept repeating to myself Jay's words of encouragement: 'If you don't go, you'll never know.'

Until now I'd dived to 18 metres around coral reef in the relatively smooth waters around the islands. But here I was about to head 22 kilometres out to sea to find a rusty old wreck lying 30 metres below the surging ocean swell. I tried to keep the negative thoughts of Guy and Char's deaths out of my mind, reminding myself that this was one of the top 10 dive sites in all Australia. I was here to enjoy it.

The camera was rolling as we bashed across the waves. James and Jason were again there to capture every moment, my pale face telling the story even before I opened my mouth.

'How are you feeling, Ben?' James asked. 'Tell the camera what we're here doing.'

I broke out of my negative thoughts and found something else to focus on. My role as television presenter on a show like *Best Job in the World* wasn't about memorising a script and delivering the lines. This was reality television reporting live from the moment, so I had to think on the fly and deliver the experience to my audience with factual, witty grabs that would have them hanging on for more. If I

wanted a chance to continue with a career in television, then I had to take this opportunity and own it!

'In just a few kilometres we'll be arriving at the surface buoy that marks the wreck of the SS *Yongala*, a cruise liner that sank over 100 years ago in a cyclone, taking with it the lives of 122 people... and a racehorse named Moonshine,' came my unrehearsed delivery, as I turned to look off into the distance.

'You nailed it, Ben. You're getting better at this every day. We'll make a presenter of you yet!' James confidently exclaimed. He was right. I no longer felt nervous in front of the camera and was happy to tell a story that would hopefully motivate people to take on their own fears.

The RIB (rigid inflatable boat) pitched and rolled in the large swell once we'd tied up alongside the buoy. I peered over the side but saw nothing in the dark green water below, the wreck still hidden from view.

'On the count of three, I want you to hold onto your mask and do a big backwards roll into the water,' instructed divemaster Heather. 'Make sure your BCD (buoyancy control device) has some air in it, and off you go.'

'Here goes everything,' I said to myself, pressing my mask into my face. I went over the side, bobbed in the water for a few seconds and readied myself. James joined me, his camera this time locked away in a waterproof housing the size of a bar fridge.

* * *

I drop below the surface, scanning the vast expanse of nothingness below. In this part of the open ocean, something as significant as a wreck on the sandy ocean floor is like an oasis in the middle of a desert. All life congregates around it. Huge rays, sea snakes and bull sharks call the wreck home, so I want to be sure there are none of these in my path on my first-ever deep-water dive. Not that I'd be able to do much about it, but it pays to be aware of everything around you.

My ears feel the increase in pressure as we pass the 15-metre mark on the anchor line. I wiggle my jaw to equalise and continue my descent, now confident in my newly acquired diving technique. James follows closely behind, his camera lights shining out like beacons as the light from the surface diminishes. I concentrate on what lies below.

What's that dark shadow in the distance? Is that the wreck? No … that's got to be a shark! I blink to focus my eyes, stare harder. Whatever it is, it's coming towards me — *fast*.

My heart is pounding and I'm breathing far too quickly. At this rate, I'll be through my air before I even get to the bottom. It doesn't help that my mask is starting to fog up. I really am a sitting target.

The shadow continues towards me and I squeeze the anchor line tighter, preparing for the worst. What a terrible way to go — my first deep dive and there's even a camera recording it!

All at once my fears dissolve as I realise the monster from the deep is actually a huge green sea turtle. It's Leroy, one of the wreck's friendlier residents.

Arriving at the topside of the wreck I am overwhelmed by its sheer size. The ship is over 100 metres long and towers above the seabed, and the variety of marine life it harbours is immense. The deck is covered in all kinds of soft and hard coral with millions of tiny baitfish swimming around in great clouds erupting from the hull. Groups of giant trevally hover motionless above the wreck. Turtles pick at the sponges littering the deck and sea snakes twist effortlessly through openings in the hull.

Two marble rays glide past just a few metres below us, five small reef sharks in their wake. Another eerie shadow passes over me and I look up to see a huge hawksbill turtle swim by.

Heather guides us along the ocean floor, tracking along the starboard side of the stricken ship. My depth gauge reads 30 metres; at this depth, our air will be used up quickly. We pass an old, still glazed porthole that has stood the test of time and on to the bow, where the ship's name still stands out.

My mind wanders back to 23 March 1911, the date the SS *Yongala* sank. The chaos and terror on board as the cyclone bore down on the ship must have been horrific. To be caught miles from shore at the mercy of the weather gods is hard to imagine.

Heather's thumbs-up signal, indicating it's time to head back up to the surface, comes all too quickly. I am enjoying myself down here in the depths, experiencing this fantastic marine world close up.

When I break the surface, rip the regulator from my mouth and wipe the snot from my nose, my previous fears are long forgotten. 'That was the most magnificent dive — how much life there is down

there! Can we do it again?' I gasp, bobbing on the surface like a discarded coconut. I started the day with an intense if illogical fear of deep diving, took a deep breath and stepped into the abyss — and loved it!

'If you don't go, you never know.' How right Jay was.

Take on your fears

My natural fears used to get in the way of achieving things in life. Presenting to a large crowd, jumping out of a plane or putting on a scuba tank all used to fill me with fear and trepidation. But by taking a deep breath and challenging my inner demons I've now added them all to my list of have-dones!

'You will never know your limits until you push yourself to them.' We all have something that scares us — it could be jumping out of a plane, skiing down a slope, holding a snake, travelling overseas alone or simply crossing the road.

- **Think about how good it feels to succeed.** Note the excitement or pleasure it gives other people, and put yourself in their shoes.

- **Take small steps towards your goal.** Take a plane ride first, then try a bungee jump and finally go for the skydive!

- **Go with friends you trust.** You need people who'll support rather than mock you.

- **Don't over-think it.** Talk to people about something completely different.

- **Use the voices in your head.** It takes 10 good thoughts to undo one bad one. Make sure you say only positive things to yourself.

- **Let your emotions run wild.** Scream and shout if you like — you just did it!

- **There's always someone more scared than you.** Other people gauge the experience based on your reaction, so if you smile and look like you're enjoying yourself it might give them the confidence to try it too.

Eating adventures—from turtle to degustation

My waistline was kept in check only by my love of running. I'd always made it the first activity of the day whenever I was somewhere new, whether in the middle of the outback or on a tiny desert island. If I hadn't have kept to this routine throughout the six months, then the vast array of sumptuous food that was served to us would have turned me from a medium into a large, that's for sure!

Bre and I tried the weirdest menu items as we travelled through Africa, although she often watched rather than partook. Who knows what street food was served to us in Nigeria and the Congo, for instance. I'm sure we unknowingly munched our way through bush rat, snake and maybe even a monkey or two.

A visit to Masig Island in the Torres Strait threw up the biggest culinary quandary of my life so far, when a dinner was presented as part of the NAIDOC (National Aboriginal and Islander Day Observance Committee) celebration. For two nights I was the guest of the immensely hospitable people who live here in the Strait, staying in the only tourist accommodation on the island: two bungalows with beach frontage, each with a plunge pool in the centre of the room. The view from the window had to be one of the best in the world—across a sandy beach, past palm trees to the bluest of oceans.

The afternoon was spent with the locals, watching traditional dancing by the school kids, sitting with the old ladies as they wove palm fronds into baskets and fans, and listening to the purest laughter I'd ever heard, rising from deep in the belly.

As night fell the smells of a cooking fire filled the air. The remoteness of the island means the population harvests most of their food from the ocean, living on fish as their main source of protein. Once a year, the NAIDOC day celebration brings the community together for one almighty feast, with food tables groaning under a bountiful banquet of…a little more than I'd bargained for—sea turtle. It turns out that Australian law allows traditional hunting of dugong and turtle by Aboriginal and Torres Strait Islanders as long as it's carried out humanely.

With James and camera in tow, I approached the group of men at the fire where they were preparing a green turtle. Both sets of flippers had been removed but the head remained. I watched (my

stomach turning a couple of times) as they carefully split open the top and bottom shells, threw in onions, garlic and soy sauce, then wrapped the body in several layers of baking foil, ready to bury it in the hot sand.

'For the sake of our film, will you tell me how you caught the turtle?' I asked the guy who stood closest to me, a large knife held in his left hand.

James repositioned to get both of our faces in shot.

'Ah yeah. We caught it yesterday, tied it up with a piece of rope to the jetty and then bashed it over the head with a block of wood to kill it,' he replied matter-of-factly.

It wasn't the answer I'd been expecting or hoping for. James looked away and said, 'Umm, I don't think we'll be able to use that!' We retreated from the fire.

That night, with the feast in full swing, one of the locals offered us some of the turtle meat. We were here as guests. It would have been rude not to accept. I have to say it tasted divine, a little like pork but even more like the wild boar I'd tasted in Africa. But I wasn't so brave when the same local returned 15 minutes later with raw turtle eggs. The soft-shelled, yolk-filled balls did not appeal.

Like most people, I don't often think about where my food comes from. We simply pick up a box of pre-prepared meat from the supermarket and consume it, never giving much thought to what was involved in getting it there. Seeing the turtle prepared, cooked and eaten was a real eye-opener for me, and an education into something I'd become isolated from — the journey between catching our food and serving it on the plate.

For the other 99 per cent of the time, our food was prepared by some of the best chefs in Australia and the meals we enjoyed were nothing short of gastronomic genius, each one more memorable than the last. The locations were pretty special too — from candlelit jetties to starlit beaches to rainforest verandas.

The array of hotels and restaurants at which we were lucky enough to feast seemed to offer ever more impressive menus as the job went on, amply satisfying my love of seafood and fresh fruit. As a state, Queensland prides itself on providing the best from both the ocean and the orchard, with a traditional Christmas lunch serving up crayfish, Moreton Bay bugs, prawns the size of your forearm and the juiciest, most luscious fruit to wash it all down with.

Every time the word 'degustation' (meaning a sample tasting of a range of different food items across several courses) appeared on the menu, I had to indulge. I convinced myself that there was no better way to experience the full array of what a chef could create. Whenever I did, it left me with an awkward, over-full waddle back to the hotel room. Had it not been for my running I would have had to dip into my salary to pay for an entirely new wardrobe.

Kayaking Hinchinbrook Island

Some of the most amazing experiences during my time as Island Caretaker happened far away from expensive resorts and gourmet kitchens. When I turned off my technology and left social media behind on a kayaking trip around one of Queensland's less-visited island wonders, I was reminded of childhood holidays. Camping under the stars, cutting my own walking trail or jumping into a rock pool are simple pleasures I'll never grow tired of or too old for. A three-day kayak trip along the eastern shore of Hinchinbrook Island was an adventure that refreshed my love of the wilderness and sowed a seed in my head for further exploration of the tropical waters of the Reef.

We had departed from the slipway at Dungeness and had spent the last hour beating into a strong headwind before our fast launch turned into the sheltered waters of Zoe Bay. Of course James and Jason were with me, loaded down with their usual array of camera, tripod and sound gear, loving every minute of their mission. We were here to link up with a company of kayakers who were halfway through a seven-day expedition to the northern tip of the island. At that stage I had explored the continental islands of the Whitsundays and the coral cays in the south, but I hadn't seen an island with such *Lord of the Rings* magnificence as this.

Hinchinbrook Island juts out of the ocean with angular, rugged beauty — a lush, green landmass with towering mountains that punch through the clouds. Arriving just before sunset, we took the tender to the beach, the plume of smoke from the campfire our guide, the smells of dinner wafting through the bush as we arrived at the camp.

Dave, Craig and Michelle from Coral Sea Kayaking had prepared a spread of Moroccan lamb, couscous and tabouli for the four other kayakers who'd been paddling since day one, with enough for us too.

Each of us grabbed a bowl and walked to the beach to watch the sunset.

Dave briefed us on the next few days' adventures. 'We'll be setting off from here around 8.30 after breakfast, paddle for a few hours then stop for lunch. It really is one of the most amazing coastlines. Just keep your eyes open for turtles, sharks and, if you're really lucky, a crocodile!'

We were now four hours north of Hamilton Island, well and truly in croc country. A long yellow warning sign next to the creek running alongside us into the bay confirmed that.

'If you need a shower, well you're out of luck, because there isn't one. But there *is* the most amazing waterfall if you follow that path in the morning,' Dave continued, pointing over his shoulder at the track winding off through the gum trees. 'The return trip will take you an hour and it's definitely worth it for the view alone.'

James, Jason and I sat on the beach listening to the sounds of the ocean and surrounding bush while the rest returned to the camp, bedding down early after a hard day on the water.

'Where do you want to set up the tents, then?' Jason asked. 'We'd better get it done before we lose the last of the light.'

'I'm game to sleep right here on the beach, as long as there are no crocodiles about,' I replied, keen to wake to the sound of the waves. 'And I'm definitely heading to the waterfall in the morning. You in?'

'Of course. Just make sure you wake me. I want to film it,' James added.

* * *

It didn't take much to wake me the next morning. There's something about sleeping under canvas that excites me so much I can hardly keep me eyes closed at night. As the first glimmers of light penetrated the tent I jumped out of my sleeping bag and onto the beach.

'Guys, I'm heading to the waterfall for sunrise, okay?'

'Uummm…yes…okay, give me two minutes,' came James's croaky response.

Following the path was easy. The Thorsborne Trail, a 32 km track that runs the length of the island, is one of Australia's most remote but popular walking tracks. Avoiding the huge spider webs was less easy. Overnight, enormous golden orb spiders had spun their silky lines across the path, leaving numerous surprises for me to walk into.

For the next 30 minutes we climbed steeply up a rocky track that finally opened onto a wide, smooth granite plateau. A slow-moving creek ran down the centre before dropping into a series of huge, round pools, worn out over millennia. The early morning sunlight lit the mist below thrown up by the most spectacular waterfall.

I walked cautiously across the rock towards the edge, or as close to it as my vertigo would allow, and surveyed the view. Before me lay a sight that's still fixed in my mind today; a calm, glistening blue ocean, the long sandy beach of Zoe Bay and a vast green forest stretching to the base of the sheer-sided mountains in the distance.

I was spellbound. We hadn't spent an hour on the water, but I knew right there I needed to do more of this: travelling the coastline by kayak, stopping off to explore places most Australians will never get to in their lifetime. Maybe I could do some more trips by kayak after the job was over? Maybe for more than just a few days? How about along the entire Great Barrier Reef? My mind wandered off again, as ideas for another adventure began brewing.

Caretaker of the Reef

I have loved nature since an early age. School holiday road trips to the north of Scotland with Mum, Dad and Becky exposed me to the sheer beauty of the natural world. I was much happier playing in the local stream or pond catching tadpoles and newts than sitting in front of a screen playing the latest computer game.

That love has grown, but it's only now I can really appreciate those early days of pitching a tent under the stars in the New Forest or heading out with Dad in our little boat onto a cold Scottish loch to fish for mackerel. This relationship with nature is something I want to pass on to the next generation of Southalls. I firmly believe that by losing this relationship we risk losing sight of the value of the natural world and becoming wholly urbanised.

During my time as Island Caretaker I learned how coral reefs around the world are under increasing pressure on many fronts. Many have been overfished and exploited to extinction, stripped of the life that's needed to maintain a healthy marine environment. In Australia, the Great Barrier Reef enjoys much greater protection thanks to its World Heritage status, but still the federal and state governments have a great responsibility to recognise the significance of them for the

future of the tourism industry rather than pandering to the demands of big business.

The Queensland coast runs parallel to the Great Barrier Reef and the pressures owed to that proximity are increasing. Coastal development, run-off from agriculture, the destruction of mangroves and the inordinate increase in shipping due to the mining industry boom are all adding to the stress on one of the most fragile environments on earth.

I've said I was a little underwhelmed when I first pulled on a mask and snorkel here. The astounding colours and diversity I'd expected from the world's most famous coral reef were revealed as rather brown and, well, dull. I saw none of the expansive branching coral formations akin to an underwater garden that I'd expected; most were rather short and stubby, broken. But I was bobbing around in the tropical waters of the Whitsundays, in the same place that 300 other tourists visit every single day. When you put that many people in shallow water above a coral reef, accidents are bound to happen. Flailing flippers can break even the toughest coral, damaging hundreds of years of growth in an instant.

My love of diving grew as the job went on. I lost my fear and started to look forward to donning my mask and heading underwater. At first I'd connected only with the marine creatures that poked their heads up above the waterline, like turtles, dolphins, sharks and whales. Now I was gaining an understanding of the changing micro-world beneath the waves as every tidal flow, passage of the moon and weather system changed the dynamics for the creatures that lived there.

I spent entire dives locked in the same spot on the ocean floor watching life happen around me — a cleaner wrasse going about its business, a moray eel opening its jaw preparing to strike, coral polyps filtering the nutrients from the water. The more I watched, the more I learned, and the more love and respect I felt for the world around me. My privileged position as Island Caretaker gave me a voice that people listened to, so I made it part of my role to educate others through my blog and social media platforms about the Reef and the pressures it was facing. It was tough some days when, as an employee working for Tourism Queensland, I had to toe the government line and hold my silence even when I didn't agree with decisions they were making. After all, they were paying my wages.

I met some inspiring characters during my travels, many of whom shared my views on the importance of conserving the underwater world. Most tourism operators and divemasters see the Reef as their employer now and into the future; it therefore only makes sense for them to look after its long-term health. Some of these people work very hard to preserve and protect their little piece of this World Heritage Site.

Our role as human beings is simple: we have to care for and sustain Planet Earth as a duty to future generations.

Behind the scenes—when there aren't enough hours in the day

Things were a lot busier behind the scenes than my movie star lifestyle might have suggested. Whereas most people visiting these iconic holiday destinations were there to simply kick back, relax and enjoy the experience, I had a very different role—essentially, to promote them as best I could using my and Tourism Queensland's digital and social media platforms.

When I arrived in one of these wonderful locations my first job would be to scope out exactly where I could set up my 'office', somewhere—preferably with a decent internet connection and enough power points to charge the multitude of electronic devices I had to carry—where I could work late into the night.

By their very nature, the islands of the Great Barrier Reef are remote and isolated, so they generally don't offer a decent internet connection, certainly not one that allows you to upload high-resolution photos or video as the job required. Even in my house on Hamilton Island I'd had problems from the start trying to find an internet signal. As I travelled to increasingly remote locations my role as a social media guru and blogger was becoming ever more difficult.

An 'average' day for the man with the 'best job in the world' went something like this:

- Get up at sunrise and head off for a run around the island or location where I was staying.

- Breakfast with Bre, the film crew and the resort manager to discuss the plan for the day.

- Take part in the day's activities while photographing and filming them for my blog, and while *being* filmed and interviewed by Beyond Productions or the travelling news/film crew.

- Do local television/radio interviews as required.

- Arrive back at our hotel in late afternoon. Download and back up all photographs and video.

- Dinner with Bre, the resort manager/local tourism organisation/competition winner/film crew.

- Head back to my hotel room to 'start' work:
 - Write a blog about the day and upload using WordPress.
 - Upload photos to Flickr, adding titles, descriptions and tags.
 - Sort all video footage, edit and upload to YouTube.
 - Respond to around five media interviews per week, ranging from answering simple 10-question pieces to writing 800-word articles.
 - Update Twitter and Facebook throughout the day.

- Pass out at my laptop; wake up and sneak into bed just after midnight.

My job specification required me to 'post a weekly blog', which had sounded simple enough. But I was enjoying so many incredible experiences that creating just a single blog each week didn't seem fair to the tourism companies who were looking after me. If I was going to give something back, I thought, I needed to up my game and produce more content.

My self-imposed work ethic meant I constantly tried to over-deliver. I was ever conscious that years of underachieving at college and university hadn't prepared me well for being the best at what I do. Now I was living life in the limelight, I wanted Tourism Queensland to have confidence that they'd made the right choice when they decided to give me the job. Then there were the 34 684 unsuccessful contenders who'd be watching, reading and commenting on each blog post I wrote and each photo I took, and who perhaps thought they could have done better.

My insecurities and self-doubt never left me. I would read through my writing obsessively, then go back and write it all over again. I was

tying myself in knots over my concern for what other people might think of me. One phone conversation with my mum finally put my mind at ease.

'Ben, if you think that *I'd* be happy reading it, then everyone else will too. This is simply a diary; you're not publishing a novel. Tourism Queensland employed you because they like the way you write — so just get on with it!'

Mothers have a keen ability to sift through the crap to find the nugget of truth.

It took a few weeks, but I finally found my rhythm with the content I was producing. Once a week I'd edit and upload a video; twice a week I'd post to my blog; and every day I'd send a couple of tweets to my Twitter account. Everything was going well, or so I thought. Then, one month into my role, the UK's *Daily Telegraph* newspaper published a story headlined:

British Winner of Best Job in the World 'Not Blogging Enough'

The story claimed that I'd written for my blog only seven times in my first month, readers allegedly complaining that my reports were too few and far between, and told little of life outside the Tourism Queensland PR bubble. It went on to blame poor internet coverage on the islands and my overloaded work schedule for the shortage of posts, answering their own claim rather well.

Anthony Hayes, Tourism Queensland's CEO, came to my defence with a brazen forward offensive that made me chuckle.

'Ben has been fielding media requests and interviews from more than 50 media outlets around the world in the first two weeks. In addition, he's had a documentary film crew capturing his every move and he's been the centre of several press conferences upon arriving in new Queensland destinations. He's handling the role extremely well and we're currently looking at ways in which we can free up his schedule to ensure he has enough time to really savour the experience and the unbeatable Queensland lifestyle.'

I decided against taking to social media to vent my frustration. Tasked with writing 'a weekly blog', after four weeks I had already posted seven times. I had done more than what my job required of me.

Fortunately, Twitter came to my rescue. The short form allowed me to share more often without having to — or even being able

to — write at great length. I used it more and more to drip-feed morsels of information and updates to my growing audience. Throughout the day I'd share photos, short videos and sound-bites on the adventures I was having, and would often receive comments back from curious followers keen to learn more.

The job was an absolute privilege and I knew I was very lucky to have it. Some people, however, saw it as a six-month holiday, imagining all I'd have to do was kick back in a hammock, read a book and drink cocktails as the sun went down. The word 'job' should have indicated quite clearly that there'd be work to do. From day one of the campaign I'd read between the lines. The Island Caretaker wasn't simply a holiday-maker who'd swan around taking photos; I was a multi-tasked employee who'd have to be a digital marketer, social media guru, public relations expert and ambassador for the Queensland brand. You don't fill all those roles successfully by sipping Long Island Iced Teas all day.

The last round of the competition had given me and all of the other finalists a clear indication of how much work would be involved. From the first light of dawn through to the last canapé of the evening networking events, we were on show and being judged. My hyperactivity, seen as a liability for so long in my childhood, became a distinct advantage now.

The team at Tourism Queensland were the driving force behind the campaign's success; they had taken a good idea and made it great. In a world where thousands of dollars are spent every year bringing journalists to holiday destinations in return for advertising column inches and television time, TQ had turned the tables. Suddenly, media from around the globe *wanted* to visit Queensland, Hamilton Island and the Great Barrier Reef to see my office first-hand. This meant additional media commitments on top of my usual blogging duties. With so many publications, radio stations and television channels wanting to cover the story, there was only one person who could tell the story of life behind the blue Best Job t-shirt: me.

Winning the Best Job sparked the busiest chapter of my life. In the 48 hours that followed the announcement I completed a record 120 interviews. Life hadn't calmed down much since I arrived on Hamilton Island. The convoy of media on golf buggies that followed me to the Blue Pearl highlighted the scale of the free publicity we were getting every single day. On most of the trips I took during my

six-month contract I was accompanied by journalists and film crews from around the world. Together we'd sample the offerings of the Great Barrier Reef; I'd write stories for my blog and they'd write stories about me writing for my blog. It was a happy marriage.

The frequent travel, frenetic pace of life and demanding work commitments were tiring, even for someone with as much energy as me. Burning the candle at both ends could only go on for so long without something breaking. I was dealing with too many things at once and spent less and less time with Bre, choosing instead to stay up late and finish my work. Something wasn't working.

Bre and I had got on well as fellow travellers, eager to learn about the world together. She'd been my training partner as I tried to stay fit enough to complete my 10 African challenges while living on the road. As the Best Job application process intensified so did my commitment to Bre. My two-week trip to visit her in Canada coincided with the news that I'd made it through to the next round. After all of the adventures we'd had together on the road during Afritrex, she had been my first choice of mission partner should I get lucky and win.

Given the privileged, very public life I was living, it would have taken a partner with a great deal of patience not to be prone to envy at times. Bre and I would travel together and share the experiences whenever the circumstances allowed. If we were filming with a television crew, I brought Bre into the picture whenever possible, carefully trying to manage the situation. When the travel show *Getaway* came to film at the Blue Pearl I could see Bre's eyes turn green as the host, the beautiful Natalie Gruzlewski, walked through the door. The 15-minute piece pitched her job as a travel presenter, which many see as another 'best job in the world', against my job.

Throughout the day, Natalie and I vied with each other on screen in an effort to prove our job was indeed THE best. Everything was set up for the sake of television, but Bre wasn't happy. Back at the house later that evening she had cooled down enough for us to work it out. A few nights later we were watching television when another episode of the show came on, with Natalie presenting. Bre instantly saw red and I had to promise never to work with Natalie again.

The trust in our relationship wasn't there anymore. To put it bluntly, the situation sucked. Here I was in one of the most perfect locations on the planet, leading a life in front of the camera that

told stories of romance and good times, yet behind the scenes I was struggling to hold together a broken relationship.

The next day I called Kerri Anderson from Tourism Queensland to ask her advice. Should I keep things going for the sake of the campaign? If I broke it off now while living in the public eye, would I be seen as heartless for dumping my girl? Kerri told me that whichever way I wanted to go, they'd support the decision. I'd been employed as the Island Caretaker for my skills and personality, not for my relationship. It was up to me to make the call on where our future lay so I decided to give it one last go. Our life slowly returned to normal but we seemed more distant than before. I was struggling to see a future for us beyond the end of the job.

Trust your instincts

There are moments in life when your head tells you one thing, and your heart another. The battle that played out inside my head was eating away at me, and my lack of commitment to making a decision was becoming destructive to my psyche.

- **Intuition is based on experience.** Your subconscious relies on archived information when forming judgements. Trust it and you trust yourself.

- **Ask yourself a question.** The first answer that pops into your mind is usually the right one.

- **Learn from your mistakes.** Have the strength of character to carry something through to the end, even it was the wrong decision in the first place.

- **Listen to the people around you.** We're often blind to the truth when we're deeply involved; we can't see the wood for the trees.

A sting in the tail

By December 2009 I'd travelled across much of Queensland and had seen more of the state than most of its residents. My work was going well; record numbers of people were visiting the website and my six-part series for National Geographic was nearing completion. With

only a month to go, Tourism Queensland's US office struck gold: I was to be interviewed live by satellite on *The Oprah Winfrey Show*. With an audience of over 7 million people in the US, and broadcast to another 149 countries around the world, this was the biggest win of all my interviews. Anthony Hayes, Tourism Queensland's CEO, couldn't stop smiling when he told me the news on my visit to Brisbane. In the initial brief he'd given to SapientNitro back in 2008, the campaign would be considered a success if it featured on one of the major US talk shows.

Under the cover of darkness, by the main swimming pool on Hamilton Island, I spoke to the 'chat show queen of the world' via satellite for eight minutes about life as the Island Caretaker. I took the opportunity to invite Oprah and her crew to film the show in Australia — and a year later she accepted, bringing her entire team and a 300-strong audience across for one of her final shows!

This short, if slightly nerve-racking, interview alone earned Tourism Queensland thousands of dollars in publicity for the state. Anthony Hayes hasn't stopped smiling since.

I had some of the most brilliant and crazy adventures imaginable during those six months. I skydived over the Whitsunday Islands, held a crocodile's mouth shut, let a carpet python wind its way down my shorts, dived with sharks and flew a helicopter with its doors off at right angles to the ground. Every experience seemed to be more extreme and outrageous than the last. In all of the time I'd spent in one of the most dangerous, spider-, shark- and snake-infested regions on earth, I hadn't been bitten or stung once. With adrenalin-pumping escapades coming thick and fast, I lost concentration just a few days before the end of my six-month contract and paid the price, courtesy of one of the smallest creatures in the ocean.

The two weeks leading up to Christmas were my official wind-down period. I'd worked non-stop for six months, giving over 250 interviews, posting 75 blogs, uploading more than 3000 photos and editing 62 videos. James and Jason from Beyond Productions had everything they needed for the National Geographic series. It was time to relax and enjoy the surroundings of the Blue Pearl for the last time.

Mum and Dad came to visit from the UK, along with Aunty Jenny and Uncle Colin from Spain. We spent Christmas Day eating shellfish and fresh fruit in the traditional Queensland way, sitting on

the balcony in the sunshine. It was a long way from the turkey and stuffing around an open fire they'd have been enjoying back home.

After Christmas my family departed for the UK, leaving Bre and me to enjoy the last few days together. Our wonderful neighbours had invited us out on their jet ski several times, and we finally had the chance to accept.

Between November and March it's advisable to wear a stinger suit (a thin lycra wetsuit) if you're entering Queensland's tropical waters, as it's prime season for stinging jellyfish. Though the chances of actually being stung are close to zero, with only a handful of cases along 2000 kilometres of coastline every year, almost everyone takes this precaution.

After a lap of Hamilton Island, with Rosie, their youngest daughter, holding on tight, I pulled up onto the beach by the airport on the island. I stepped off the back of the jet ski, took a handful of water and washed the salt off my face. As I did so I felt the slightest of pin-pricks on my forearm that was gone a second later, and I thought nothing more of it. I got in my golf buggy and drove up the hill to the island spa where my massage was booked. Halfway there my bottom lip started to tingle. A minute later and my jaw was shaking and clenching uncontrollably. Something was up. I raced to the spa as fast as my buggy could take me.

Damian, my sports masseur, had worked as a lifeguard on the island for a number of years and recognised the symptoms straight away.

'Have you just come out of the water, Ben? Did you feel anything?'

'Just a tiny prick on the arm. Nothing major,' I replied, dismissing the idea of a jellyfish sting. 'I didn't see anything at all.'

'Well I'm not 100 per cent certain, but I think you may have been stung by an Irukandji jellyfish. They're no bigger than your fingernail and totally transparent, so you wouldn't have seen it; but they pack a nasty punch. I think we'd better get you to Dr Morris for a check-up.'

The emergency medical centre on the island is only 200 metres away from the spa, but by the time I arrived, the poison from the jellyfish was coursing through my veins.

Irukandji syndrome takes quite a toll on the human nervous system, causing blinding headaches, nausea, severe sweating, high blood pressure and cramping around the entire body, especially the kidneys and lower back. It felt like I was being squeezed in a vice, the

jaws slowly closing tighter and tighter around my waist. I couldn't get comfortable and squirmed around on the bed like a poisoned child. My head felt like it was about to explode with pain, which shot down my spine and through my lower back. The last thing I remember before passing out was sweating out of every pore, as though a shower head was attached to me, and convulsing in uncontrollable waves.

Dr Morris injected me with a triple cocktail of Valium, morphine and another drug to ease the pain. I came to a few hours later, with my neighbours and Bre at my bedside.

'Welcome back, Ben! Man have you been saying some funny things!' Rosie giggled.

'Oh Rosie, leave him alone. Ben, are you okay?' her mother Andy asked.

'I think so. What the hell happened?' I croaked. I had completely forgotten the last couple of hours of my life.

'You took the hit for me, Ben. Just to think it could have been me that jellyfish stung—thank you!' Rosie, one of the cheekiest and cleverest 10-year-olds I've ever met, beamed at me.

A few hours later I was discharged and allowed to go home, feeling no further effects of the poison. Back at the Blue Pearl I was starving and devoured an entire chocolate bar in seconds. Irukandji syndrome is exhausting and certainly generates an appetite.

There was no keeping a secret on the island, and word of my 'accident' soon got out to the press. I could see the headlines already:

Best Job in the World Winner Stung by Deadly Jellyfish

Australian Killer Jellyfish Takes Out Island Caretaker

Whichever way the penny fell it wouldn't be good publicity for Queensland. My phone began to ring almost immediately for the inevitable interviews. I ignored them all. I needed to hear the official line I should take, conscious that one incident could undo all of the hard work I'd put in over the past six months. Emma Croft, TQ's Corporate Communications Advisor, was the first to reach me.

'Hi Ben, how are you feeling now? Listen, don't worry about what's happened; it couldn't be helped. What I need you to do is write a story for your blog as quickly as possible. You'll need to explain that you went against the advice to wear a stinger suit and that's how the situation occurred.'

'No problem, Em.'

Every newspaper in Australia featured the story the next day. It was that quiet period between Christmas and New Year when nothing much happens, so it was bound to get some column inches. The BBC News website even displayed it as their 'Most Read' article. It turned out to be the biggest spike we'd had in publicity since the start of the campaign.

Anthony Hayes called me, with his usual chuckle. 'Ben, you're the king of publicity. Just when the interest is dropping off, you manage to get it right back up there again!'

The sympathetic messages continued. David Alrich, the Executive Producer from Beyond Productions, called me to complain, 'We follow you around for six bloody months with a camera glued to you and you get stung a week after we leave. Thanks a bloody lot!'

Mum and Dad had flown out from Hamilton Island only 24 hours before. They knew nothing of it until they got back home three days later and a Google Alert for Ben Southall popped up in their email, reading:

Best Job in the World Winner Killed by Deadly Jellyfish

It didn't take long for them to realise this was just another example of the sort of wayward journalism we'd become used to. It did make me laugh when they called me up just to check!

The best article to come out of the whole episode had to be the one in *The Daily Mash*, an online British satire site offering funny stories on news and current affairs. My 'sting incident' gave them fodder for a very witty piece. I laughed out loud as Dad read it to me for the first time:

The tiny jellyfish who stung Ben Southall last night insisted he was only doing what anyone would have done in the same circumstances.

Julian Cook, an Irukandji jellyfish from the Great Barrier Reef, encountered the professional git when the two were swimming off the coast of the paradise island Southall is paid £84,000 to prance around on thinking he's better than you.

Cook said: 'I was floating over to another bit of the sea—just for a change of scenery—when I saw this man swimming towards me.

'I thought he looked vaguely familiar and sure enough, when he was about six feet away I realised it was that bastard Ben Southall. So I stung him. It was great.

'Generally speaking, I'm not one of those jellyfish that gets involved in anything too confrontational, but when you see Ben Southall's insufferable grin floating towards you, your instincts just kick in.'

He added: 'Me? Don't worry, I'll be fine. I'm not a bee.'

Mr Southall said: 'It didn't hurt at the time, though I'm pretty sure I heard this tiny, high-pitched voice calling me a "smug prick".'

He added: 'Actually, come to think of it, ever since I arrived here I've noticed that quite a lot of the flora and fauna have been trying to kill me.

'I woke up one night to find a frog with its little hands around my throat and I can't walk under a palm tree without being bombarded with large, heavy coconuts.

'I've checked and there were no animals in the trees and it wasn't windy, so I can only assume that palm trees are in fact prone to bouts of small-minded, violent jealousy.'

Roy Hobbs, a 62ft palm tree, added: 'Yes I've lived here all my life but no-one's offered me eighty-four grand to ride a fucking jet ski. He's an arse.'

A hilarious end to what could have been a disastrous incident. Next time I'll put on the stinger suit and look like a drowned condom instead.

CHAPTER 5

What to do for an encore

Two months before the end of the job, my mind turned to what would come next. Living in the public eye for so long would naturally create a vacuum after the project had finished. It was up to me to make sure I lined up my next project and hit the ground running so I could make the most of what I'd created.

Time to capitalise

I received all manner of interesting job offers during those six months, ranging from working with the Brazilian Tourism Board to presenting television shows to representing product sponsors. I could have sold myself short and followed the biggest dollar sign that was dangled in front of me, but money has never been my driving force. Adventure, travel and loyalty have.

I'd engaged in some pretty epic underwater experiences and seen first-hand the beauty and diversity of the largest coral reef system on the planet. The press reports I read from some of the biggest publications in the world claimed the Reef was dead or dying, and that coral bleaching and the crown-of-thorns starfish had killed most of it.

This simply wasn't true. Yes, areas of the Reef had been affected, mainly around the pontoon sites where large numbers of visitors were in the water at the same time. But of the 62 different dive sites I'd visited, which make up less than 0.1 per cent of the total area the Great Barrier Reef, I'd seen little or no impact.

My blog told the story of the Reef to a global audience of more than 8 million people, but I was tasked with focusing on its resorts and islands, not the underwater coral gardens I'd seen so much of.

I wanted to tell *that* story, take a snapshot of the Great Barrier Reef and showcase it to that audience so they could *see*. I wasn't interested in sharing the over-saturated marketing images or the sensationalised bleached coral of a decade ago. I wanted to make people feel as though they were putting their head underwater for a peek.

I wanted to combine an expedition-style adventure and a voyage of discovery, and play it out online. So came the idea for my next project: a 1200 km, four-month journey by kayak along the Reef. I'd follow in the wake of Captain James Cook, the original British adventurer, and take a support boat along from which we would film and photograph the marine life we found. I'd deliver this information to my audience through my blog and Tourism Queensland's website.

When I suggested the idea to Tourism Queensland's CEO, Anthony Hayes, his reply was, 'Sure! We'll give you a kayak and a tin of beans, push you off at the town of 1770 and see you again in Cooktown. It's brilliant!'

Well, it would take a little more than that to make it a success; but at least I knew I had the support I needed. Now I just had to make it happen.

Meanwhile the team at Tourism Queensland had decided that it made good sense to keep me on as their Global Ambassador. Unbeknown to me, they'd spoken to their international offices to see what media interest there'd be if I were to visit on a whirlwind tour of the breakfast television shows in each of their key markets.

Executive Marketing Director Steve McRoberts gave me a call to pitch the idea. 'Ben, we'd like to offer you an extension of your contract for another 18 months. For the first six, we want to send you around the world and get you on the television shows of our key markets, and then you can work on making this crazy expedition happen. How does that sound?'

It doesn't take a genius to predict my response. I accepted the offer with enthusiasm. It would give me a great opportunity to stay in Australia, a country I'd grown to love, help the tourism industry in Queensland further promote the Great Barrier Reef *and* send me on another expedition — one that I wouldn't have to save for three years to make happen.

My final week on Hamilton Island was filled with goodbyes. I'd made some great friends during my time there, and my farewell party at the Hamilton Island Yacht Club was a great send-off. I may even

have shed a tear or two. But this wasn't the end of it all, as some journalists suggested; rather, it was the start of the next chapter of my life. When they asked me, 'What do you do *after* you've had the best job in the world?' my reply would be, 'Get out there and lead the *best life in the world*'. It's a motto I continue to embrace today.

The Best Job campaign had been a resounding success that brought in over $430 million worth of publicity for Tourism Queensland—not bad for an investment of $4 million! It had given the islands a global identity and helped launch social media into the spotlight as a vital marketing tool. The Best Job in the World concept became a brand in itself, winding its way into the vernacular around water coolers in New York, cafés in London and offices in Tokyo. Many copycats tried to follow our lead, offering way more prize money—yet they all bombed. No one seemed able to replicate what we'd managed to do.

In 2014 Tourism Australia reignited the brand with its own 'Best Jobs in the World', bringing together six states by offering jobs that ranged from Taste Master to Chief Funster to Outback Adventurer. While it was successful in its own right, the campaign never really hit the heady international heights of the original campaign. The first version of a unique idea like this is always the best.

A quick tour of the planet

Bre and I left our tropical island behind and moved 1200 kilometres south to the state capital, Brisbane. Tourism Queensland's office is in the heart of the city and I had to move where the work was.

The view from the balcony wasn't nearly as good as that from the Blue Pearl, with no whales swimming by, no turtles popping up to say hello, no tropical water lapping at our doorstep. Moving into my first city apartment was a big reality check. I had two weeks to settle into Brisbane life before starting my duties as an Ambassador. The title sounded very grand, but I realised early on the role came with a lot of responsibility. I'd be representing the 150 000 businesses around the state that relied on tourism for their income. Ultimately, I'd be their global voice pushing the brand.

Bre and I were getting on well again. The change of scene brought us closer together as we explored our new home. My new role meant I'd be out of the country for a couple of weeks at a time, so Bre decided

to get a part-time job at Riverlife Adventure Centre, for the income and new friends it would bring.

My first overseas trip was to New Zealand to visit Clarke Gayford, the Kiwi finalist I'd got on so well with. It was great to see him again. For two days I toured Auckland's radio stations and television studios, appearing live on air to talk about the experience while gorgeous images of Queensland were flashed up on screen. Clarke is a DJ at one of the city's radio stations so I dropped by to appear on his show and realised how good a presenter he was compared to me. I still had a lot to learn if I wanted to cut it in the media world.

When I got back to Brisbane the next few trips had already been planned and my itinerary looked incredible: Hong Kong, China, Taiwan and Japan, the last of which Bre could join me on, much to her delight.

These trips coincided with the airing of my National Geographic series, so publicity and promotion were even more the name of the game. It was a delight to travel to Hong Kong—somewhere I hadn't visited since I was a year old, so of course I didn't remember it at all—and to witness the diversity and culture of a city sandwiched between the hangover of the British Empire and the Chinese revolution.

There was a huge amount of interest in the Best Job throughout Asia, and all the media there wanted interviews and photos. The days went by in a blur as I was whisked from one studio to the next, reliving the experiences of the past year over and over again. The most memorable experience was appearing on stage with Angelababy, one of Hong Kong's hottest supermodels. I looked like a pasty Englishman standing next to her.

During my visit to China I toured the cities of Shanghai, Beijing, Shenzhen and Guangzhou, marvelling at the Olympic Village, the Great Wall and the Forbidden Palace in my downtime from the media commitments. It was another whistle-stop tour of a country I swore to return to. The biggest acknowledgement of the Best Job's success in China came when I was asked to open a new travel agency that specialised in Queensland. I asked why there was a long line of people outside the store and was told, 'They're all here to get an autograph from *you*, Ben!' My embarrassment was taken up another notch when I looked up at the shop-front decorated with huge Best Job logos and my ugly mug blown up to fill the entire window.

My television appearances in Taiwan were great fun. It would have been even better had I understood a word of what was going on. It was only when I was on stage to sample the 'local delicacies' that I realised they may have been mocking me, just a little, feeding me bubble tea, fried insects and stinky tofu (which has to be smelt to be believed!) then zooming in on my reaction. Unfortunately for them my palate had been tempered in Africa, so I was ready for the bizarre textures and flavours.

Bre had always wanted to travel to Japan, so was beside herself with excitement when we arrived in Tokyo. Our host for the two-week trip was Anthony Willoughby, a friend whom I'd met in the UK after Afritrex. He kindly organised the towing of my Land Rover from a muddy hole when I'd tried to venture down a lane too far. At the time he'd spoken of serendipity and the chance meetings in life. My trip to Japan a year later was a perfect example.

I was speaking at locations such as the National Press Club of Japan and the boardrooms of major international corporations, and I was rather enjoying it. My trip to Dubai gave me the biggest speaking opportunity of my life — the opening keynote speech to an audience of 2000 people at the Emirates airline's brochure launch. I stood at the lectern and looked out at a huge room full of people who were intrigued by my stories of adventure and travel around the planet. I knew by the rapturous applause at the end of my presentation that I must have done something right.

Enjoy public speaking

I've always been fearful of failure, especially in front of lots of people. Who isn't? But if you have enough information and believe in the story you're telling it doesn't matter if you're talking to a group of friends or a hall full of people.

- Talking to a room full of people is the same as talking to someone in the street—they just don't often respond!

- Get used to chatting with people at networking events, engage with people at the bus stop and feel comfortable talking to strangers—it does help.

(continued)

Enjoy public speaking *(cont'd)*

- The larger the crowd, the easier it becomes. It's better when you can't see the whites of their eyes bearing down on you.

- Share your stories and inspire. The reason you're up there in the first place is that people see you as a leader.

- Do your research. The more you know about a subject, the easier it is to talk about it.

- Use images and videos so the focus isn't solely on you.

- Don't read from cards. By all means use bullet points as a guide, but the most natural speaking comes from your heart.

- Weave your message through your presentation and keep referring back to it.

- Have a solid conclusion, something people can take away at the end.

- Rehearse aloud in front of a mirror.

- Remember to smile and make eye contact with the people who are lucky enough to be listening to you!

The most stupendous experience of my world tour came when I attended the G'Day USA event in Los Angeles — a chance for the bigwigs of Australia and the USA to meet and pat each other on the back. As if walking down the red carpet of the famous Kodak Theatre on the arm of Queensland Premier Anna Bligh wasn't enough, the rest of the evening was pure Hollywood. The black-tie evening featured stars of stage and screen from both countries, and once it was over, and I'd enjoyed a few glasses of wine for Dutch courage, Wendy Harch, Tourism Queensland's International Executive Director, set me a challenge.

'I doubt you'll have a better opportunity than this to meet some of Hollywood's finest. Get out there and see who you can shake hands with!'

Over the next hour I casually introduced myself to Greg Norman, John Travolta, Holly Valance, Keith Urban, Nicole Kidman, Toni

Collette and Cameron Diaz — and with the exception of John Travolta they had all heard of the Best Job campaign. I went to bed that night blown away by the new experiences the job continued to bring.

Back in Brisbane I started to formulate a plan for my expedition. For the first time in my life I was enjoying the experience of working in a corporate environment, although my job was very different from those of most of the people in the office. My previous expeditions had involved overland travel, mountains and marathons. Now I was taking on an entirely new discipline, one I'd really enjoyed a few months before on Hinchinbrook Island — kayaking. The excitement of having a new project to sink my teeth into meant I was the first into the office every day and the last to leave.

Working out logistics, sponsors and the long list of equipment required for such an adventure took over my life. At the end of each day I'd head home and spend the night with Bre, who had embraced the Brisbane lifestyle and was enjoying her new job as an Activity Leader. I was happy she'd also finally found friends to spend quality time with after being transient for the best part of the last five years. But with work trips taking me away around Queensland for extended periods of time, our relationship was more and more distant. Neither my heart nor my head was committed to a future together so I made the decision to finish the relationship.

Bre and I parted ways a few days later, saying goodbye at the airport for the last time. We'd shared some incredible moments together, but now it was time for me to get on with the rest of my life. I was a new man, in a new city with a new challenge. I was ready to keep my own company for a while.

A new start

With the world tour over, I started to rebuild my life. I moved into a new house and started looking for a housemate. Living by myself in a designer townhouse in the eclectic inner-city suburb of West End probably wasn't the most intelligent move I've ever made, economically. I needed someone to share the financial burden.

I was chatting with a friend who still lived on Hamilton Island when she mentioned that one of her contacts was heading to the city

after seven years living on the island. Tom was a few years younger than me and liked to party, but she 'guaranteed' he'd make a great housemate.

'Give him my number. He could be just who I need!' I said excitedly. Why not take a chance?

Tom moved in two weeks later. We bonded straight away. We joined the local climbing club to exercise, spent evenings discussing life and love and headed to a local bar at the end of a busy week to wind down. Life finally felt like it was getting back to normal.

One of the many offers that came my way was from Tourism Whitsundays, the regional tourism organisation under which Hamilton Island fell. I'd often worked with them and had built up a great relationship with the team there — they'd referred to me as 'the Golden Boy of the Whitsundays'! Every year in October the group hosts a black-tie awards night to celebrate the hard work the local tourism industry has put in during the previous 12 months. In 2010 they asked me to emcee the event in front of 350 people. I'd never done anything like it before, so I excitedly accepted.

Daydream Island

I arrived on Daydream Island the afternoon of the event and met my co-host, David Whitehill, an experienced television presenter (and favourite with the ladies). We ran through the script for the evening and stood on the stage we'd be using later that night. Once we'd thrown a few jokes and customised our outfits a little (I chose to replace my trousers with board shorts, much more in keeping with my reputation) we relaxed on the beach before heading to our rooms and changing for the event. The theme for the evening was 'Under the Sea'; the huge function room had been decorated with hanging seaweed and fish mobiles. The entrance was a long white tunnel.

The guests started to arrive at 6 pm. There were lots of familiar faces — people I'd worked with during my time in the Whitsundays. I stood with my friend James exchanging pleasantries as the room started to fill. The atmosphere was building, as were my butterflies. It was almost time. Then the most beautiful girl I'd ever seen emerged from the tunnel. I couldn't take my eyes off her. Who was she? Who was the guy she'd just arrived with? Too old to be her boyfriend, surely?

I turned to James and said, 'Whoever that girl is, I need to talk to her. She is absolutely stunning.'

'That she is, Ben. I'll leave the introductions to you,' he replied.

I had a job to do first, though.

The evening went well. The audience laughed in the right places, loving my strip from black tie to beach bum. Throughout the night I scanned the room, knowing the mystery girl was out there somewhere. But I just couldn't spot her, even from up on the podium.

David wrapped up the evening, thanking everyone for coming, and we hit the bar. Suddenly, there she was, standing with the same guy she'd arrived with. How on earth was I going to get my chance to talk to her? *Could* I even talk to her? I was so out of practice I doubted myself. There was only one way I could manage it: a quick double vodka and Red Bull to pluck up the courage and wait for the right moment.

Excellent, I thought, her chaperone is talking to someone else. Now's my chance. I grabbed a glass of red wine from the bar.

'Hello, how are you? I'm Ben,' I semi-slurred. 'Are you having a good night? I have to say, I noticed you as soon as you walked in.'

'I know who you are. I'm Sophee and yes I noticed you too,' was her unexpected reply.

Did she really say that? Good-looking girls usually run a mile or laugh at me; they don't encourage my clumsy advances.

'Tell me, where are you from and who's the guy here with you?' I asked, pushing my luck.

'Oh that's Peter. He's a great friend of mine and one of the award winners tonight. He invited me along to keep him company. I'm actually from Brisbane.'

That was the perfect reply. I don't exactly remember the chain of events from there. My hastily downed drink was starting to take its toll. Without thinking I made my move, leant over towards Sophee and kissed her. As I did, my hand lost its a grip on the glass and it dropped, smashing right next to her foot.

The entire bar turned, and so we shared our first romantic moment with everyone in the room. I remember thinking, at least it was something we'd both remember.

I woke the next morning with a slightly fuzzy head. After showering, shaving and brushing my teeth I threw the last of my clothes into the suitcase and made my way down to breakfast. My eyes

scanned the room for a familiar face. I spotted James and Danielle tucked away in a corner, the effects of a late night just visible behind their welcoming smiles.

'Well good morning, Ben! You seemed to have quite an effect on that girl last night!' Danielle broadcast across the room as I walked towards them.

'Can you believe it? Have you seen her this morning?'

'Er, don't look now, but she's just arrived,' James whispered under his breath.

Ten minutes later I finally plucked up the courage to approach Sophee.

'Good morning! How are you today? No trauma from blood loss last night?' I asked, trying to extract some wit from my fuzzy head. 'How's the foot?'

'Hello Ben, it's fine. You missed me, thank goodness. It was quite an entrance!' she replied wryly, the corners of her mouth turning into a cheeky smile.

Sophee and I happened to be on the same ferry and flight back to Brisbane that day so we sat together talking about life, work and whatever popped into our heads. At the baggage carousel back in Brisbane, I asked if I could see her again. She wrote her number on a piece of paper and said, 'Don't be a stranger'.

We went on our first formal date two days later. Two days after that I cooked her dinner at my house in West End, putting all I had into a classic recipe my best friend Luke had wowed me with in the UK— roast pork belly. I emailed him for the ingredients and method, determined to get everything spot on. He replied almost immediately, ending his message with, 'Now if that doesn't get you laid nothing will'.

There's nothing like a good friend's wisdom.

* * *

I'd posted one blog a week to the islandreefjob.com website since leaving Hamilton Island, continuing to tell stories of the experiences and adventures that could be found around the state. The original Best Job campaign focused on the islands along the coast, but much of the state fell outside this area and the other regions wanted their share of publicity. So Tourism Queensland had started to send me on state-wide missions, spreading the love. This injection of new destinations ensured my writing stayed fresh and engaging and took me to some of the lesser-known destinations: the exciting Mount Isa

Rodeo, the remote desert town of Birdsville and the hidden beauty of the Gold Coast hinterland.

When Tourism Queensland received an offer from China Tourism for me to appear as a judge on their televised version of *Best Job in the World*, it was too good a chance to refuse. With the numbers of Chinese visitors to Queensland growing every year, it was a great opportunity to broadcast images of the Great Barrier Reef to millions more prospective tourists.

The *No.1 Super Mission* television show was held on Hainan Island in the South China Sea, and was one of the most bizarre and fascinating projects I've been involved with. The nationwide competition to find an Ambassador for the island was held over two weeks in front of a television audience of nearly 30 million people.

I arrived at the airport to a pop star's welcome, complete with television cameras and journalists. Later that day at the resort I was introduced to the 12 finalists, all very good-looking girls dressed in bikinis. My role was to judge who best carried out a number of environmental tasks.

The underwater world around Hainan Island leaves much to be desired. Overfishing and pollution have yielded a desolate marine environment with few fish and little to attract divers or snorkellers. But that didn't matter, because we were here to *plant coral*. We were about to try to recreate an ecosystem that takes nature thousands of years to form in clean, pristine tropical waters, and this was to be set in motion by a single dive to a barren, rocky bottom. According to the theory, in around 10 years' time the island would have its very own coral reef for people to visit and snorkel around.

In a torrential rainstorm, brought on by a passing typhoon, each of the finalists had to don scuba gear, descend to the bottom and 'plant' a piece of coral, all in front of the television cameras. My role was to observe and judge how well they coped with the challenge of diving for the first time and using a hammer underwater to literally nail a plastic frame with a tiny piece of live coral attached into a rock.

Later that day, as I summed up for a live television audience how each of the finalists had done, images of the Great Barrier Reef were projected onto a huge screen behind me. If I was one of the millions watching and compared the underwater images from Hainan Island with those from Queensland, I know exactly where I'd be taking my next holiday. Another great win for Tourism Queensland!

Life back in Brisbane was exciting. Sophee and I were seeing each other a few times a week and our relationship was blossoming. Not long after meeting her, the 2011 floods hit the city. My West End townhouse was in the centre of the flood zone and on January 11 we were evacuated along with hundreds of other people. Sophee invited me to come and stay at her place in New Farm; after all, it was only for a few days. By the time I'd moved in that afternoon the flood evacuation zone had extended to her apartment. Two months after we'd met, Sophee and I both moved in with her mum. Things were moving rather fast, but I was absolutely fine with it.

A week later water levels were back to normal. Both our homes had survived but we'd discovered that living together was something we were very comfortable with. Six months later we would put that idea to the test in the tight confines of a 12-metre yacht.

CHAPTER 6

The Best Expedition in the World

In 1770 Lieutenant James Cook sailed the HMB *Endeavour* up the coast of Australia. His initial landfall on the continent was at Botany Bay in New South Wales. He was one of the first Europeans to walk on the Great Southern Land. Cook had sailed from Plymouth across the Atlantic, down the coast of South America and around Cape Horn, before crossing the Pacific Ocean to New Zealand and making his way up the eastern seaboard of Australia.

He came ashore in Queensland, at what is now a town called 1770, in search of fresh water and supplies. From here his voyage continued northward up the coast, hemmed in by the treacherous waters and coral reefs of the Great Barrier Reef.

In the wake of Captain Cook

As an adventurer I've always admired the early explorers, the brave men who were first to cross oceans and climb mountains, who navigated the world using the stars and sun and drew our first maps. Their fearlessness and determination answered our persistent questions about what lay over the horizon.

When I set out to create my 'Best Expedition in the World' I wanted to follow in Cook's wake. His story inspired me, and as a fellow Brit I figured the historical link would interest the media. I would leave the town of 1770 as the Captain Cook Festival was in full swing, celebrating the week he anchored in Bustard Bay and came ashore some 241 years before. It would also coincide with a visit from the replica of HMB *Endeavour*, on its own circumnavigation of Australia.

Since I'd never before kayaked more than 20 kilometres, I knew it wouldn't be easy to get the insurance and legal team at Tourism

Queensland to sign off on my challenge of taking on more than 1600 kilometres of open ocean. The expedition was in their name, so it had to be both safe and a guaranteed success. No government would court a PR disaster by backing an enterprise that was likely to come unstuck halfway through.

My goal for the project was twofold: to kayak the length of the Great Barrier Reef, and while doing so to take a snapshot of life above and below the water to help the tourism industry combat some of the negative press the Reef had suffered.

I knew from the start that a solo adventure wasn't feasible. If I was going to make this an endeavour that Tourism Queensland thought worth supporting, as in the Best Job, I'd need to provide a constant flow of digital content for their website, photo galleries and YouTube channel and to my own blog. Equipping a small kayak with a laptop, modem and waterproof camera wouldn't provide me with a reliable enough office to deliver the goods on a regular basis. However much I might want to set off into the sunset on my own, I knew that this project required a team of helpers *and* a support boat.

Over six months and with the help of my meticulous project manager, Kayleen Allen, the Best Expedition quickly took shape. We planned our own 'Voyage of Discovery' that would retrace the route of HMB *Endeavour* from the town of 1770, 1600 kilometres north to Cooktown. The expedition would leave Bustard Bay and stop at reefs and islands to photograph, film and write about the marine life we found and the experiences we had.

We had the plan. Now we had to execute it, which required us to reach out to bring potential commercial partners on board. Our first and most important request was for a support vessel. I needed somewhere to rest and recuperate at the end of each day on the water and somewhere to work, and we needed somewhere for the journalists and film crews we'd bring along to bunk down.

Sunsail, a yacht charter company based on Hamilton Island, offered us a 12-metre catamaran we could use. The boat was due for imminent retirement so there would be no charge. We'd just have to cover the costs of maintenance and $58 a day for the insurance. They saw the loan as great publicity for Sunsail and also as a thank you for the promotional work I'd done while living on the island.

I tried out several styles of kayak in the months leading up to the adventure. This project was all about getting people outdoors to try something new, and my boat needed to reflect that. My Hobie Adventure Island kayak cum trimaran was perfect. At five metres, it was big enough to take on the ocean swells, but small enough to use as a snorkel platform in the lee of islands when conditions permitted. Having two outriggers and trampoline platforms meant lots of storage space and made it ridiculously stable, plus it had room for two people.

After visiting Mal Gray and his team at Sunstate Hobie for a test run, I was hooked. He kindly offered to sponsor the vessel and provide essential support both during the build-up and throughout the expedition. His first email, though, suggested that he didn't have 100 per cent confidence in me:

> You will need to put a firm proposal to me. We as a responsible company need to be sure that we are not just helping some mad Pom to join the long list of recipients for the Darwin Awards!

Top tips for gaining sponsorship

Executing a successful expedition takes a lot more than having an idea and rolling with it. Finding both product and financial sponsors to back you can turn your money-draining idea into a profitable experience, *if* you go about it the right way.

- **Plan your budget before you go into that all-important first meeting.** Go in and demonstrate exactly why you need the $$$s. Show competence and professionalism. Don't overestimate wildly but add at least 10 per cent to your final figure—things *never* go according to plan.

- **Define exactly why your expedition is different.** Have a unique selling point, something that sets you apart from the 597 other people trying to climb the tallest mountain in the world this year.

- **What are you offering in return?** This is probably the single most important point from a potential sponsor's perspective and is worth its own breakdown.

(continued)

Top tips for gaining sponsorship *(cont'd)*

- **Don't aim for the global giants just because they have money.** Think of the companies whose brand you live with every day so you're a natural fit for them, and look locally first. If you can promote your newly formed relationship in the local media it's good exposure and a win for both of you.

- **Visit relevant trade shows, conferences and exhibitions to press the flesh with potential product sponsors.** Networking and the power of personal interaction can't be overestimated, though it's almost a lost art these days!

- **Build your brand and create a style sheet you can use across all your marketing.** If your website, business cards and expedition clothing show off your expedition logo it shows you're deadly serious about delivering on the project. Everyone wants a successful outcome.

- **Send a hard copy of your request.** Receiving a letter is 10 times more satisfying than receiving an email, which more often than not will be swept into the trash along with other electronic pests. It may take more time, but delivering it by post on branded paper sets you apart from the rest.

- **Be persistent.** If at first you don't hear back, follow up your communication with a phone call a week later—just to check it arrived safely, of course.

- **Find a contact name within the company at all costs.** Don't just address your request to the 'Sponsorship' or 'Marketing Manager'. A quick phone call to the reception desk will usually bear fruit, if you're upbeat and friendly—which leads me to my last point:

- **Be positive and happy!** You'll get knocked back time and time again, but keeping the same enthusiastic tone of voice for the tenth phone call as with the first is vitally important.

Organising my crew was the next job. I needed a group of people who'd bring a range of skills to the project. On top of the everyday

chores essential to life on board a small yacht, there'd be the media work of documenting every aspect of the adventure ready to share with our online audience.

To ensure that everything ran like clockwork, each crew member would have a job title, along with specific roles and responsibilities. Living on a 12-metre boat would mean mucking in when required and being able to live, work and sleep at close quarters. And they'd need to be people I could trust.

By March 2011 Sophee and I had been together for five months. I didn't want to leave her behind. Seeing her only a couple of times over the four months would be tough for both of us, as we'd grown close in such a short period of time. With two months to go I had a brainwave — surely her skills as a copywriter and publisher would come in handy on the expedition?

I wasn't sure of either her reaction or Tourism Queensland's when I floated the idea of her joining the expedition, but I had to give it a go. Throughout the expedition I'd be working closely with the PR team in the Brisbane office anyway, so having someone on board who could handle the interviews, help with filming and write some great articles made perfect sense. Sophee and TQ both agreed with the idea. I had my first crew member signed up and my girlfriend on board.

One of my best friends, Jay, had qualified as a sailing instructor a few years before in the south-west of England. He and his girlfriend Danni had been considering a trip to Australia around the same time I planned to set off on my adventure, so I pitched the idea to him. They were both really excited about the opportunity to sail along the Reef and work at the same time.

It would have been perfect to have Jay as the skipper, but his UK certification wasn't recognised in Australia. He'd be able to come in as first mate but not take sole charge of the boat. Danni's MSc in Conservation and Biodiversity, together with her experience in marine ecology, added another dimension to the crew's skillset.

I needed an Australian skipper, someone with the skills, qualifications and good judgement to take on such a challenge. My connections in the sailing industry came up with a few possible candidates and Kayleen and I set about contacting them.

Paul, a Master Class 5–rated skipper based in Coffs Harbour on the New South Wales coast, turned out to be our best bet. We flew down to meet him, and Paul and I got on straight away. His easygoing character was backed up by the experience we needed. We pored over marine charts and the expedition itinerary. After much head-scratching, Paul turned to me and said, 'Some of the sections are pretty tightly packed, and we've got some serious distances to cover, but I think it's possible. It's not me I'm worried about; I'll get the boat there. *You're* the one who has to kayak that distance!'

So I had the four crew I needed to safely carry out the expedition. They hadn't all met each other yet, but I've always considered myself a pretty good judge of character and I didn't foresee any problems. Back in the office, Kayleen worked around the clock to sign up commercial partners from around Australia. Some would bring finance to the project while others would supply vital products in exchange for publicity associated with the expedition.

Since the early days of planning I knew Mum and Dad would be flying out from the UK to join me. It was a great chance for them to explore the rest of Queensland following their brief visit during my Best Job stint. The plan was for them to drive along the coast and meet up with us every couple of weeks when we made landfall.

I decided to put them to work. My kayak adventure would only appeal to a select audience of adventurous, outdoor types, whereas their road trip would open up an entirely new angle of publicity — for the 'Grey Nomad' road-tripper. We approached Apollo Motorhomes as a potential sponsor and they jumped at the chance, providing Mum and Dad with their own brand-new vehicle. All they had to do was learn how to blog and upload photos of their adventure to my website. The Best Expedition in the World was now targeting two completely different markets, making the team at Tourism Queensland very happy.

Two weeks before the expedition start Paul, Jay, Danni and I prepared our catamaran *Sunshine* for the adventure ahead as she sat in the marina at Airlie Beach. We installed a state-of-the-art 3G internet communication system that would give us perfect reception up to 100 kilometres offshore, and loaded, checked and secured the computers, cameras and dive equipment.

With a week to go I flew back to Brisbane for the press launch, while the crew sailed south, ready to meet Sophee and me at the

wharf at 1770. Preparations had been rushed in the final 24 hours before departure and with heavy weather expected for their trip south, I could already sense tension between Jay and Paul.

At 2 am on May 22, 2011, I made my final preparations for the 90 km open-ocean trip due east to Lady Elliot Island under cover of darkness. My camera batteries were fully charged, the course plotted and Davo, an Aussie male hand-puppet, tied firmly to my bow as a good luck mascot.

Joining me for the first leg in an identical Hobie were Mal Gray (Sunstate Hobie) and Peter Gash, who leased the island from the Commonwealth Government. Pete and I had become great friends during the Best Job, and after I'd mentioned the expedition to him three months earlier he couldn't resist the idea of purchasing his own kayak for the trip and joining me. Sophee, who was keen to get involved and show her mettle too, joined me in the kayak for our own 'voyage of discovery'.

Pushing off from the slipway I turned and waved goodbye to Mum and Dad. They'd fly out to Heron Island to join us in a week's time. Jay and Danni stood on the bow of *Sunshine*, torches in hand, lighting the way for Paul as he followed the mast lights on our kayaks. There was little moonlight and the night was dark, almost foreboding. The bright light from my chart plotter blinded me when I looked up from it, so I turned it down, conscious I'd need all my night vision to cross the sand bar a few hundred metres on. The lateral lights ahead marked the safe passage to follow. With two boats following close behind it was up to me to navigate us safely out. We'd left the slipway under pedal-power, with our sail furled. With little wind and the surf still to cross, maintaining forward speed was important.

My eyes were slowly adjusting to the ink-black night. The sound of the waves grew louder. After each crash I could just make out the line of white water created.

'Pedal as fast as you can, Soph; we need to keep our speed up. Are they close behind?' I asked, concentrating on keeping the kayak pointing into the waves, ready for the first impact.

'Yup, they're right behind. This is amazing, Ben,' she replied, full of excitement. 'And a little nerve-racking at the same time!'

I could feel the kayak lift as the first line of white water passed under us. The breaking waves were off to our right, leaving us to cut

through rolling white water to our exit from the river. I kept pedalling hard, conscious we weren't out in open ocean yet. A quick glance over my shoulder confirmed that Mal and Pete were on our tail, pedalling like fury but whooping with excitement.

Five more minutes and we were clear, the sound of the surf far behind us. All I could hear now was the distant sound of *Sunshine's* diesel engines as she followed behind.

I could feel the land breeze on the back of my head, so unfurled the sail and it flapped into life. Mal and Pete were one step ahead, and a few seconds later had pulled alongside, their boat already speeding along.

'Hobie kayak, Hobie kayak, Hobie kayak. This is yacht *Sunshine, Sunshine, Sunshine* — come in, over,' the radio beside me burst into life.

'Go ahead *Sunshine*, this is Hobie kayak,' I replied, after fumbling for the transmit button.

'Well done on getting us out of there, Ben. How does it feel to be underway?' Paul asked.

'Absolutely bloody awesome!' I yelled.

For the next few hours the wind continued to push us along at a good speed. We watched the sun rise out of the ocean, slowly warming us from the chill of the night. Dolphins joined us for a while, dancing and leaping in our bow wave. It felt great to be alive.

Sophee was enjoying herself, taking plenty of film for the blog at the end of the day. The other kayak was racing along. Mal's experience as a dinghy sailor was coming into its own as they surfed down the waves. *Sunshine* followed closely behind, her engines now silent and sail up as the wind drove her forwards.

As the day progressed we devoured our packed lunches. The cold water and hard pedalling drained more energy than we'd expected. The chart plotter indicated there were 20 kilometres to go. At this speed we'd make it easily before sundown.

'There it is, can you see it?' Sophee cried out. 'Look there, that's the lighthouse on the island.'

My eyes scanned the horizon until I caught the tiny fleck of white in the distance. 'Oh yes, amazing... Not far to go now, baby!'

And then the wind died. Just like that it went from powering us along at 15 km/h to ... absolutely nothing. Ten minutes later it had picked up again, but this time blowing directly into our faces.

I shouted, 'I'm afraid we'll have to furl up the sail and pedal, Soph.'

That little lighthouse remained little for far too long. The change of conditions dropped our forward speed to less than 8 km/h and suddenly the friendly wind that had pushed us towards our destination seemed to be chasing us away. *Sunshine* drew alongside, back on diesel power once more.

'Keep going, guys; it's not that far,' Jay shouted down from the deck. 'Are you okay to stay out there?'

'We've come this far! We're not going to quit now!' I replied.

There was an hour of sunlight left as we pedalled the kayaks over the last few hundred metres towards the coral beach in front of the lighthouse. We'd timed our journey to perfection. Four weary adventurers splashed through the shallow water and dragged the two kayaks up onto the foreshore. The crew on board *Sunshine* found one of the island's moorings and made safe for the night.

After 14 hours of sailing, pedalling and very little paddling we'd just completed the first known crossing by kayak from the town of 1770 to Lady Elliot Island. After much hugging and celebration, the staff from Pete's resort handed out well-deserved beers and food. We had four days to recover.

The Great Barrier Reef runs parallel to the Queensland coast, 100 kilometres offshore at its southernmost tip, right on the edge of the continental shelf. The further north you travel, the closer it approaches the mainland until, just north of Cairns, the edge of the Reef and the mainland collide. Ninety kilometres is a big stretch of water, whatever type of transport you use. Day one was the longest leg of the entire four-month adventure and it was good to have it in the bag!

Aground!

Knock, knock, knock!

'Ben, get up!' a frantic voice whispers loudly through the open door.

'Uuhh … hang on … who is it? What's up?' I reply groggily. The first light of day is just starting to relieve the darkness outside.

'You'd better come quickly. It's your boat — it's on the rocks!'

'What do you mean?' I throw on a t-shirt, grab my shoes and fall out the door.

It's Bow, the island's caretaker, and the look of concern on his face confirms this isn't a prank.

'Where is it?' I ask.

'Jump on and I'll take you there now.'

'Let me grab Jay and Paul,' I say, dashing to the room next to mine.

I glance across at three anxious faces as we race across the grass runway on the buggy towards the north-west side of the island. What could have happened? When we last saw her the catamaran was tied onto a secure mooring. How could this happen on the first day of the expedition?

We follow Bow as he runs through the arch of trees onto the beach. Sure enough, there is *Sunshine*, 100 metres away, flat on the reef, rocking as the waves break over her stern, the mooring lines still attached to the deck cleats. Paul is already splashing through the shallow water towards her. Jay and I are close behind. We know we have to get her off before she is smashed to pieces on the unforgiving coral bottom.

My foot drops from under me. I've stumbled into a hole in the coral floor, my shin scraping up the jagged side, tearing through my soft skin. I barely notice, all my concentration on reaching the boat. With an almighty heave I pull myself onto the deck.

Paul is already alongside, frantically surveying the situation. 'I don't understand. What the hell happened?!' he yells at me.

'It really doesn't matter now. We have to get her off here fast,' I reply, conscious we're on a rising tide. 'Paul, get the engines started.'

'We need to get moving. Ben,' Jay says, 'help me tie an anchor to the stern and we'll send it to the bottom to stop her being pushed further onto the reef.' He looks over the side. 'Shit, guys, one of our rudders is gone. It must have been knocked off already.'

Paul runs to the fore locker and grabs the longest ropes he can find to prepare for a tow. The dive team from the island have already got their boats on the water and are angling towards us, their engines loud in the quiet of the morning.

'We need to get a line to them,' Paul says. 'The longer we stay here the further the tide will push us towards the beach.'

By now Jay has hefted the huge second anchor from the aft locker up onto the rear deck, securing the long chain to another line.

'Ben, give us a hand to throw this over the side will you?' We let it slip from our grasp and tumble over the side into the clear, blue water

below. 'Okay, now grab the rope and get it onto one of the winches, then grind like fury,' Jay commands, his calm professionalism coming through.

The dive boat is now only a few metres off our stern. Clinton, the island's divemaster, is at the wheel and calls across to us. 'Throw me a line and I'll take it out to the mooring. You can wind onto it!' His voice is loud above the engine's murmur.

Paul grabs the monkey fist knot he's already tied, swings it a few times and launches it towards the boat, landing it on the canopy above Clinton's head.

'Okay, I've got it. Now give me all the line you've got,' he calls, glancing at the great swirl of rope that lies on the deck.

Sunshine's engines kick into life, Jay is onto it, slowly building the revs before slipping her into reverse gear. The prop breaks the surface, whirring loudly with nothing to bite on, her stern lifted momentarily by a passing wave.

Fifty metres off our stern, Clinton has secured the rope to the mooring.

'You feed the rope out, Ben. I'll winch. When I get tired we'll swap, okay?' Paul says, as he begins to grind the stainless steel winch like a madman, taking up more of the slack with each turn, until the rope is taut.

I take over, putting everything I've got into cranking the handle until I too am beaten. 'Stand back, guys. If this breaks it'll slice you in half!' Paul yells out, knowing all the weight of the boat is now resting on a single winch and rope.

Below my feet I can feel the hull grinding against the bottom. Each time a wave lifts us clear its passing thumps us back down again, threatening to crush the fibreglass hull. I jump into the galley and lift the floorboards to inspect the damage. Seawater is seeping in from somewhere, but at this stage the hull seems secure.

Up on deck the situation remains fraught. I hear Paul cry out and as I look towards him see a spray of blood fly from his hand, peppering the white deck.

'Paul!'

'It's okay, just the shock. Caught my wedding ring on the rope, forced it up into knuckle and sheared off the skin. Give me that rag … Anyway, have you seen your leg?'

Blood is pouring down my leg.

'Oh well, at least we match now,' I say, realising it is the first time we've smiled.

Jay's efforts are starting to pay off, the tension on the winch enough to pull *Sunshine*'s stern into the oncoming waves. Finally we aren't being driven back further onto the reef. Jay's professionalism and skills are just what are needed in a crisis like this.

Slowly but surely the boat is coming unstuck. Then the excruciating sound of the hull scraping on the coral as she breaks free. The propeller is working hard now, cutting into the water and inching the stricken vessel off the reef.

Jay pulls the rope clear of the winch and takes up the tension by hand as the engine takes over.

'Clinton, can you take this line — we're done with it,' Paul says over the radio.

With her engines working overtime, *Sunshine* backs away from the reef wall and out into open water. We've done it. I look across to Jay and Paul, their faces flushed with effort. For now, we've narrowly avoided the yacht becoming another dive site. But how had it happened?

On later inspection we discovered that the shackle securing the mooring to the concrete block on the ocean floor had somehow sheared. The swell had picked up overnight and was much larger than forecast, putting a huge load on this crucial link. In hindsight we knew we should have moved *Sunshine* to the lee side of the island out of force of the wind.

* * *

My head was teeming with thoughts. I needed to take stock and work out how to get things back on track. That was all that mattered. I was spearheading a government-funded expedition that had hit disaster on the second day, and I knew questions would be asked, quickly.

A quick assessment of the boat's condition revealed that things weren't as bad as we'd first thought. Yes, we'd managed to lose a rudder, and there were some structural questions about the hull, but she was floating, not leaking fuel and secure — for now. We'd have to monitor her closely over the next few hours to see how much water she was taking on.

My biggest concern was the damage done to the reef. I'd fallen in love with the underwater world, especially here at Lady Elliot Island,

and constantly preached about protecting it for future generations. I hoped we hadn't caused much damage below the water. I seemed to be emulating the voyage of James Cook, who'd also had a close encounter with the reef hereabouts, a little *too* closely!

Once we'd found a more secure mooring, Jay and I took the tender back to the point of impact on the reef flats. Jay pulled his mask on and dropped over the side and swam to where we'd jettisoned the anchor. After a few descents, he was satisfied there was no significant damage. He dived back down and surfaced with the heavy chain in his hand before climbing back on board. After much heaving and grunting we succeeded in hauling the heavy anchor into the tender.

Back on terra firma there was work to do. We'd need to get *Sunshine* back to the nearest mainland slipway to get her out of the water for a complete inspection, and in her current condition she'd require a tow.

Our towboat from Maritime Safety Queensland arrived two days later. It took eight hours to complete the journey from Lady Elliot Island and up the Burnett River to Bundaberg. Sunsail, the company who'd supplied the boat, were straight onto the job, recognising the importance of the expedition and the weight of the government axe that hung over our head. Within a few hours their shipwright Mark had assessed the damage and ordered the replacement parts. He reported that while it was all pretty superficial, a few parts would need more serious repair.

'How long do you think it'll take?' I asked anxiously, conscious that every day out of the water was a day I'd have to make up in the kayak.

'You'll be back out there in a couple of weeks,' he said, smiling. Mark worked around the clock to get *Sunshine* back in the water, going above and beyond what could be expected. Ten days later, as we launched her back into the water, I couldn't help but think how supportive the entire community had been. The Best Expedition, like the Best Job, was all about promoting the wonders of Queensland and the Great Barrier Reef to help bring tourism dollars into the state. The television and media publicity we had already gained since the launch brought us into the hearts and minds of the public, and they responded by supporting us.

Kayaking the Great Barrier Reef

It felt great to be back on the water, ready to carry out the hard work I'd promised from the start. But the expedition was now two weeks behind and 80 kilometres south of our start point at Agnes Water, so we had some catching up to do. I decided to revise my original plan to kayak slowly through the Bunker Group of reefs, passing Musgrave Island, One Tree Island and Fitzroy Reef before stopping off at Heron Island. We now had to motor-sail as fast as we could to Mackay, the next stop-off with media commitments.

Although we were playing catch-up, there was still time to overnight in some beautiful locations en route. You can't rush a once-in-a-lifetime trip through the waters of the Great Barrier Reef.

On most days Paul and I woke well before dawn. We'd quietly set sail in an effort to get as many nautical miles under the keel as possible, standing together as we watched the first dull colours of day seep into the eastern sky, as the bright stars and moon were replaced by a warm winter sun, with the sound of the water against the hull the perfect musical accompaniment.

After a full day's sailing north we'd drop anchor in some of the most beautiful locations imaginable. I was working my camera overtime to capture and share the experience with our online audience. My aerobic work in the kayak was substituted for technical work in our makeshift office. We stopped off at Great Keppel Island for a night, waking to the serene sound of a fish eagle circling high overhead. Another day north and we anchor in the sheltered waters of what is still one of Sophee's favourite places on the entire Queensland coast — Middle Percy Island.

To the south of the Whitsundays lie the Northumberland Islands, Middle Percy being one of them. Visited only by passing yachts, the island is 140 kilometres from the mainland, and the epitome of a Robinson Crusoe island. Palm trees sprout from icing-sugar beaches, and wooded hilltops descend to the indigo Coral Sea. It is paradise undiscovered. We spent a morning exploring its surroundings and swimming offshore before retiring to the large A-frame set up on the beach adorned with boat signage and maritime memorabilia.

Once we arrived in the waters off Mackay, the reality of the resource-driven Queensland economy hit us. We picked our way carefully through the ship-park of coal tankers anchored off Hay Point, all waiting to load up with dirty coal for export around the

world. It's said you can tell the state of the global economy by the number of vessels waiting here.

By the time we arrived in Mackay, we'd travelled more than 650 kilometres. Unfortunately, all but 90 had been on board *Sunshine*.

With my media commitments out of the way, we departed from Mackay a few days later. We were refuelled, restocked and refreshed and the crew were in good spirits, the pressure of the last few weeks having finally subsided. And I finally got a chance to take to the water in my kayak again for the 40 km crossing to Keswick Island. The light tailwind propelled us along. Sophee sat up front pedalling her heart out, and we made it into the sheltered waters between Keswick and the neighbouring St Bees Island in a little over four hours.

The next day the wind was up, chopping up the smooth surface of the ocean. It was my first chance to unfurl the sail and try my hand as a sailor. According to my chart plotter, my destination for the day, Brampton Island, was 30 kilometres north.

Whack! The sail snapped taut as I unfurled it, the force of the wind accelerating my Hobie across the surface, spray flying from the bow. *Sunshine* followed me closely. Paul's remit was to keep me in sight at all times. A vessel as small as mine could easily be lost in an ocean this big, and even with two radios on board, I felt comforted having the mother ship watching over me.

My first two hours were full of mistakes as I learned to balance the kayak and figure out the size of the sail it could handle. It was exhilarating and terrifying at the same time to take the kayak to the limit of its capacity in these conditions. Rounding the final headland, I turned south into the sheltered bay off Brampton Island with *Sunshine* following me round. I was soaked to the core, but I'd loved every second of it. Maybe tomorrow I'd go a little faster and push a little farther?

Two days later it was time to set off again. With the wind pushing 20 knots, the ocean looked lumpy and unforgiving, steely grey, with whitecaps whipped across the surface chasing an infinite horizon.

That day's 50 km passage would take me past Goldsmith, Silversmith and Blacksmith Islands, named by early surveyors as they sailed past. Perhaps they hoped to find their fortune hidden on these remote rocky outcrops. The conditions were again challenging. With stronger winds than before, I furled my sail until only a scrap the size

of a handkerchief showed. My GPS had me whipping along at over 15 km/h. I stayed close to the islands, feeling the full force of the ocean as waves crashed against the short cliffs before bouncing back towards me. The water was choppy and confused, unbalancing my kayak as I powered through the eddies and swirling currents.

The tidal flows around the Whitsundays are some of the strongest along the east coast of Australia, a tide range of nearly seven metres causing rips and standing waves under certain conditions of wind and tide. With my confidence growing through the day I started to really push my Hobie again. I got better at fine-tuning its performance and began feeling like a downwind master, clocking 18 km/h!

Shaw Island, our anchorage for the night, loomed large. After a full day on the water, I was looking forward to a rest. My body was cold, fingers wrinkled and I was *hungry*. The muesli bars I had munched on weren't nearly enough to replace my sapped energy. Rounding Burning Point, with the sheltered waters of Shaw Island only a few hundred metres away, I thought, oh what the hell, time for a play! With a little bravado and much stupidity, I decided to completely unfurl the sail for the first time that day. The wind was pushing 20 knots (pretty much the limit for the Hobie), my upwind outrigger was completely out of the water and I was flying along, the GPS reading 22 km/h.

The wind was a lot less predictable in the bay, though, with huge bullets racing across the water towards me. I could see dark patches whipping up the surface towards my little kayak before thumping into the sail and pushing me even faster.

I forced the rudder around for one more downwind run before I headed to the beach to retire for the day. We started to heel over, my leeward outrigger digging deep under the water. I scrambled onto the trampoline in an effort to counterbalance us but it was already too late.

The next part only *seemed* to happen in slow motion. In moments I was dumped unceremoniously into the sea as the kayak capsized, and suddenly the mast and sail were pointing straight down to the sea floor. I could hear shouting in the distance and then *Sunshine* and my support crew were there to offer me their own special take on 'support': laughing and cheering at my latest underwater adventure. I felt stupid and great at the same time — happy I'd managed to keep everything in one piece but annoyed that I'd pushed the Hobie too far.

Then Jay's words echoed in my ears: 'If you don't go, you'll never know.' I'd chalk it up to experience. And since my GoPro cameras had been rolling at the time, at least I had it on camera, ready to upload to the website later!

Life on the ocean wave

I was usually first up, poking my head out of the deck hatch to survey the day and conditions I'd be facing before climbing out and diving into the ocean to wake my body up in the most dramatic way I know. I love the way diving into cold water shocks the body into life.

Paul usually appeared next to prepare for the day ahead. He would lay out his charts on the table to search for suitably sheltered spots for lunch and our evening anchorage. Jay, Danni and Sophee would all drift from their cabins once we were under way and the throb of the engines became too much under their heads. There's no big rush for them, since it was only me who needed to get moving, readying for another day in the kayak. Jay worked hard throughout the day maintaining *Sunshine* in top condition, cleaning and repairing things as the need arose. There's always work to be done on a boat.

Danni had the most important job on the boat as the chef, pandering to everyone's personal tastes as often as possible. Both she and Jay prefer a vegetarian-based diet, while Paul is an Aussie guy who loves his meat. I needed lots of carbs to replace the energy I was losing during my long days, and Sophee will eat anything that's put in front of her. As our marine biologist, Danni also had the task of data logging any interactions we had above and below the water, recording sightings for the GBRMPA (Great Barrier Reef Marine Park Authority) 'Eye on the Reef' network. We were at the start of the humpback whale migration up the east coast of Australia, and there were turtles everywhere. When we snorkelled, our dive slates soon filled with the wonderful creatures and beasties we encountered.

Sophee was responsible for our media commitments and the website. During my time out on the water, she jumped between filming me in the kayak from afar, writing blogs, uploading photos and editing the video we'd shot. Keeping the website full of up-to-date, fun, interesting content was one of the most important parts of the expedition.

When I met up with *Sunshine* at the end of each day I would secure my Hobie on the nearest beach and return to wash down my gear, warm up and recharge. When it was windy, I spent the entire day concentrating on my heading, following the course on my chart plotter and staying out of the spray. On calm, sunny days I had much more time to look around and take it all in.

Kayaking and sailing up the Reef is another one of those once-in-a-lifetime experiences I wanted to share with the world. Fortunately, the technology on board allowed me to do just that.

As *Sunshine* cruised slowly alongside me, the onboard wifi network allowed me to connect my iPhone (in its waterproof casing) and upload my current position, photos and video while out on the water. The map on my Best Expedition in the World website automatically displayed each of these updates, giving anyone watching a live snapshot of life on the expedition.

We arrived at Hamilton Island, in the heart of the Whitsundays, a few days later. Our plan was to stop there for a couple of weeks to work with the local tourism industry and take some of the journalists we'd invited along for short kayak trips. Using *Sunshine* as a base we took them out on day trips around the islands, so they could see what life was like out on the water.

Everything went well, but tensions had built among the crew by the time we were ready to set off again on our journey north. Jay and Danni had taken to retreating into their cabin every night after dinner, opting out of the evening's discussions or entertainment. Paul and Jay didn't seem happy with each other, with the smallest issues triggering major arguments. Jay had his way of doing things and Paul had his. Maybe having two qualified skippers on the boat who both wanted to make the decisions hadn't been such a good idea? I felt it was time to work it out, so I took each of them aside to allow them to air their frustrations.

Living in the close confines of a 12-metre boat with four other people exaggerates any interpersonal problems a thousand times; you can't walk away from it, and your only personal space is your tiny cabin. Jay had only recently qualified as a skipper and he'd learned everything by the book. This made him the perfect teacher, and rigorously precise and efficient with everything he did. He also had a pretty short fuse. Paul had spent most of his life sailing all along the east coast of Australia. He too knew his stuff,

but he approached his duties in a much more relaxed way — *too relaxed*, in Jay's eyes.

As expedition manager I felt it was my job to step in. For the success of the venture we needed a cohesive crew who knew their responsibilities, trusted each other and, above all, got on. After talking to them both and listening to their grievances things seemed a little calmer. I only hoped they'd stay that way.

Once we left the smooth waters of the Whitsundays behind, our route took us offshore to the outer edge of the Great Barrier Reef. For the first time since Lady Elliot Island, we were able to turn our focus to filming and photographing the coral reefs and marine life. The expedition wasn't all about kayaking; it was a voyage of discovery designed to share the Reef with people around the world.

We spent two days diving around the Stepping Stones, a row of towering coral bommies, among the reef sharks, turtles and sting rays that live there. Forty kilometres out from the mainland, deep ocean currents bring crystal-clear water to the reefs that make for epic diving conditions.

The next morning I was woken by the sound of rushing air and leapt out on deck. A pair of humpback whales swam alongside *Sunshine*, no more than 20 metres away, their huge backs breaking the surface like glistening islands as they came up for air. Each time they breathed, a plume of spray shot metres into the air, producing fleeting rainbows in the morning sun. I grabbed my camera and called to the others to join me — but by the time I looked back, the whales had dived into the deep ocean. Perhaps moments like this aren't meant to be shared through social media but rather savoured in the mind for solitary pleasure?

The ocean threw many such moments my way on the journey, private moments to remember with awe: the time when flying fish jumped across my kayak, when a dolphin surfaced off the bow so close I thought I'd hit it and when a cleaner wrasse nibbled my fin while I was diving.

We continued to voyage north over the next couple of weeks, with perfect weather making for good progress. A brief stop in Townsville, an overnight on Magnetic Island and then up through the Palm group of islands. Orpheus Island was a day's paddle north. To get there, I skirted the western shore of Fantome Island, past shallow bays and coral reefs that jut out of the water as the tide recedes. Only

six months before, Cyclone Yasi had hit the area with devastating force, and the evidence of the storm was still very clear. Huge swathes of trees had been flattened by the wind, as though dropped in a game of pick-up sticks. Sections of beach had been reshaped by nine-metre ocean swells that hauled coral from the deep and dumped it in long, towering dunes, now bleached white by the intense sunshine. Cyclonic winds are selective. The damage was total in some areas, while a few hundred metres away there was no evidence at all.

We spent two days moored off Orpheus Island research station, a James Cook University facility that sits on one of the most beautiful and diverse bays on the island where it is sheltered from the intense winds. Snorkelling and diving among the 320 different types of coral found here gave the crew ample opportunity to relax while still working, as we logged and photographed the things we found. From here we passed the eastern coast of Hinchinbrook Island, my original source of inspiration for the expedition, and took shelter in one of Dent Island's bays as the wind started to strengthen. The Hobie could handle wind speeds of up to 25 km/h, but anything past that and the risk simply wasn't worth it.

Dent Island bore the brunt of Cyclone Yasi, with wind speeds of 250 km/h smashing into the island from the Category 5 storm. On a visit two years before the resort looked idyllic with its palm tree–lined beach, swimming pool and beachfront bar full of happy tourists enjoying their holiday. One night of carnage changed everything. Every tree had been snapped, the roofs of the buildings peeled back like tins of sardines and the immaculate pool filled with sand, the storm surge dumping the entire beach 20 metres inland. We wandered round the buildings in awe of the mess that remained, and left feeling depressed. What had so recently been a luxury retreat now resembled a war zone. It was a harsh reminder of how fragile life in tropical waters on the edge of the Great Barrier Reef can be.

With a lull in the wind we made the decision to sail east to the outer Reef for two days' diving, unsure what we'd find when we got there. With no island to hide behind, the Reef offers virtually no protection if the wind or swell gets up, and the risks are high. Paul's skills were brought to the fore as he navigated through the myriad coral bommies scattered around the inner sanctuary of Yamacutta Reef. Jay stood on one bow and I on the other watching for obstacles, calling directions to Paul at the wheel.

The protected lagoon inside the reef is as smooth as a millpond with impossibly blue skies reflecting from it. It was hard to see the definition between ocean and sky. For two days we dived and snorkelled, becoming familiar with the immaculate reefs just a few metres away from the yacht.

The crew worked hard in their roles, spending time in and out of the water. We updated the expedition website every few hours, sending more images, blogs and video online than ever before. The real-time snapshot of the Great Barrier Reef I wanted to create was happening. Things were going well.

Losing a friend

I'm still not entirely sure of the chain of events that led to the start of the end for us.

We were in the tender on the way back to the yacht after a dive when Jay and Paul started to argue. Something had gone wrong with our surface-watch procedure and the tender wasn't waiting for the divers to surface where it should have been. It was a serious breach of our safety procedures. By the time we got back to the yacht accusations had been thrown and tempers lost. The tensions I thought we'd buried back in the Whitsundays burned brighter than ever. Jay stormed off, not wanting to listen or reason. Paul skulked around on deck cursing and I was left wondering how to get the crew dynamic back together before something serious happened.

Conversation was almost non-existent on our sail back to the mainland. Jay wore a frown like thunder. Paul muttered away to himself under his breath while Sophee and I talked quietly about how on earth we were to handle the situation.

Early in the afternoon we anchored off Mission Beach and prepared to go ashore. One of the expedition's sponsors, Youth Hostels Australia (YHA), had offered us free accommodation any time we made landfall near one of their backpackers' hostels. It couldn't come soon enough. Paul would stay on board, while the rest of us made for the backpackers'.

That evening Jay still wouldn't talk. The situation was fast becoming ridiculous. I knew I needed to talk to him but had to speak through Danni just to get an answer. I called Kayleen, the project manager, to see what my options were.

'There are two ways it can go, Ben. Either they resolve their differences or one of them will have to go,' she said bluntly. 'You need to forget that it's your friend and look at it from a professional point of view. The expedition is at stake here and you can't go on without a skipper.'

I headed to the dining area where Jay and Danni sat to one side of the room having dinner. Jay spotted me and looked away. I knew the time had come to sort this out, so I put my expedition manager head on: 'Jay, today has been awful and it can't keep going like this. I know you have problems with Paul and vice versa. But for the sake of what we're trying to achieve here, can't you just try and sort it out?'

Nothing. Not even a glance.

'Look at where we are and what we're doing.' I tried to put things in perspective. 'You're on a yacht, sailing up the Great Barrier Reef and being paid for it. There are people who would give their left leg to be where you are right now!

'I need a skipper for the adventure, and that *has* to be Paul. Yes, it would have been great if it was you, but you don't have the right paperwork for that. So we're left with this situation. Either you both sort things out or one of you will have to go. Whatever happens I'm finishing this expedition.'

I'd as much as fired my best friend. There was no going back from here. When Jay decides to do something he sticks by it. I knew this from years of travelling, working and playing with him.

He walked away. Danni got up to follow.

'Danni, I understand your position and will respect your decision if you choose to go too, but please understand this has no reflection on you or the work you've done,' I said trembling, trying to salvage something from the situation.

An hour later, I drove Jay and Danni to the bus station. We shook hands in silence, and then he turned and climbed onboard. I haven't seen or heard from Jay since.

Run to the Endeavour River

Kayleen flew up from Brisbane to join us the next day. We had to have a fourth member of the crew as part of our safety plan; plus having her with us was a reward for the time and effort she'd put into the logistics and planning. There was no better person.

We waved goodbye to Mission Beach and our problems. There was a different feeling onboard now and the change of crew signalled the start of the second part of the expedition — my run to the finish line. I was deeply saddened by what had happened, but I knew it was the best thing for the expedition.

Paul raised the anchor as I prepared my kayak on the deck of *Sunshine*. There were a few running repairs to carry out on the rudder and sail system, but after three months in the water my little yellow Hobie was holding up well. I was raring to get paddling again though. After the few days' hiatus exploring the Reef, then the stressful stop on the mainland, all I wanted was to get out onto the ocean and hear nothing more than the sound of my paddle cutting through the water.

It was less than 300 kilometres to the lighthouse at the entrance to the Endeavour River beside Cooktown that would signal the end of the journey. If the winds stayed from the south-east, I could sail it in a week but with two PR stops still to go, in Cairns and Port Douglas, it would be more like three.

I was concentrating so hard on repairing the Hobie that I failed to spot the motionless whale-island that had just surfaced off our port side. Paul suddenly cried out as he cut the engines.

'Ben look, there's a whale just there. Is it moving? Is it dead?'

I looked up from the kayak and, sure enough, no more than 20 metres away was the vast dark back of an adult whale. Sophee and Kayleen raced out from below deck, eager to see this wonder of the deep up close. We'd almost stopped moving, slowly drifting alongside, all of us watching in anticipation.

There was no sign of life. Its huge body merely floated on the surface. Then its tail moved, not much, but enough to let us know it was there, and alive.

We stood motionless, enchanted by being so close to such a mammoth beast.

'Do you think there's anything wrong with it, Ben?' Sophee asked.

'I have no idea, but it seems pretty relaxed. Maybe it's just sleeping?' I replied.

A few seconds later, its pectoral fin started to move, a long slow movement alongside its body, then the other side did the same, as though it was starting to wake up. *Sunshine* was only 20 metres away now. The light wind had gradually pushed us towards the gigantic

plankton eater, and with hardly any wave motion it was easy to see the dark shadow below the surface.

It gave its tail a flick then another, only quicker and with more force. Another long drag of its fins and it propelled itself through the water, moving forwards with surprising speed. It flicked its tail one more time, then next to its huge body a small grey lump appeared in the water alongside, bobbing up and down, resting against the flank of the whale.

'What *is* that?' Kayleen asked.

I had an idea but wasn't exactly sure. 'I've read somewhere that new-born humpbacks are a light silvery colour... you don't think that could be its baby?'

We leant against the rails of the yacht, transfixed by what we were watching. The grey lump started to move and twist before it suddenly expelled a breath of exhaust air in one short blast.

'*No way!* It *is* a calf,' I cried out. 'Look!'

A tiny tail appeared from the water (as tiny as a baby whale gets, anyway) and thrashed at the surface a number of times, followed quickly by its fin. Whatever was happening we were first on the scene and the *only* observers!

For the next 15 minutes we watched one of the most beautiful things I have ever seen. That peaceful mother whale had been giving birth to her tiny calf at exactly the moment we stopped alongside, the blast of air its first in our world.

I ran below, grabbed the camera and started shooting. This was the perfect experience to share on my blog. The wind had pushed us further now, slowly taking us from the scene. The four of us stood on the deck, warmed by this wonder, basking in the glow of it.

Later that morning we lowered the kayak back into the water. I needed to get going if I was to make it safely to our next overnight stopover. Time, tide and whales wait for no man.

* * *

Two weeks later, with the population centres of Cairns and Port Douglas behind us, I was into the final 100 kilometres of the expedition. This is the only place on the planet where two World Heritage sites run side by side — the Great Barrier Reef and the ancient Daintree Rainforest.

Tracking close to the coast I could see mangrove-lined rivers winding inland where saltwater crocodiles feed. With this thought my paddling became a little more urgent and even the most innocent splash in the water nearby had my mind playing tricks on me.

Below me, members of the most diverse underwater community on the planet would occasionally come up to say hello. Turtles were the most common visitors along the edges of the reef as they surfaced to breath every few minutes. Long tom fish would dart out of the water at lightning speed, skimming the surface in front of me. Shoals of baitfish, surprised by my silent arrival, would leap from the water and dive again for cover. The ocean this far north teems with life. Very few people live along this coastline, with only the odd eco-resort and mud-crab fisherman — making an interesting contrast between total luxury and total recluse — drawn to this place.

Sailing, paddling and pedalling the last 20 kilometres to the headland at Cooktown was poignant for me. It was the end of another huge chapter in my life — a journey that had taken 18 months to plan and four months to execute. I'd made many new friends along the way, and lost one I never thought I would. And it proved to me that Sophee and I would last forever. If you can share the close confines of a small yacht, living, working and sleeping together, then you're good for life.

My time on the Coral Sea was drawing to a close, and as we passed the famous Endeavour Reef I thought about the harrowing time Cook and his crew must have experienced, their ship stuck fast on the isolated coral reef, many kilometres off an unknown land. I had travelled a mere 1600 kilometres up the Queensland coast in a kayak; 240 years ago Cook had crossed the world with no chart plotter, GPS, PLB, EPIRB, lifejacket or support boat.

On the morning of my arrival in Cooktown the wind was howling at 50 km/h, whitecaps whipped off the surface, and a big ocean swell pounded the rocky bays and headlands that jutted out from the coast. My Hobie was racing along, a tiny triangle of sail all I was brave enough to show. I'd made it this far with no major breakages, and with the media waiting upriver I wasn't going to risk anything now.

Rounding the final headland into the Endeavour River, I saw *Sunshine* following obediently behind. Paul, Sophee and Kayleen were all on deck, ready to celebrate with me — either that or they felt too seasick below!

From a distance I could see Mum and Dad waving enthusiastically on the pontoon I'd been told to head for. Around them were television cameras and some of the Tourism Queensland staff who'd helped make the expedition possible.

I furled in the sail for the last time, pulled my outriggers in and secured them, and dropped my pedals back into their slots. I'd have to pedal the remaining few metres through the crocodile-infested waters.

I leapt from the kayak, stepped into the muddy water and grabbed the bow line, towing my kayak behind. Davo, my trusty mascot was still on the bow where I'd cable-tied him the night before we set off on day one, a little faded now and a few of the corks on his Aussie hat were missing, but he'd weathered the elements rather well.

Mum ran down the slipway towards me, followed closely by Dad and I went to meet them, hauling the kayak as far from the water as I could.

'Oh Ben, well done my son. You've done it and I'm so proud!' she said with tears in her eyes.

The television cameras were in our faces but I didn't care. I was thrilled to have made it to the end. At the top of the slipway the statue of Captain James Cook stood proudly guarding the entrance to the river. It seemed only fitting to head over there and pay my respects to the great man.

The Best Expedition in the World was over. All that remained now was a day of media interviews and then a huge sail south to deliver *Sunshine* back to Hamilton Island.

CHAPTER 7

Aussie 8

'Okay Ben, I want to do something big, something to really challenge us. I reckon we should try to run a marathon on each of the seven continents around the world.' Luke offered with an expectant smile on his face. 'I've put together this spreadsheet that'll explain everything.'

I've got a plan

Luke is a planner; someone who works meticulously to ensure that every detail of a project is taken care of and no stone left unturned, minimising the chances of failure. He also likes a challenge, usually a seriously physical one that pushes his body to the limits of endurance. To Luke, a run is not a run unless it involves at least an hour of heart-pounding, calf-cramping tracks that undulate like an AC sine wave. We're very much alike in that way.

We'd met the year before when I was working full-time as Tourism Queensland's Ambassador. Luke worked for Brisbane Marketing. The corporate lifestyle we both endured — being stuck inside a concrete box, stapled to a weekly routine — was eating at both of us. A mutual friend introduced us one lunch break at 'Run Club'. This group was an outlet that restored our sanity, a chance to pull on the running gear, lace up the shoes and hit the pavement for an hour of freedom in the middle of the day. We could let the tension of the office drift away and get outdoors for some serious sweat time.

Luke had already completed the North Face 100 km race in the Blue Mountains earlier that year, so I knew he had the mettle to take on a serious endurance adventure. But how would he feel about partnering up for something that would take much longer than 24 hours to complete? That day's lunchtime rendezvous gave us the chance to chew over a plan for another expedition. We'd come

to the table with our own ideas of a serious physical test involving something that hadn't been done before.

'I love the idea of racing around the planet. It sounds pretty gruelling and we'd travel to places we'd never normally go. My only reservation is that it's been done before,' I answered, feeling slightly deflated. 'There's a guy who did exactly this at the age of 57, only four months after a double heart bypass. Sir Ranulph Fiennes. Compared to that, ours would pale into insignificance.'

It was time to roll out the big guns, deliver my idea and see if I had a mission partner in Luke. Would he be up for a serious challenge? Or would he leave me standing at the altar, as Owen did?

'How do you feel about running up some mountains with me, and taking on the best this country has to offer? I want to run up the tallest mountain in each state in Australia. I don't think it's ever been done before, and I think we can set a record by doing it.' I'd delivered the concept; it was time to see how he swallowed it.

Luke's eyes looked away for a fraction of a second, his brow furrowed. He looked down at the spreadsheet. I had taken his plan, screwed it up and then delivered my own counter-plan.

'Let me get this straight, you want to *run* up ... how many states are there? Seven. Okay — *seven mountains* all around Australia?' As I was preparing my convincing follow-up arguments, he cried, 'Bloody oath!'

'Oh, and there are eight not seven. I've had a look on the map and I think the greatest part of the challenge is actually going to be getting to them!' My mind was already going through them in order. 'We start in ACT, head to New South Wales, then Victoria, off to Tasmania, head into the Northern Territory, back to South Australia, the long haul to Western Australia and then finish up here in Queensland,' I blurted like a hyperactive schoolboy, 'and here's the thing, because Australia's mountains aren't actually that high we try to get up and down them as quickly as possible — say, 10 days ...'

Luke seemed as intrigued as I was. This was reality TV in the making — real life with real people embarking on real adventures. I wanted to produce a documentary on the back of the expedition that showcased the awe-inspiring vistas and panoramas of the country, but I also wanted to get people up off their sofas to explore their local national parks and make them realise there's more to life than watching other people do these things on television.

I'd dreamt about this expedition — and sharing it with the world through the media outlets I'd worked with over the past few years. Yes, I would be using social media and television as the engine to get people away from their televisions and computers. But I figured that as long as I'd built this audience based on my active lifestyle, why not use it to do some good? My overriding goal would be to get the documentary onto domestic television in Australia — and I'd do whatever it took to make it happen, even if it meant filming it ourselves.

'When do you want to do this?' Luke asked, conscious we'd need some serious training to tackle even one of the mountains safely.

'I think next April would be about right. I'm getting married in November so this year's out,' I replied, thinking about my big day less than a year away. 'Well I'm getting married in March,' Luke laughed, 'so we need to make sure it's not too close to that either.'

It was going to be a juggling act making sure we preserved our new marriages while heading off on our boys' own adventure around the country.

Aussie 8 was born.

Luke and I spent the next several days poring over maps, timetables and distance tables, working out how we'd get around the sixth largest country in the world the fastest way possible. For me the planning, the logistics of making it happen, is always one of the most riveting parts of an expedition.

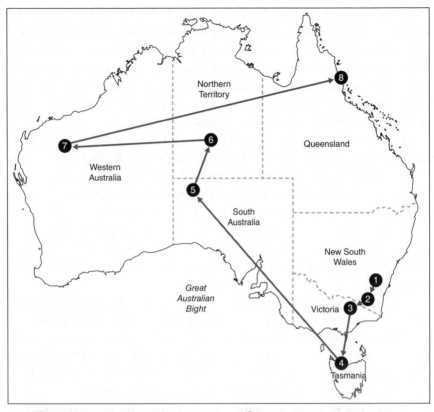

1 Bimberi Peak, 11/04/2013, 1912m

2 Mt Kosciuszko, 11/04/2013, 2228m

3 Mt Bogong, 12/04/2013, 1986m

4 Mt Ossa, 13/04/2013, 1617m

5 Mt Woodroffe, 15/04/2013, 1435m

6 Mt Zeil, 16/04/2013, 1531m

7 Mt Meharry, 18/04/2013, 1249m

8 Mt Bartle Frere, 19/04/2013, 1622m

To get around the eight states and territories of Australia in record time we'd have to fly, that much was certain. There was no way we'd have time to take on a 25 000 km road trip, not if we were going to set a record and keep our wives happy. There are only two airlines that cover the whole country and only one of those services the remote regional locations we'd need to reach to access the mountains.

Previous expedition planning had taught me that it's easy to get 'product' (read, expedition equipment) out of companies, as it's a great way for them to test it 'in the field'. However, getting cash or a contra-deal out of them is rarer than rocking-horse shit—unless, of course, you can offer them something back, like gratuitous publicity.

The Best Job taught me a lot about meeting people and networking, and dropping your business card at every opportunity or, better still, exchanging cards. You never know when that stack of cards next to your desk will come in handy. It might take up space, but it pays dividends in the long run.

Raising the capital for an expedition

If you're scoping out the idea of an expedition, funding is always one of the biggest challenges—and of course is the difference between success and failure. The best-planned expeditions will remain nothing more than pipe-dreams if the cash flow isn't there, and there are only so many times you can beg, borrow, steal or re-mortgage your house to make them happen.

Publicity is one of the keys to a successful pitch. The company you're approaching will want to be persuaded that they're going to benefit from this newfound relationship. If you offer something they can't achieve through their own public relations or marketing team, then you've won half the battle.

Taking their message to the world through your endeavours is a great way to maximise exposure and is the starting point for a great alliance. It was exactly this opportunity I saw with QantasLink.

QantasLink, Qantas's regional subsidiary, runs a fleet of small planes to middle-of-nowhere places with weird names like Paraburdoo, Wagga Wagga and Kununurra. Our route for Aussie 8 would take us to some of these remote locations. We wanted to get as close as we could to each of the starting points for our ascents — in a seriously mountainous country they'd be referred to as basecamps; in Australia they're merely car parks.

In the process we'd provide Qantas with publicity and media exposure for their involvement. It was time to kiss some corporate ass or we'd have to dig into our own pockets to the tune of $30 000 — the cost of 10 flights for three people around this big red lump of rock once known more eloquently as the Great Southern Land.

Visualising your dream and being able to convey it to a marketing team with energy, belief and passion in 30 seconds takes a certain kind of skill. You must be clear about what your proposal is, what you can deliver to them and what you expect in return. Walk into the room with a smile and greet them with a handshake. Remember, whether you're at an African border post or in the boardroom of a multinational company, no one shoots you when you've got a smile on your face.

Your 30-second pitch

In business it's sometimes referred to as 'the 30-second elevator pitch': how do you get your message across by the time you hit the ground floor? Be clear, concise, powerful, visual, targeted and goal-oriented, and leave them with a hook, wanting more.

That final handshake as you leave the room needs to sign and seal the deal. It's at this point I hand over my 'one-pager', an essential document that summarises your pitch, something for them to read once you've left the room so they don't forget you.

We spent the next few weeks going over the logistics of the expedition: flight times, time needed to run up and down the mountain then drive to the next one, where we'd stay, hire cars, fuel needed between airports, service station opening hours, transit times and so on. Our daily lives continued as usual, of course, with Luke crunching numbers at Brisbane Marketing and me blogging away at Tourism

Queensland. We met twice a week, once for a training session on Mount Coot-tha (at a whopping 287 metres above sea-level it just about qualifies as a mountain in Australia, and is one of the only serious inclines around Brisbane), and once to sneak out for our all-important Friday morning *mystery meeting*.

Most people who work in a corporate job know that it entails sharing your every movement with managers and colleagues. Holding this 'official' meeting once a week with Luke was the best way to explain our absence from the office. What, specifically, we were discussing was irrelevant; it was a chance to brainstorm the logistics and planning. The problem was that we were adding things to the to-do list quicker than we were ticking them off.

While working at Tourism Queensland I travelled around the state for all manner of events—heading out into the dry and dusty outback on 4WD charity adventures; presenting television programs for foreign film crews about the Great Barrier Reef; even a few trips escorting journalists on 'famils' (familiarisation trips). One of these famils brought journalists together from around the country to experience Tropical North Queensland, an area that spruiks itself as 'Adventurous by Nature'. My job was to chaperone the media darlings while they had a go at stand-up paddle boarding, mountain biking and other adventures designed to test their city-mettle.

Before this trip, I'd read through the upcoming itinerary and list of attendees. It was a list of the usual suspects: lifestyle magazines, weekend newspaper supplements, and then my eyes latched on 'Patrick Kinsella—Editor, *Get Lost Travel Magazine*'. Hmmm, he could be an interesting one. I'd read the magazine a few times and really liked it. I felt an affinity with the writers as they told tales of far-off adventure, often having to drag myself back to reality from the world they took me to. I'd have to wait and see who Pat would turn out to be.

* * *

A wall of tropical heat and humidity hit me as I left the air-conditioned terminal building at Cairns Airport. A summer's day here is like opening an oven door when you're roasting a chicken. The super-heated air knocks you back and you immediately start to sweat.

Living in the tropics means moving from one micro-environment to another, over and over again: heat and humidity to AC, AC to heat and humidity. I'm not a great fan of air conditioning. Driving

through the Sahara in a Land Rover Defender, probably the least well ventilated vehicle in the world, proved that.

As I waited at the pick-up lane in front of Cairns Airport, an overloaded car pulled alongside. A man dressed in cycling shorts and t-shirt jumped out, legs covered in mud, a baseball cap masking his features.

'Are you Ben?' he asked in an English accent.

'I am indeed.'

'Sorry I'm a bit late; I've just ridden the Bump Track on someone else's mountain bike and realised I was running late so had to race here to meet you!'

Pat had arrived.

We spent the next few days taking part in all manner of adventurous activities that were laid on for us as though they were lifted out of a thrill-seekers' guidebook to Queensland: paddle boarding and snorkelling with reef sharks around Low Isles off Port Douglas, kayaking the Babinda Creek in torrential rain, trail running around Dunk Island at sunrise and racing the barge from Townsville to Magnetic Island on surf skis.

Pat collected material for his writing as I blogged, photographed and videoed everything we did. We broke for dinner one night and headed to the restaurant where we were staying at Mission Beach. Being guests of the local tourism board meant everything was laid on, including a sumptuous dinner, drinks and the great company of one of the local adventure race organisers, Richard Blanchette.

'I'm going to have to leave you for a local tourism committee meeting, if that's okay,' Richard declared after dinner. 'Bob Katter is coming along and I'd like to introduce you to him if possible.'

'Sure, no problem,' I replied nonchalantly. I figured one more federal MP wouldn't be that different.

As I wiped away the remnants of my dessert, I felt a hand tap me on the shoulder.

'Mr Katter, I'd like to introduce you to Ben Southall.'

'G'day mate, how's it going?' the inquirer barked. 'They tell me you've got the best job in the world, is that right? So what on earth are you doing here?'

Bob's abrasive voice and directness caught me off guard. 'Umm we're here scoping out the course for an adventure race later in the year,' I stumbled, slightly stage-struck.

'Oh, I see,' Katter rapped back, his hand now firmly planted on the crutch of his trousers as he adjusted his crown jewels for all to see. 'Well, I've got an idea for an adventure race.' This should be good, I thought. 'We all fly into the outback by muster chopper, jump on dirt bikes, race as fast as we can to the coast where we swap them for jet-skis and see who gets to the beach first.' Right there, political gold, and probably the reason you're not prime minister!

After 30 minutes of eclectic banter the night drew to a close, Pat and I bade our farewells and made for our rooms, having shared a special evening. I love a crazy politician as much as the next guy, but that was unreserved genius.

Driving between locations the next day gave us plenty of time to talk about our lives before arriving Australia. How did two Englishmen from almost the same neighbourhood get to be driving the east coast of Australia together doing fun shit like this? As I dug deeper into his life and he into mine, we realised our paths had been pretty similar. Travel, adventure and telling stories were part of our everyday lives. I don't want to be remembered simply as 'the guy who won the Best Job in the World'. I'd like people to think of me as an adventurer, a traveller with a purpose, someone who encouraged people to get outdoors and explore the planet for themselves.

'Would you be interested in writing a story for *Paddlemag*?' Pat asked. 'People would love to hear about your kayak journey up the Reef and what's in the pipeline next. In fact, you haven't told me yet — what *is* the next adventure?'

I hit Pat with my marketing spiel, unwrapping the complexity of the Aussie 8 task that lay ahead, describing how high the peaks were, the distance between them, and our ongoing training in preparation.

'Well, it sounds all right, but hasn't someone been up all of them already?' Pat asked in a rather dismissive way.

Damn. I'd wanted his reaction to be one of enthusiastic admiration, seeing something he'd write stories about, not something he'd dismiss as unoriginal and prosaic.

'Ummm … yeah … a few have, but nobody's ever tried to do it under time pressure,' I replied, slightly miffed at myself for having left out this crucial part of the challenge. 'So if I can race around the country and tick them all off in anything under three months I'll have set a new world record, in theory …'

That should impress him, give him a sense of the grandeur of the conception.

'And how long do you think it'll take?'

'If the logistics work out, our flights are on time and we don't break anything, we should be able to finish in 10 days.'

'Now that would be impressive. It's a damn big country and from what I've seen of Tasmania and the southern states they're still pretty big climbs.'

I could tell Pat was intrigued now, but what he said next totally threw me.

'Is there room for another person to come along with you... like me?'

Luke and I had made this *our* big adventure. *Was* there room for another person? Wouldn't it make the logistics even more difficult to organise, and with Pat living in Melbourne and us in Brisbane how would we train together? There were other serious considerations. Adding another person to our partnership—someone we didn't know that well—could jeopardise our plans. I could imagine some of the 'pressure cooker' situations the expedition would throw at us: cramped vehicles with minimal food and sleep, driving long distances in the heat of the outback. I knew from previous experience that working and living in close proximity in an expedition environment can stretch even established friendships to the full.

The decision in my head wasn't 100 per cent made, but my mouth blurted out the answer without really consulting my brain. I responded as I have done so often in my life: jump in *now* and deal with the consequences later.

'Pat, I'd love you to take part. You'll have to do some serious training over the next few months, and I'll have to run the idea past Luke of course, but why the hell not? You can get some great publicity for us too!'

The countdown

With Christmas out of the way, we had four months until we hit the slopes of Bimberi Peak, our first Aussie 8 mountain challenge. And there was still so much to do. Luke and I trained every Thursday

morning on Mount Coot-tha overlooking Brisbane. We set off at 5 am, hauling backpacks loaded with 8 kg of weight up the excruciatingly steep Kokoda Track over and over again. Adding repetition work to the monotonous distance running we were doing twice a week was essential not just for our own sanity, but to build those all-important calf muscles that would heave us to the summit of the eight mountains.

Over the course of six weeks, we increased from four climbs to an impressive 10 ascents of a slope that still fills me with fear and trepidation. I remember that feeling of virtually passing out and being sick at the same time, and looking across to Luke at the top of the final climb and thinking, *if it's hurting him as much as it's hurting me, then we're doing something right.*

Pat was monitoring our updates from afar. He was paddling his surf ski every day rather than trail running, so his training was much more upper body than lower — not ideal for running up mountains. Though I had confidence in his mental approach to the expedition, there were some serious question marks over his outright fitness and ability to keep up, especially on the later mountains when we would be counting on our endurance and stamina, something you build up only from countless hours' training on the trail.

Logistically, things were starting to fall into place. We'd been working closely with the team at Qantas on their latest timetable, which allowed us to plan our itinerary — on paper, anyway. We all know air travel is subject to unexpected delays; all we could do was march forward in good faith knowing that the information we had in front of us was what we had to plan to. We'd deal with any unforeseen issues if and when they occurred.

My previous adventures hinged on securing support from a number of sponsors. Companies are more than willing to help supply an expedition as it costs them virtually nothing. Gaining hard cash sponsorship through cold approaches to private companies is seldom successful, but a personal link to one of the management team, a board member or even the CEO helps.

Failing that, think about what makes you and your project uniquely appealing.

What can I offer a sponsor to sweeten the deal?

Planning your first expedition is a huge task to take on, and sponsorship is just one of the many elements needed to make it happen on time and on budget.

There's no such thing as an easy leg-up if you're chasing hard cash, but over the years I've learned that coming to the table prepared and ready to offer something in return for your chosen sponsor's support can result in more than just a pat on the back and a polite rebuff. If you're really lucky you may get a smile and a nod, or the chance to come back and do it all again with the person who *actually* holds the purse strings.

- **Use social media**. Do you publicise your life through social media? How many followers have you got on Twitter? Are your posts shared and liked on Facebook? Do your blog posts get lots of visitors? All of these platforms offer potential exposure to your sponsor, so make sure you deliver a snapshot of your global geek-reach.

- **Create a media report**. Collect all the press exposure you gained from a previous adventure. Totalling up the PR value is a great way to show off what you can achieve.

- **Befriend the media**. Build a relationship with your local media well in advance of departure. Do something to create a bit of media buzz!

- **Use logos, banners and naming rights**. How much exposure you'll need to give a sponsor will depend on how deeply they are prepared to commit to your project. Value your primary sponsor spots accordingly: featuring their company name or logo on the front page of your website or giving them naming rights to your entire project needs a pretty serious cash injection.

I knew the Aussie 8 expedition would be a serious test of both physical endurance and logistical planning. Three people who barely knew each other would be squeezed into a stinky social cauldron of rental car back seats, backpacker hostel bedrooms

and airport gate seating areas. Add minimal sleep and tired bodies to the mix and I couldn't ignore the potential for an explosive, expedition-ending bust-up.

What we needed was a weekend away; a chance for the three of us to meet properly for the first time, plan the final details, mull over the challenge ahead, share a beer or three ... oh, and maybe even go for a run together. No work, no girls, just us, a mountain and total adventure.

Trying to find a weekend and a trail-running event somewhere between Queensland, where Luke and I live, and Melbourne, where Pat rather inconveniently chose to reside, proved to be a little problematic. If I was free, the other two had 'family' duties; if they were free, I'd be off gallivanting around the country with work. Finally one weekend when all three of us would be free stood out like a shining light on a stormy night — the Mount Baw Baw running festival two hours outside of Melbourne.

We upped our training in preparation for the event, and Pat finally acknowledged the logic to lacing up trail running shoes and hitting the hills every morning instead of paddling across the frigid waters of Port Phillip Bay.

Two days before we were due to fly to Melbourne, Luke rang me, explaining a little awkwardly, 'Er, Ben, I've got a bit of a problem. It's not going to jeopardise the Aussie 8 expedition proper, but it means I won't be able to run this weekend.'

His words brought back Owen's six years before as he'd backed out of Afritrex. 'Is everything okay?'

'Well it sounds serious, but apparently I'll be out of my cast in a couple of weeks.'

'You've got a bloody *cast*? What the hell have you broken?'

'The doctor tells me I've got a grade 2 stress fracture of my right tibia caused by overtraining.'

There's much to be said for being at the peak of your game, the height of your fitness and ready to take on the world when called into action, but if it means breaking yourself in the process it does no one any good. I had the utmost confidence in Luke, though. If he said he'd be fit in time I could count on it.

I stepped and Luke hobbled out of the terminal building and out into the bright Melbourne sunshine, the cool Victorian winter's day very different from the Brisbane humidity we'd left only a

couple of hours before. We dragged our expedition holdalls stuffed with sponsored Mountain Designs gear across the waiting area to the kerbside. It wouldn't be long before Pat arrived and I'd know for the first time if we'd end up as the Three Amigos or the Three Stooges—the fine interpersonal balance of an expedition team is crucial to its success.

Just as at our first meeting in Cairns a few months before, he careered into the car park at the last minute, arriving like a man with too much on his plate.

'Hey Ben, how are you? And you must be Luke, finally we get to meet in the flesh!' Then he noticed. 'Er, that cast doesn't look like you'll be running anywhere soon?'

'Don't worry about it, Pat. It'll be off before you know it,' Luke replied with well-rehearsed optimism.

With a weekend of adventure ahead, we made for the exit and hit the road to Mount Baw Baw, two hours east of the city, close to some of the biggest mountains in Australia. The Three Amigos were together for the first time. Our plan suddenly seemed very real, and I liked the feeling.

* * *

The next 48 hours were perfect practice for the Aussie 8 expedition. Focusing our weekend on a mountain marathon gave us a great sense of what it would be like to live, travel, run and work in close proximity to each other.

That night we pored over the maps and itinerary, confirming every last detail of the challenge we were set on. We rechecked the flight and drive times and figured out where we'd refuel the hire cars. We knew that every minute would count towards making the connecting flights that were essential to our success.

Meantime our flights were due to depart from Melbourne airport at 9 am the next morning, giving us a three-hour drive from the mountain resort. We packed our bags and weary bodies into the car and hit the pitch-black back roads of Victoria's alpine region. Thirty minutes later, a flashing beacon up ahead brought us to a grinding stop. Pat wound down his window and was greeted by a stern-faced road worker holding a glowing wand.

'Sorry guys, you won't make it through here for at least a couple of hours. A semi-trailer has rolled down the embankment and

there's some serious shit to clear up before we can open the road again.' We looked at each other. Luke and I would miss our flight back now for sure, unless of course we could find another way round. 'You could go via the village of Moe, but it'll add at least 50 kilometres to your journey and it's a hell of a windy drive,' came the helpful response.

Three hours later we screeched into the departures lane at Melbourne Airport and just made the gate in time to board the flight home. It was a serious wake-up call to what we could expect during the Aussie 8 expedition.

Trying to set a world record driven by an itinerary with so little margin for error opened up the risk of failure due to any number of incidental causes, from flight delays to bags lost in transit to road works, or even a missed morning alarm as the exertion of the challenge took its toll. At this stage, we just had to believe in our plans and do everything we could to stay ahead of the itinerary by pushing ourselves as hard as possible on the mountains. Of course, that was easier said than done.

I worked with Tourism Australia throughout the launch of their Best Jobs in the World campaign early in 2013 and had forged a great relationship with the team there. Early on they'd seen in Aussie 8 the perfect opportunity to combine our brand ethos of 'find adventure in your own backyard' with their National Landscapes program. We'd travel through five of their recognised areas of outstanding natural beauty during the challenge, and filming a documentary that would capture the beauty of these rarely visited parts of the country would help draw attention to them and increase visitor numbers.

I wanted to have a film crew along for the entire adventure and produce a documentary that would air nationwide, one that would deliver a real account of how good life can be if you set yourself goals and try as hard as possible to achieve them.

Enter Gordo and the team from Nothin' But Shorts, a production company based in Sydney with years of experience covering some of the most extreme adventure sports in the world's most inhospitable locations. If anyone could keep up with three hyped-up adventurers running up mountains, they could.

I spent most of January racing around the country—six states in just over three weeks—filming a series of clips for Sunrise TV, road-testing each of the new Best Jobs for Tourism Australia, from

racing camels in the Northern Territory, to diving with manta rays in Queensland, to stuffing my face with chocolate in Western Australia.

What it did give me was a sense of the scale of the task we'd be taking on in just a few months' time. Travelling across Australia isn't easy. It takes five hours to fly from coast to coast and driving anywhere often takes a lot longer than planned. The change in climate from one city or region to another means having clothing ready for all conditions, from the chilly rain of the south to the scorching dry heat of the red centre. It was something I hadn't completely appreciated when I started out.

One last scare

With a fortnight to go before the start of Aussie 8, everything appeared to be on track. Our incline training sessions on Mount Coot-tha had reached their peak. I remember looking across to see Luke pale faced and about to faint at the top of the final 1:2 climb, suffering from the 'butterfly effect', as he called it. It was good to know he was putting in the same effort I was.

The media had picked up on the adventure too, with requests for radio and television interviews coming in fast. These all helped drive visitors to our website and social media pages, which in turn brought messages of support from around the world. It was wonderful seeing people getting motivated to push themselves a little further, even *before* we'd started the actual expedition.

Luke and I headed off to see Matt and Tony, our go-to partners with the project's main sponsor, QantasLink. We had to nut out a few final arrangements, check and double-check the flights for the three of us and the film crew of Gordo and Viv.

Tony's brow was furrowed as we entered the boardroom. 'Lads, I'm struggling to get this across the line with the team down in Melbourne who make all the decisions on sponsorship.'

'What do you mean?' I asked, my stomach sinking.

Luke glanced anxiously across to me. Surely this couldn't happen at the eleventh hour, not after all the planning, training and commitments we'd made over the last year? They wouldn't pull the rug from under us like this, would they?

This wasn't the time to beat about the bush. We needed answers now.

'Be honest with me, Tony. How likely is it that they won't support the expedition at all and we'll be left stranded with no flights and have to buy them ourselves ... or even worse, can the entire project?'

'Look, I'm going to do my best to make it happen, even if I have to do it from my own budget. They just haven't given it the green light yet.'

We left the meeting feeling dejected, having lost all confidence that things would go our way. We were dealing with a huge company. We hadn't even met the decision makers in Melbourne and there was no written contract between us, just a gentleman's agreement and a handshake.

I was at home that evening when my phone rang. At first I was too absorbed in updating the Aussie 8 Facebook page to hear it ringing away in the bottom of my bag. An unidentified Brisbane number flashed up on the screen.

'Hello, Ben speaking.'

'Ben, it's Mark from Qantas.' My heart immediately skipped a beat. It had been a few hours since we'd spoken and the passage of time had only increased my fears. 'I've got some good and bad news for you ... They've given us the go-ahead for all of your flights *and* the film crew's!'

That's *awesome* news. Well done, Mark, I could bloody kiss you!' I whooped at him. 'Hang on, what's the bad news?'

'Nothing major. They just want you to write an article about the adventure for our inflight magazine once it's over,' he said, quietly chuckling, knowing I'd been expecting to hear something a little more drastic.

'I'll bloody well write it now if they need me to!'

Aussie 8 was now definitely happening. We had just four days until that first flight to Canberra — they couldn't have left it any later to give us the green light. I got off the phone to Mark and rang Luke and Pat with the good news.

* * *

The reality of what we were about to take on over the next 10 days started to dawn on us as we arrived at the airport. An hour before, we'd said goodbye to our understanding wives. Sophee and I had been married for only six months and I'd spent two of those flying around the country on work assignments. Luke was pushing the

marital boundaries even further, as he and Bonnie had tied the knot only 10 days before. Now we were both heading off again, this time to some of the most inhospitable parts of the country.

As we walked into the arrivals area at Canberra Airport, my phone flashed up an incoming message: 'Missed my flight guys. Sorry. They've got me on the next one though. Will be an hour late'. Problem #1.

I gave Luke the bad news. Luckily we had built in a day's leeway in the city for preparation before starting the expedition itself.

We headed for the baggage carousel, where a friendly voice announced, 'You must be Ben and Luke. I'm Anthony Gordon and this is Viv', introducing the girl who stood beside him, both of them dressed ready for adventure.

Gordo and I had spoken at length on the phone over the past few weeks but had never actually met. His production company, Nothin' But Shorts, had been instrumental in getting our pitch across the line at Tourism Australia. Their experience of filming extreme sports in remote locations around the globe meant we'd secured the funds required to bring them along to capture the 10-day adventure. Twenty minutes later I was standing in exactly the same spot at the carousel when the flashing orange beacon stopped and the squeaky belt ground to a halt. I was *that* person left waiting expectantly for the bag that never turns up.

I sauntered across to the lost baggage desk, explained my predicament, filled in the form, cursed a little and wandered back to the group. 'It's coming … just not on this flight,' I explained dejectedly. Problem #2.

Not even one day in and we were already one person and one bag short. If this happened on any of the next seven flights we'd be taking, it would derail any chance of keeping to schedule.

Problem #3 was only a short hop away at the car rental desk. To keep costs down, we'd booked as big a vehicle as our budget would allow. What we *hadn't* taken into account was quite how much gear the film crew would be carrying, including boxes, bags, tripods and of course their own bags. After three attempts at squeezing everything in using every conceivable corner of the estate car including the glovebox, we reached the somewhat obvious conclusion: we needed a bigger vehicle.

After some deft negotiating with his contact at the rental company, Luke returned to the car, looking suitably pleased with

himself. 'Avis has upgraded us to a people carrier at each of our rental locations — free of charge!'

Later that evening, after we'd settled into our YHA accommodation in the city centre, both Pat's and my bag arrived. The five of us made final preparations. It was like Christmas Day, with new head torches, socks, shorts and even ready meals exchanging hands. The only problem was where to store everything. One thing was certain: we'd have enough gear with us to change all our clothes right down to our socks every day. The value of this can't be overstated when you're travelling in such close proximity with four other people.

Sponsors need a return on their investment, that was a given. In the lead-up to the launch we'd used our PR networks to help generate some fantastic interest, and the day before the launch was dedicated to being full-time media whores. We'd talk to anyone and everyone to get our message into the public domain, but we hadn't dreamed we'd get the response we actually did.

I'd given television and radio interviews before we'd left Brisbane. Sunrise TV, Channel 10 and the ABC were all interested in what 'the guy who'd had the best job in the world' would do next. Now here we were at Parliament House in Canberra on a cool, bright autumn day with Assistant Minister for Tourism Don Farrell wishing us well in front of numerous television, radio and print journalists.

With the formalities over, it was off to our next appointment, with the British High Commissioner, His Excellency Paul Madden. He'd asked us to attend an event he was hosting to recognise Indigenous Australians who'd gained scholarships to Oxford and Cambridge universities in the UK, something very few people achieved.

Halfway through his talk, Paul alluded to our expedition, referring to 'three guys at the back of the room who are setting out to achieve something out of the ordinary'. Hearing that felt good and made the handfuls of crustless cucumber sandwiches seem a little more worthwhile as we carb-loaded ready for the next day's big send-off.

Referencing the 1990s Ferrero Rocher advert in the UK ('the Ambassador's receptions are noted for their exquisite taste'), we left a box of the ostentatious gold gems on Paul's entrance chair before hitting the road south.

It was time to set a record.

1. Bimberi Peak, ACT

Height: 1912 m above sea level
Climb: 1192 m
Distance: 22 km return
Time: 5 hr 6 min
Date: 11 April 2013

The crunch of frost on canvas introduces me to the frigid morning. I shrink back into my warm cocoon, recoiling from the chilly conditions outside. I haven't camped somewhere as cold as this since my drive back over the Alps in 2008 at the end of Afritrex. A glance at my watch confirms that my body clock has done its usual trick, waking me 15 minutes before my phone's harsh alarm would tear through my eardrums.

Zipping open the tent door reveals a magical panorama. Moonlight still bathes the frosted heathland, creating sparkles as far as the eye can see, my exhaled breath turning the cool air to steam.

Bodies stir in the tents around me; yawns and stretches can be heard and pools of light illuminate up our surroundings as head torches are flicked on. One by one we give up the warmth of our tents, set about our preparations and think about the scale of what we are about to undertake.

Breakfast is a gutful of porridge and banana washed down with hot tea. Luke, Pat and I are wrapped up in several layers and still shivering. The temperature is hovering around freezing but with first light just appearing on the horizon, it won't be long before the warmth of the day melts our icy fingertips.

Gordo grabs a quick interview with each of us as we check our route for the umpteenth time, start our watches and plod off into the darkness — destination Bimberi Peak, around 11 kilometres away.

There are times in life when I find myself doing a double-take on exactly where I am and what I'm doing. Experiences and moments like these are exactly what I live for — striding out across the frosty expanse of a part of the world I've never visited, not knowing what lies around the next corner.

We follow the Australian Alps Walking Track through eucalypt bushland, across open pasture and along muddy tracks, slowly gaining elevation, the vague outline of the distant mountain range drawing closer through the early morning darkness.

Our pace over the ground is good. We've run only once together as a team, at sunrise the day before, and that was only to the top of Parliament Hill for a quick shakedown of our gear. Three runners with different styles, speeds and body shapes are now working as one, steadily ticking off the kilometres between us and the summit.

Our specific roles in the group are falling into place too. With our commitments to social media, sponsors and the documentary team, we have our work cut out to capture the different aspects of each climb.

Gordo has given us three video cameras for each climb (2 x Drift, 1 x GoPro). We'll film everything on the trails while they will concentrate on filming our departure and arrival at each basecamp, along with capturing the essence of the mountains; the timelapse and b-roll footage that will make the documentary about so much more than just three idiots running.

Pat needs great photos to back up the stories he'll be writing for his magazine, which means stopping every half an hour to set up the shot. Luke and I grab every opportunity to update our social media platforms wherever mobile phone reception allows. I have to keep my audience abreast of the adventure and Luke has to reassure Bonnie he hasn't been eaten by the Great Australian Drop Bear.

After two hours on the trail the GPS indicates a sharp turn to the north. From here we'll leave the beaten track behind and bush-bash our way to the still unseen summit. With the clock constantly ticking we need to ensure every step we take is in the right direction. Before departure I preloaded the waypoints of each of the eight summits into my Garmin Montana, and as we hit the first real incline on Bimberi Peak I'm glad I did.

Clambering over fallen trees and scrambling around large boulders, we finally break out of the bush and onto a discernible track. Looking up from my feet and GPS for the first time in a while, there in the distance is the sight I'd researched on the internet: the summit marker of our first mountain.

'How good does that look?' Luke blasts out with determined intent.

Ten minutes later we race the final few steps and touch the trig point on top of Bimberi Peak, at 1912 metres above sea level the highest point in ACT. After a quick celebration it's down to

business: Luke is absorbed in taking photos, Pat fills in the visitors' logbook and I fire up the video camera to record our first ascent.

I check our stats on the GPS. 'Lads, we've just knocked off 11 kilometres and climbed 700 metres in two hours, which puts us well ahead of schedule. Let's make sure we eat and drink according to plan, even if we don't feel hungry. We've still got a massive task ahead of us.' Once we make it back down to basecamp there's still a two-hour drive to Thredbo before setting off for the second mountain of the day — Australia's highest peak, Mount Kosciuszko.

By now the sun has broken the distant horizon, contrails temporarily scarring the sky out to the east. Beneath a crisp, clear sky rolling mountain ranges drop into mist-lined valleys. The sheer beauty of this early morning panorama is a feast for our eyes; I suspect at that moment we are the only ones around to witness it!

We throw on our sweaty running packs, bite off a final mouthful of energy bar and hastily retrace our route back down the mountain. The confusing mass of fallen trees and rocks we struggled through on the way up is much easier to negotiate on the descent and we fly down the mountain, although I am conscious of preserving my weak ankles as we race along. During training in the weeks leading up to the expedition I rolled both on the slopes of Mount Coot-tha, and one loose footing could have devastating consequences.

We turn left onto the road nearly five hours after leaving it. The complete darkness at the start masked the remote beauty of our overnight camp. Wild brumbies romp in the distance. Bubbling springs splash beside the gravel road. We drink in our surroundings silently with a shared sense of wonder. But unlike the horses we have a timetable to stick to: 150 kilometres along twisting mountain roads lies the winter ski resort of Thredbo, our basecamp for the second climb of the day — Australia's highest mountain, Mount Kosciuszko.

On paper, the mountain looked so much more manageable than in reality. At the planning stage, taking on two big climbs on the first day appeared perfectly feasible. What we didn't allow for is the lack of sleep last night from last-minute work and nerves, missing out on a proper lunch and spending two hours with our legs squashed together on the drive in between. There are better ways to prepare.

'Hi, we've got a few rooms for the night, booked through your head office,' I declare at the Thredbo YHA front desk.

'Oh yes, you're the mad guys who are racing around the country, aren't you?' comes the informed reply. 'You're in a bit of a hurry I imagine, so here are your keys.'

Sixteen minutes later we all meet outside with clean socks, charged batteries and freshly vaselined balls and toes to reduce chafing on the 22 km run that lies ahead.

2. Mount Kosciuszko, New South Wales

Height: 2228 m above sea level
Climb: 863 m
Distance: 22 km return
Time: 4 hr 5 min
Date: 11 April 2013

Gordo and Viv just missed the final ski-lift but somehow managed to talk their way onto the staff lift, the last of the day to bring workers back down from the top. Apparently adding aerial footage of us struggling up the serious inclines will make great television.

There are two official routes to the summit, via Charlotte's Pass and Dead Horse Gap Track. Both are fairly long but neither is particularly challenging, especially after Bimberi Peak. With time running against us, the most obvious route appears to be straight up the horrific-looking slope dead ahead. My body flinches involuntarily as I take it in. It's time to fire up my chicken legs and go for it. Luke and Pat seem ready. A few stretches, another mouthful of energy bar and we're off.

Minutes later my heart is pounding like a metronomic boxing glove, my lungs are bursting and the lactic acid coursing through my legs renders them weak and unresponsive. I can't let the guys down, but I wonder whether the morning's efforts have done for them too.

I glance at Pat and see that he's struggling. Sweat is pouring off Luke's cap, discomfort tattooed across his face. Now we're on the face of this ugly climb, I begin to doubt that our training schedule has been intensive enough to carry us through.

'Guys … let's walk it out for a bit or my legs are going to cramp up big time,' I splutter, gasping for air.

'Thank god you said that. I was close to breaking too,' Pat replies.

The clouds seem to hug the land ahead as we pass the last of the cable car stations. So far we've been pretty lucky with the weather,

with only light drizzle here and there. With the sun dipping towards the western horizon we're now contemplating a finish in the dark, something we wanted to avoid at all costs. Trail running is an amazing sport when you can see where your feet are landing, but taking away daylight adds both exhilaration and danger to the equation.

The metalled track between us and the summit seems to stretch on to infinity. The track offers the everyday hiker a stable, secure route across the open mountain range. To us it delivers a slippery, dangerous surface on which our tired legs falter on more than one occasion. Maybe that's why the sign at the edge of the trail clearly states 'No running'.

The Rawson Pass junction signals the final section of the climb to the roof of Australia. We've covered 32 kilometres since sunrise, and the thought of three more before we can turn for home doesn't fill me with joy. I turn my mind to the cold beer waiting for us back at the YHA. With light rain starting to fall we don our Mountain Designs Gore-Tex jackets; there's no point catching a cold up here.

Our last 500 metres to the highest point on mainland Australia are nothing short of majestic. As we take the final steps to the 2228 m summit, the clouds in the west part, sending the most intense orange sunlight through the rain and deep into the valley below, as though a flaming cauldron has been fired up for our arrival, so we send cheers and hoots back down in gratitude.

Formalities on the summit are intense but brief. Photos are taken, short pieces filmed for the documentary and, thanks to near-perfect cell phone reception, we update our social media channels, keeping followers up to date with our progress.

With daylight fading and bodies tiring we turn and start the 12 km descent towards Thredbo. Two hours later we stumble under head torches into the twinkling lights of the town and a feast of takeaway pizza.

We've been up for 18 hours and have run over 43 kilometres — not bad for the first day. My head hits the pillow hard.

The next morning, my eyes squint through the darkness at the glowing iPhone rudely vibrating on the bedside table. It's 3.30 am and time to move. Day two of Aussie 8 is here.

Ahead of us lies a huge day: a four-hour drive to Mount Bogong and a bruising 1200 m ascent up the infamous 'Staircase' to the summit.

Race back down, then a four-hour drive to Melbourne Airport, a flight to Launceston and finally a two-hour drive to the world-famous Tassie Tiger Bar at Mole Creek, our basecamp for Tasmania's highest peak, Mount Ossa. Simple enough.

Passing through some of Australia's most beautiful high country at speed is a stupid way to explore it for the first and possibly only time. It's not that we're breaking the speed limit, but we are missing out on the wonderful views still cloaked in darkness.

As the first splashes of light penetrate the distant horizon the silhouettes of mountain ranges flash between the breaks in the treeline, offering glimpses of what we've been missing. As we drop into the valleys between, cool mist engulfs us, reducing visibility to a few hundred metres. Our headlights pick out wallabies and kangaroos as they bound across our path.

'I think this is the turn-off.' Luke mumbles. 'Yup, pull in here. I can see the sign up ahead.'

3. Mount Bogong, Victoria

Height: 1986 m above sea level
Climb: 1535 m
Distance: 18 km return
Time: 6 hr 26 min
Date: 12 April 2013

We arrive at the Mount Creek picnic area, jump out of the car and ready ourselves, heavy with the task ahead. When we researched Mount Bogong (Aboriginal for 'Big Fella') a few months before, the trip reports kept referring to 'The Staircase', a gruelling 1200 m climb that opens out onto relatively flat sections. With the weight of yesterday's double ascent still filling my legs like a tonne of lead, I'll need a while to get the blood pumping through them again — ideally via a long, flat section and then a gradual, slow climb.

We wave goodbye to the film crew and made our way along the single track that winds its way through the huge eucalypt forest. There is little conversation as we trudge towards our first checkpoint, the three of us pondering the brutal ascent that lies ahead. I take a moment to look up. Off to our right I can see the spine of the hill climbing sharply from the forest floor; the entrance to Staircase Spur is upon us.

The Best Job in the World

My legs are turning over like a slow-revving diesel engine now. I place one foot in front of the other, knowing there's no point in running the steep sections. I know that a fast pace will save my breath and be a much better approach than using up all of my energy and collapsing in a heap.

The coolness of the morning seems to disappear within minutes of starting the climb. My body heats up rapidly until sweat is seeping from every pore and even my legs are wet from the exertion. It's not long before my feet are squishing in my saturated socks every time they hit the ground. This is a clear warning sign. If we don't keep drinking every few minutes, we'll dehydrate pretty quickly, which we have to avoid at all costs.

We carry three litres of water in our Salomon running packs, along with another bottle of electrolyte drink on the straps to keep our salt levels topped up. It's amazing how much dried salt sticks to your face and body towards the end of a long run. It's this we need to replace to ensure cramps and muscular problems don't start to cause problems at the end of each day.

I'm breathing much harder now too. Rather than sticking to my usual one breath in, two out I can feel my lungs screaming for more oxygen and start to pant like a dog. I turn around to see how Luke and Pat are dealing with it and notice they've dropped back a long way. I'm dragging them up the hill at a pace that's overstraining all of us.

As we approach the treeline, the windblown skeletons of dead snow-gums stand out along the ridgeline, their bone-white branches reaching up like dead fingers from the surrounding green alpine landscape. It's as though a recent flood or napalm attack had killed them and life has yet to return.

We pass the Gadsden Monument, a tribute to four climbers who perished in a blizzard in 1943, and a harsh reminder of how quickly the weather can shift. From here the track follows the exposed ridgeline all the way to the summit. With the wind cutting though our soaking wet running gear we pull on our Gore-Tex jackets. Three hours and 15 minutes after leaving the car park we're on top of the tallest mountain in Victoria. Summit number three is ticked off the list and we're feeling proud of our achievement.

Our descent is nothing short of breakneck: we tear down the mountainside, hopping down steps, leaping across tree roots, eyes darting between foot falls, micro-adjusting every step to keep our

balance. So far we've avoided a single fall and my ankles have held up under the constant pounding.

Being in full flight through an Australian national park, with two friends racing alongside, is a privilege for a trail runner. It's tough to look up from the track but when I stop and take in my surroundings I feel my connection with the planet return, a sensation you just don't get living in a city.

The waters of Mountain Creek are like an ice bath to our aching bodies. We spend as long as we dare soaking away the efforts of the day in the babbling stream that runs alongside the car park before preparing to move on. We have an evening flight from Melbourne Airport that won't wait for us.

<p align="center">*　*　*</p>

Check in the hire car, trolley our gear to the Qantas counter, update our Facebook page, website and social media platforms and try to relax. We saunter to the departure gate for our evening flight to Launceston, Tasmania. Once on board I pick up the inflight magazine and read all about this wonderful part of Australia we'll be visiting for all of 36 hours. One day I'll come back and spend serious time here.

What seems like minutes later we are loaded up and on the road — destination: the Tassie Tiger Bar at Mole Creek.

The lights of the pub glimmer through the rain that streams down the windscreen. Twenty minutes ago, the night was perfectly clear and I was optimistic that our brief venture into Australia's southernmost state would give us a wonderful day on the trail. How wrong I was.

I check into my plush 1980s décor room, spread my wet gear over the chunky oil-filled radiators and head downstairs to join the team in sampling a pint of the local ale. We've been on the go for 20 hours and I'm beginning to fade. The beer will ensure the nervous gremlins inside me fall asleep at exactly the same time I do.

4. Mount Ossa, Tasmania

Height: 1617 m above sea level
Climb: 1539 m
Distance: 42 km return
Time: 10 hr 28 min
Date: 13 April 2013

I awake to the sound of rain on the tin roof. Not light, pattering rain but a heavy, thumping downpour that resonates through to my warm, dry bedroom. *Urrrghh!* Within an hour we'll be out in it, soaked to the core. But this is what I signed up for — rain or shine. I'm up and out of bed even before my iPhone's electronic wake-up fanfare has a chance to shock me into consciousness.

I've been looking forward to exploring Tasmania during the months leading up to the expedition. Friends and family who have visited tell of beautiful panoramas and stunning national parks comparable to parts of the west coast of Scotland, where I spent many childhood summer holidays and fell in love with the great outdoors.

Even with torrential rain I can't wait to get out and explore it. I pull on fresh socks, dry running tights and a warm Gore-Tex jacket and gorge on a hearty breakfast. We'll be carrying all our food and water supplies for the day, and with a full marathon ahead it makes sense to fill up now before heading out to face the full brunt of the weather.

The hire-car wipers labour hard all the way to the car park at Mole Creek. Our headlights pierce the darkness, throwing their beams out into the heavy curtain of rain that stops them well short of their usual range. We drive for an hour on tarmac before turning onto a small forestry road that leads to a smaller track and arrive at our destination without passing a single car. It would seem even locals and hardened hikers have decided to stay at home today.

I pull my shoelaces tight, unroll my hood, draw it over my head and fire up my head torch. With sunrise still an hour away we'll need them to find our footing on the waterlogged track that lies ahead. Unlike our climb on Bimberi Peak I doubt we'll see the sun for the first half of the day at least; this will be a very different day in the saddle.

Within 500 metres of the car park my socks are sodden. With water rushing down green, moss-clad gullies before spilling across the path, there's no way to protect them. Even stepping carefully across the slippery rocks means submerging our feet to just below the ankle. This is like winter running back in the UK!

'How epic is this, guys!' Pat shouts, his voice just breaking through the din of the rain on my hood.

'How different is this!' I holler back. 'And how good does it feel … but I'm soaked to the bloody core.'

For all my discomfort, I just have to look up and take in the surroundings to be reminded how lucky I am to be here. It's easy to forget about nipple chafe, hotspots on your feet or sore knees when every few kilometres the view just opens up and delivers landscapes like nothing I've ever seen in Australia.

The path winds through Cradle Mountain–Lake St Clair National Park, past old growth forests, typical Australian bush, along bouncing swampy walkways and across the occasional suspension bridge.

As we approach New Pelion Hut, the halfway point of our outbound leg, huge rock walls tower through the low clouds in the distance. The sheer faces of the Walls of Jerusalem peek out momentarily from the murk above. Pademelons (small marsupials that resemble wallabies) hop lazily through the puddles, some almost close enough to touch. They're a pretty hardy creature living in one of the coldest parts of the country with little shelter from the elements. Without any natural predators, only the occasional overzealous hiker will give them cause for alarm.

The hut is a welcome sight. We arrive to curious looks from the early-morning hikers only now waking from their comfortable, dry beds. The sight of three sodden souls dressed in lightweight running gear and carrying next to nothing on a day when the heavens are fully open will do that.

Socks hang from drying racks and the smell of bacon wafts from the kitchen as we sit on the benches to refuel and take in the view. A park ranger makes his way over to us, keen to interrogate the newly arrived drowned rats.

'G'day guys, where've you come from so early in the day?'

'We left Arm Road before sunrise and are making for the summit of Mount Ossa. How do you think it'll be up there?'

He looks us up and down. 'It was a glorious day yesterday. You should have been here then! But dressed like that with conditions like today? Good luck!'

Not the blessing we hoped for. Thoughts of running aground on the Reef during the Best Expedition run through my head. I know first-hand how quickly an expedition can be thrown into disarray by a simple mistake. Imagine if we got ourselves stranded on a mountain through ignorance or injury. Heaven forbid, the press would have a field day.

I rummage around for the PLB (personal locator beacon) buried deep in my bag. If things do go wrong out here in the wilderness a simple press of the button will be enough to alert the emergency services to our position. Though it might not save us, it's a precaution we were required to take by our commercial partners.

We head out into the grey gloom, the summit of Mount Ossa still eight kilometres away. The rain hasn't eased at all. The rocky path ahead has disappeared under a torrent of water and now resembles a fast-flowing stream, not the easygoing trail we'd read so much about in our preparation.

The Overland Track is usually a busy hiking route during April, but with the conditions as they are today it's empty. No doubt some have chosen to wait for a break in the weather; maybe some have decided to cancel their entire trip.

A sharp right turn signals the one-way track to the summit. After checking the GPS and maps for confirmation we optimistically scan the horizon for signs of our destination. All we can see is the next 300 metres of track; anything past that is lost in cloud.

The track narrows and starts to climb. We are walking more than running now, picking our route carefully through the rocky landscape. With no horizon for reference, I use the compass and GPS to maintain our direction. It would be easy wander off and lose the track up here.

With less than a kilometre to go, the ascent becomes serious. Our progress is slowed to little more than walking pace, then it's a measured, hand-over-hand climb. My fingers and toes are numb as the rain turns to sleet and blows at me in sheets powered by the rising wind, chilling me to the core.

Pat and Luke crest the first false summit ahead, exposing themselves to the full force of the howling wind. Until now the rocky path has protected us but as we clamber up onto the spine the buffeting gusts almost blows us back down the sheer slope. The sleet and wind chill drop the temperature to well below zero as we cling to the side of the wall.

'Jesus boys, I'm cold,' Luke stammers, his blue lips contrasting with his white face.

'Me too,' I reply, teeth chattering. 'Maybe it's time to put on our base layers?' We need to protect ourselves from the elements. Our exertions together with the effects of exposure on our brains have somehow delayed the simplest of decisions. We've run to the top

of the highest mountain in Tasmania dressed in little more than lightweight running gear.

I throw my jacket down, bracing against the wind whipping across my body, pull my Merino base layer over my wet arms, and hurriedly drag my jacket back on. My fingers fumble with the zip and toggles before I'm locked away, protected from the world outside. I feel the positive effects immediately, as the lightweight, ultra-soft wool hugs me.

I follow the GPS track up onto the exposed ridge until we are as close as we can be to the summit. With no obvious marker or trig point, it's hard to tell exactly where the highest spot is, but we're certain we've made it all the same.

We rattle through our video and photo tasks in double-quick time before beginning our descent, desperate to get out of the hypothermia-inducing conditions. There's no point standing around to take in the view, as there isn't one!

The rain doesn't ease up the whole way back to the hut; in fact, it only gets heavier. By now the track is a raging torrent, easier to run alongside than through. I'm glad we double-bagged everything in our running packs last night. Ration pack number three is bone dry as I rip it open for a feed. Potato crisps, muesli bars and chia seeds have never tasted so good. I was careful to conserve my water consumption on the previous climbs but here, with flowing water all around us and the halfway hut ahead, there's no need to hold back. I gulp down the last few mouthfuls, refill, zip up and head out into the elements for the final 13 kilometres back to where we started the day.

The beauty of the landscape through which we're running finally comes into view as the brisk wind parts the clouds. We're travelling parallel to a long, dark lake surrounded by marsh grass and low trees angled towards the horizon, disfigured by the prevailing wind. Behind us, the ground juts towards the heavens, granite monoliths forced from the valley floors at the dawn of time, now softened by the elements. Lichen and moss colour the rock like nature's own graffiti.

We've been running for 10 hours straight and the end of the day is fast approaching. As we hit the final few metres back into the car park my Garmin watch records that we've run just over 41 kilometres that day. Pat, having never completed a full marathon before, decides he'll keep going for the full distance down the road. And because an ultramarathon is defined as any distance over 42.2 kilometres, Pat

not only runs his first full marathon but goes on to complete his first ultra!

<p style="text-align:center">* * *</p>

We'd thoroughly earned our pints at the Tassie Tiger Bar that night. It had been a slog to get through the savage conditions and now as we sat and refuelled on hotpot and apple pie we could look back at the toughest climb so far, knowing we'd formed a special bond through adversity.

5. Mount Woodroffe, South Australia

Height: 1435 m above sea level
Climb: 742 m
Distance: 11 km return
Time: 4 hr 2 min
Date: 15 April 2013

Day four is more about travel than running. We catch a dawn flight from Launceston to Melbourne then board another to Alice Springs, three hours away. We are headed to our YHA base and the start point for the next two mountains, Mount Woodroffe in South Australia and Mount Zeil in the Northern Territory.

Leaving Tasmania's wintry conditions behind us, we touch down in Alice with the mercury resting on 32 °C. We need a change of clothes to suit the conditions. We leave our thermals and jackets in storage at the YHA and head for the local outdoor clothing shop to buy one of the most essential items of kit for life in the red centre — a frillneck sun hat. We have a 300 km drive south on the Stuart Highway into South Australia before turning due west along a red dirt road that stretches for 130 kilometres to the lands of the Anangu Pitjantjatjara Yankunytjatjara people.

Expeditions like Aussie 8 are as much about logistical preparation as they are the physical challenges. Each mountain stage requires a different organisational approach to ensure everything is in place for our arrival and departure. One, however, proved more problematic than all of the others put together.

Mount Woodroffe is as close to the centre of Australia as you can get. It lies deep in Aboriginal land and plays a major part in the spiritual history of the people who live there. A permit is required,

both to enter the land and to climb the mountain, and an application can take up to six months to be granted.

I'd started my conversations over email with the area's Land Manager, Doug Humann, in early 2013. He'd explained how we'd receive authorisation only after each of the five village elders had agreed that our visit wouldn't damage the integrity of the community and that we wouldn't film or photograph any of their sacred sites or the faces of their people. One of the elders' biggest concerns was that if we were injured or, heaven forbid, died on the mountain, it would leave bad karma for their spirits. Of course, we wanted to avoid such a scenario as much as they did.

I called Doug the week before the expedition started to see how our application was going. Leaving things to the last minute really isn't my style, and I was starting to get more than a little concerned that this administrative issue would prove more of a hurdle than flying 15 000 kilometres around the country and running 150 kilometres in eight states. I raised my concerns with the utmost diplomacy. 'Doug, we're a few days away from the start of our expedition. Have you had any updates from Peter [the last of the elders whose agreement we needed]?'

'Ben, these things don't just happen overnight. Peter lives three days' walk from Ernabella at the base of Mount Woodroffe and he wants to meet you in person before deciding whether or not he'll let you climb the mountain. He's off on walkabout now and I can't get in touch with him. He doesn't have a phone and email's out of the question. So all you can do is wait.'

I didn't like this one bit but had no choice but to suck it up. All I could do was hope and believe that by the time we got to Ernabella, something positive had come through from Doug.

On our arrival in Canberra my phone finally delivered a reply from Doug with the good news. Peter was on his way to Ernabella, where we would meet with him to get final approval to climb his mountain. There were no further details about where, at what time or how to find him: 'Just drive into town and ask around. Everyone knows him.'

* * *

Our headlights reach far ahead as night approaches on the eastern horizon. We've driven for five hours and finally arrived on the outskirts

of Ernabella. Stray dogs skulk off into the bush, abandoned cars line the street, a young boy picks up a pedestal fan and appears to chuck it through a windscreen off in the distance. No one inside the car says a word but we are all thinking the same thing: Where the hell are we? And are we *really* going to stop here for the night?

I pull the car up outside a rundown property, its kitchen light casting shadows across the yard.

A young boy approaches but keeps his distance. 'Whaddya want, mister?' His assertive voice belies his age.

'Er, we're trying to find one of the elders, Peter. Do you know where he might be?' Even to me I sound every inch the nervous Englishman in a foreign land.

'Foller me.'

And with that, he takes off across the dusty yard and into the darkness. By the time we've caught up with him we've driven deeper into the town. Curious locals peer out of doorways, suspicious of the new arrivals.

The boy saunters over to my window and says, 'He's over there', pointing towards a small brick building in the distance.

I knew that imposing on Peter's evening might not be the best way to kick off our relationship, but I needn't have worried. Peter is standing in the open doorway.

We spend the next two hours slowly but surely laying Peter's fears to rest. Eventually he invites us to erect our tents outside his home and bids us goodnight. The sounds of the night aren't nearly as scary knowing we've found a friend.

The day dawns on a very different world from the one we glimpsed last night. It's just an ordinary little town; nothing untoward looks like it's about to happen. When Peter finally emerges from the darkness of his smoky room, his full white beard splits and he delivers a beaming smile and a hearty laugh as he remembers the new arrivals camped on his doorstep.

He hasn't yet said he'll grant us permission to climb his mountain, and I'm certainly not going to rudely ambush him with the question. We just have to tell our story and wait. For the next two hours we listen to the story of his travels and admire his treasured collection of old family photos, then Peter picks up his message stick and starts drawing lines in the sand representing the town and the mountain.

'We go here and I leave you here. You'll do your run, then sun come, moon come, rain come...' His voice trails off, before he erupts into the most wonderful full-bellied laugh I've ever heard. He jumps up, grabs his Hello Kitty pink backpack and makes for the car. We're off!

Our route to the top of Woodroffe begins only four kilometres away. We've stupidly assumed an easy run to the summit. This isn't Tasmania, though. There's no well-trodden path, no running water and certainly no signs pointing us in the right direction. For the first time on the expedition, we have to bash our own route to the summit.

Making a beeline for the summit waypoint we have in the GPS probably isn't the most sensible thing to do. All guns blazing we tackle the steep ascent head on, picking our way around and over the large, abrasive red rocks that litter the hillside. As our feet fall between the rocks I imagine we could inadvertently disturb all sorts of creatures. It's the middle of the day and temperatures are already hitting 34 °C, perfect for snakes to slide out to sun themselves. We're a good three hours' drive from the main sealed road, and another three from Alice Springs. Now wouldn't be a good time to get bitten (as though there was a good time). My eyes are working overtime scanning the ground ahead, checking for signs of movement.

Our task is made more difficult and dangerous by the presence of another silent enemy, spinifex grass. In the lead-up to the expedition I read many horror stories about this round, hardy, spiky bush. With spines as long as your hand, they're so tough they don't break if you stand on them. The final few millimetres simply break off in the offending body part, and this can often lead to infection. The slope ahead of us is all rock and spinifex as far as the eye can see.

Scaling the last few metres to the ridgeline, I'm feeling pretty chuffed with myself. The gaiters I'm wearing have stood up to the battering and we've taken only an hour to reach what we assume is the final few metres to the summit. How wrong we are!

In front of us lies another huge hill jutting up from the valley below. We've somehow climbed a false summit that lies between us and the actual peak of Mount Woodroffe. This means a descent of 100 metres before climbing another 600 metres to the summit proper, and the path is just as tough and challenging as before.

'Never underestimate the power of a sacred mountain!' I shout to Luke and Pat as we race the last few metres to the stone cairn, 'That was much harder than I thought it would be!'

We follow the usual top-of-mountain protocols, taking photos, recording our interviews and enjoying the view. This *really* feels like the centre of Australia. The ground is bright red ochre rock and very little appears to live here; the barren landscape and arid conditions make sure of that. In fact the only life we've seen since leaving the car are the thousands of flies. Our sun hats really come into their own here, shielding us not only from the intense sunshine but also from these marauding assassins. Through the small gap we leave for our eyes we gaze out over the parched land that stretches away to infinity and the distant West MacDonnell Ranges.

'I'm sure that's Uluru off in the distance,' Pat pronounces, having spotted possibly the most famous monolith in the world. Sure enough a little blip breaks the horizon 100 kilometres to the north, its unmistakable outline leaving no doubts in our mind.

'How cool is that!' Luke replies. It's the first time this Australian has actually seen this iconic destination that draws so many international tourists every year.

With the heat of the day beating down relentlessly, we have to move. Mountain number five has been conquered, but we still face a steep descent and a long drive before we can rest our weary bodies. We avoid our previous mistake and choose the more logical route around the second peak rather than over it. Our path follows the track along a dry riverbed, passing through a stunning cutting complete with green rock pools beneath sheer cliffs.

* * *

After successfully negotiating both the administrative hurdles and the difficult terrain of Mount Woodroffe, the 120 km drive back to the main road feels like a victory lap. The expedition had delivered us a treat of an experience through our interactions with Peter the elder. Our fuel gauge read less than a quarter of a tank. It was time to pull into the last service station before the final 150 km slog back to Alice Springs.

Also filling up at the pumps was a white Toyota Corolla with a sign stuck with electrical tape across the back window. It was indecipherable from a distance but as we approached I could finally make out the words: 'Tony Mangan — Ultra Runner'. We were about to get an education from a really committed individual.

I walked into the dimly lit service station to the sound of an irate Irishman complaining: 'Whaddaya mean the kitchen closed 10 minutes ago? I've run 65 kilometres today and I'm dying for a burger. Surely you can open it up again for me?'

'Sorry mate, ya missed it. The chef's packed up and gone home,' came the unsympathetic reply, 'I don't care if you've run from bloody Timbuktu!'

'I ran halfway across the world to get here tonight, but don't let that worry you. I've got a packet of biscuits for moments like this,' Tony replied sarcastically.

People told us we were crazy taking on something as 'out there' as the Aussie 8 expedition, but this wiry Irishman with the tired old running kit hanging off his body — well, surely he was the epitome of crazy. For two and half years he'd literally been running around the world, having started at the Dublin Marathon in October 2010. By the time we met him he'd racked up nearly 30 000 kilometres, running across Canada, North and South America, and the length of New Zealand, and covering over a marathon a day. He's still got to cross all of Asia and mainland Europe before he's finished. His a achievement certainly gave us food for thought — and a bit of motivation — as we drove through the night back to Alice Springs.

6. Mount Zeil, Northern Territory

Height: 1531 m above sea level
Climb: 1031 m
Distance: 18 km return
Time: 6 hr 23 min
Date: 16 April 2013

Day six starts with the usual rude awakening from my phone. I'm getting used to the morning ritual of lowering my achy legs down from the comfort of my bed and testing that initial step to see how fatigued they are. Nothing feels *too* bad so far, and we've ticked off five of the mountains. I'm thinking the adventure isn't actually going to prove that challenging physically ... but then again we haven't got to Mount Zeil yet.

And we don't have the easiest time finding it.

'It's back the other way, I'm sure. We've missed the bloody turn-off!' I shout. Somehow we've managed to drive 50 kilometres past

the dirt road we're supposed to take off the highway to the base of the mountain. Maybe we *are* getting tired after all. Our bodies and minds have been racked by six days of long runs, minimal sleep and cramped conditions driving monotonous outback roads. Little mistakes are starting to creep into our decision making. Further evidence of this comes as we are kitting up ready for our ascent a couple of hours later.

'Ah crap, I've forgotten my head torch,' Luke exclaims, cursing his stupidity.

'No way…me too! I'm sure I put it in here last night.' I fumble through my running pack, convinced I've just overlooked it.

'We're not going to be much use with just one, are we?' Pat says. 'Now we *have* to be down by last light. Game on, gents.'

We've learned relatively little about Mount Zeil through our research. Lying 150 kilometres from the nearest town makes it pretty isolated, so it receives relatively few visitors. Only one person who has climbed to the top has ever written about the experience online, an account we therefore take as gospel. It details the route in from the dirt road to the 'car park' and the best entry and exit points for the climb. Luckily it also includes a GPS track of the route, which I've added to my GPS. Now it's just a question of following it. Up and up the track goes, winding its way across the rough terrain that leads off into the distance. With half the day already gone and over 20 kilometres to cover, time is of the essence.

The sun is almost directly above us as we gain elevation over the first few kilometres. A hot wind driving across the arid, flat surrounding land adds to the dehydrating effects of the sun. There's absolutely nowhere to hide; it's a total contrast to the cool, damp conditions we experienced in Tasmania only two days ago.

The landscape of Mount Zeil seems raw and unexplored. There's no track to follow, no flattened grass to suggest a path; we're on our own. It's us versus nature, the planet — and ourselves.

During our run to the top the three of us bond properly for the first time on the trip. Not that there's been anything *wrong* up until now; we've just been focused on thumping through the Australian outback, three guys on a mission, all driven by the same purpose — to get outdoors and have a serious life adventure with friends.

For four hours we thread our way between rocks and giant spinifex mounds until finally the summit mast comes into view. We edge along the last steep precipice and arrive at a set of solar panels

powering a radio mast. Tucked beneath the mast is a small steel box housing the visitor's book. Pat removes it and reads the latest entries. We are the first people to reach the top for two weeks, and the last two guys arrived by helicopter. Maybe that's the only way our record will be broken in the future — flying between the summits of the eight mountains!

Time is against us. To get back to the car before dark we'll have to fly down the mountain — and not by chopper. Over the next two hours we run, leap and race our way down the side of the mountain. I lead for most of the descent, GPS in hand following the wavy line on the screen to ensure we don't head off down the wrong valley. My feet skim the tops of the rocks, spending a fraction of a second stabilising my stride before launching off for their next temporary foothold.

Trail running downhill at this speed demands total concentration. The margin for error is tiny. One misplaced foot could all too easily result in a rolled ankle, followed by the inevitable crash into an unforgiving spinifex bush. I scan the ground in front me constantly, my eyes searching out the slightest changes in the surface, my brain sending instantaneous signals to my legs and feet as they float across the uncompromising terrain.

My track record isn't good though: I fell numerous times in training, old hockey injuries making themselves felt at the most inopportune times. But so far everything is going well, and we are hitting speeds you'd expect on a flat street track rather than a lumpy, rocky mountain slope. It feels incredible to be moving across the ground with such calculated grace and speed. No one speaks, each of us locked away in our own personal battles with mind and body, and recognising the importance of total concentration.

The landscape around us glows with the ferocity of the sunset but there's no time to bask in the glory of that golden hour. Pat stops a couple of times to take photos, and drops off the back of Luke and me as we tear on. So lost are we in our own world that it takes a bellowing shout to remind us that sticking together is the best option. Pat has the only torch, after all.

The radio crackles into life with Gordo's voice. 'How are you guys getting on? It's pretty dark down here in the valley and we've just seen a dingo wander by. Be careful out there.'

'Yeah, we can't be too far away now,' Luke replies, conscious that the added distraction of Australia's biggest carnivore is now part of

the adventure. 'There's only a 100 metres of descent before we're on the plateau and then we'll make a beeline for you.'

'Don't know about you guys, but I'm not going to risk being bitten by one,' I say, bending down to pick up a cricket ball–sized rock. 'Grab a dingo-rock just in case!'

So here we are, three exhausted, sunburnt trail runners winding our way through the bush of the Northern Territory with a single head-torch to guide us, our tired senses on alert for the slightest sound in the undergrowth. The light on Gordo's camera shines brightly in the distance like a star in the night, guiding us back to the support vehicle and the completion of mountain number six.

We've covered 18 kilometres of brutal, bruising terrain in six and a half hours, and the soles of my feet are feeling it. I strip off my shoes and socks and let the cool evening air wash over them, experiencing immediate relief. My Salomon trail shoes have taken a beating too. Freshly out of the box a few days before the first mountain, they now bear the scars of six ascents, with chunks of the sole missing and the tread worn down to next to nothing. They'll have to survive a little longer though, as our next chance to stop off at a Mountain Designs store will be in Cairns, and a little lump of rock in Western Australia named Mount Meharry lies between us and there.

We gorge on food and electrolytes on the drive back to Alice Springs, having burned up more than 5500 calories through the day. Arriving back in Alice Springs at 10 pm, the neon signs of Domino's Pizza are the only lights still burning brightly as we trawl the streets for something to eat. Conversation is decidedly limited as we satisfy our monstrous appetite. I wouldn't normally grace the counter of a fast food restaurant, but tonight is different. I have to refuel, and of course it's only for the sake of the expedition and a potential world record!

Once I've got my social media commitments and the usual post-mountain interview out of the way, I hit the shower. The cold water rushes over my salt-encrusted body, bringing consciousness back to my tired muscles. But my head is exhausted, the exertions of the expedition taking their toll. Sleep comes as soon as I close my eyes.

* * *

Australia's bloody huge, that I already knew. So far we'd travelled through the south-east corner of the country to the red centre, and

now we had to fly west to the most remote substantially populated city in the world — Perth, in Western Australia.

7. Mount Meharry, Western Australia

Height: 1249 m above sea level
Climb: 512 m
Distance: 10.5 km return
Time: 2 hr 2 min
Date: 18 April 2013

Day seven of the Aussie 8 expedition is all about travel, 4500 kilometres of it. First up, a three-hour flight across the barren Gibson Desert, followed by a two-hour flight north to the mining town of Newman before finishing up with a 200 km drive to the arse-end-of-nowhere, Auski Tourist Village.

We are well and truly in mining country now. Digging holes in the ground is a national obsession in Australia and nowhere was that more obvious than on the drive to our overnight accommodation. Even the horizon appears man-made, with huge slag heaps piled into perfect flat-topped mountains. Imagine Table Mountain in Cape Town, then remove all the beauty and panoramic perfection.

As we pull into the car park of the 'tourist village', there isn't a tourist in sight. They left years ago, with truckers and mining workers taking their place. We check in and make for the restaurant before staggering back to our deluxe rooms and the luxury of a saggy, hard bed. My legs are feeling the effects of the last week of exertion, stiffening up every time I sit down for longer than a few minutes. With two mountains to go the end is almost in sight, and tomorrow's ascent doesn't even register in the 20 highest peaks of Australia. We are about to take on 'The Freckle', as I've started to affectionately refer to it — Mount Meharry.

'A four-wheel-drive track winds all the way to the summit of Western Australia's highest mountain,' reads Pat as we turn off the highway onto Packsaddle Road.

The challenge for us throughout the Aussie 8 has been to run from the unofficial basecamp of our deciding to the summit of each mountain. We aren't going to cheat and drive up, following in the wheel tracks of many a weekend warrior; instead, we'll find a suitable start point on the plateau below and make our way up from there.

There's a noticeable lack of flies as we pull on our running gear this morning. The last two climbs have been made all the more difficult by the determination of hundreds of them to squat in the corners of our mouths, ears and eyes, and their absence came as a welcome relief.

Our departure format is a set routine now. We each know our respective responsibilities. Water bladders are filled, batteries and memory cards checked, food supply bags sealed and loaded and, most important, sun cream passed around, something that's easy to forget on a cool morning.

We wave goodbye to Gordo and Viv and head south along the gravel road. There's no need to get the GPS out; the least proficient navigator in the world could find their way to the summit of this mountain blindfolded.

An hour later we summit the tallest mountain in WA, at a whopping 1249 metres above sea level. Well, 'summit' is rather an exaggeration; it's more like we *strode* up the slight incline to find a summit pole decorated with two miners' hats, a beer bottle and a barbecue grill set up next to the car turnaround area, all ready for an evening drinking session.

Even though I knew this would be the easiest of all eight ascents, I still feel a little short-changed. I came into this adventure on the back of months of training and so far, bar stiff legs in the evening, I haven't felt like I've pushed myself as much as I hoped.

I dreamt of emulating the true adventure legends I grew up watching on television, and more recently enjoyed on YouTube. Like extreme surfer Laird Hamilton, who trains by running across the ocean floor holding rocks. Or Kílian Jornet Burgada, who ascends mountains as iconic as Mont Blanc with seemingly no effort, sprinting up almost sheer slopes.

I say very little to Luke and Pat as we jog back down to the car. How can I call myself an adventurer if I only take on challenges as easy as this? My attention wanders as I dream of future adventures. My mind is working overtime, dissecting the expedition, trying to work out why I feel disappointed. From the perspective of a physical challenge it had *looked* gruelling: eight mountains in just 10 days in some of the harshest, most barren (and most beautiful) places on earth. But so far it hasn't *truly* tested me in the way I was seeking.

'Luke, grab the itinerary, will you? I want to look at something that's confusing me.' Luke spreads out the paperwork on his lap. 'Okay, so we arrive in Cairns at 10 am tomorrow and then spend the entire day waiting around to climb Bartle Frere the next day? What the hell are we waiting for?' I demand.

Luke quickly grasps my point. When we planned the expedition a few months ago it seemed like the obvious thing to do: have a relaxing afternoon when we arrived in Cairns then take on the final mountain the next day. Our research indicated that Mount Bartle Frere wasn't to be taken lightly. On a good day, it was a 10-hour slog up steep, muddy slopes with a rocky scramble to the summit, then down again — not something you'd want to take on towards the end of the day as the light started to fail.

But we're adventurers, men who like to push the limits, and we are presented with the chance to better a record we haven't even set yet. If our flights line up we have a chance of reducing the Aussie 8 from 10 days down to eight and a few hours. Suddenly this had a much better ring to it: eight mountains, eight states, eight days. The idea instantly reignites the fire in my belly. The challenge is back on.

8. Mount Bartle Frere, Queensland

Height: 1622 m above sea level
Climb: 1520 m
Distance: 15 km return
Time: 6 hr 25 min
Date: 19 April 2013

A wall of humidity hits me as I step off the plane at Cairns, much as it did when I met Pat for the first time a few months ago. Gone are the dry conditions of Western Australia. This is North Queensland at its winter best — 30 degrees and 80 per cent humidity. A bead of sweat trickles down the nape of my neck. We've chosen a hot day to attempt a 10-hour round trip in just six.

Seventy-five kilometres south we turn into the car park of Josephine Falls, the official start of our final climb. Everything around us is lush and green. We've arrived in the true tropics, with towering rainforest trees thrusting up from the fertile forest floor, twisting vines and creepers hanging from every limb.

The upper slopes of the mountain are blanketed by thick cloud for 350 days of the year. Rain falls with monotonous regularity; not today though. Picture-perfect conditions greet us as we pull on our runners for the last time. Bright blue skies stretch to the horizon without a cloud in sight, the summit of Bartle Frere just about visible away in the distance.

The biggest of our previous climbs had been a 1500-metre ascent stretched out over 20 kilometres. Bartle Frere is different, jutting 1600 metres up from the cane fields that surround its base, over just seven kilometres. This will be the greatest vertical ascent of the trip — and we have only six hours until nightfall.

'Okay, it's time boys. Stop worrying about your hair and get a move on,' barks Pat, ready to roll.

The draining humidity of the tropics is indescribable. I sweat more than the average human, so when you add a seriously steep trail run and three kilograms of water on my back, along with the challenge of setting a record, I'm leaking like a showerhead within minutes of leaving the car park.

The ecosystem we race through is completely different from anything we've experienced so far. In place of the spiky spinifex grass of the Australian outback are the strong, sharp and aptly named wait-a-while vines. The only way to free yourself from these assailants is literally to stop, walk backwards and unhook the razor-sharp barbs that latch onto any item of clothing or body part that brushes past.

A mere two kilometres from the car park the path narrows until we are forced into single file, but we're still running at a good pace under the forest canopy. Our eyes and brains are working overtime searching out a safe landing spot for the next footfall. With so much moisture, the grass grows thickly and at ankle height the edges of the path are barely distinguishable.

And then it happens. The moment I've been dreading for the past year. One of my warm-chocolate-weak ankles catches the side of a rock, rolls and sends me crashing to the ground like a bag of nails.

I stay down and grab the offending ankle tightly in an effort to stop the pain — or possibly to mask the embarrassment. I lifted my eyes momentarily to look about me, mesmerised by the beauty of where we are, and I paid the price.

Luke does exactly what I'd want him to do: he takes out the camera and starts filming. Until now we've had no drama in the expedition

documentary and as I unlace my shoe to inspect the damage he thrusts the camera in my face and prompts me: 'Tell me how you feel, Ben.'

'At the moment, bloody sore. I think I just need to get it strapped up, down some painkillers and keep going.' There, that was a manly response. It doesn't cross my mind that I won't be able to go on, that I'll have to stop and head back to the car park. This is the Aussie 8 expedition, and if I have to finish it crawling hand-over-hand then I will.

What greets me under my wet sock isn't pretty. I've rolled both ankles in the past so I know what to expect, but this time I see a serious sprain. My ankle joint has blown up to the point where I can't distinguish it from the rest of my foot; it's one fat, puffy mess.

Pat throws me the first-aid kit. We've taken turns carrying it on every climb, and finally it will prove useful. I tear open a roll of bandage and support brace and set about strapping it up as best I can. Four paracetamol down the hatch and I'm good to go, albeit rather gingerly at first, slowly pushing the boundaries of how much weight I can apply and the angles I can work it to.

The climb up Bartle Frere is the best it could be given the circumstances. It's not a huge distance to cover and our speed is limited by the quality of the trail rather than by my disability. At times we are climbing up near-vertical tree root ladders covered in light brown, slimy mud and green algae.

Occasionally we break free of the canopy and arrive at a creek crossing. They're never wide but fast-flowing enough to make us stop and consider the best route across. Most of them are spanned by fallen trees, but these are green and slippery, requiring extra attention. We're draining our water bladders very fast, gulping down two litres of water an hour as our bodies struggle to stay hydrated. The creeks provide welcome opportunities to bathe our salty faces as well as refuel.

After three hours of testing conditions the track starts to level out and follow the ridgeline of the mountain. Above us the tree canopy ends, opening up an unrestricted view of clear blue sky. The track passes an overnight rest hut complete with helicopter landing pad. It's one of the best campsites I've ever seen. We stop to take in the view. To the east the horizon stretches to infinity, the inner reefs of the Great Barrier Reef clearly visible among the ocean's sapphire blues; in the opposite direction the fertile green fields of the Atherton Tablelands, one of Australia's food baskets.

To say we've hit the jackpot would be an understatement. Normally at this time of year all this would be hidden behind thick, wet clouds and misty rain. Today is one of only 10 cloud-free days per year.

The final 800 metres to the top of Bartle Frere is a scramble and climbing it is a bit of a challenge even in the dry. But excitement is coursing through our veins and nothing — certainly not a sprained ankle — is going to slow us down.

On the true summit, our view of the surrounding lowlands is totally masked by trees and there's no way to see the route we've taken. We clamber precariously out onto a jutting rock, take a few photos to prove we've been there and prepare for our descent.

The climb took us just over three and a half hours, and with dusk approaching we need to keep going. Moving through rainforest at night on steep, slippery slopes wouldn't be much fun. The trip back down is pretty uneventful. Pat takes a good tumble and comes back up with bloody knees, but at this stage he doesn't care. We've always said our record will involve climbing *and* descending the eight mountains around Australia, and this is the final leg.

As nimbly as our tired legs will take us, we fly down the side of our eighth mountain in as many days, pausing only to share our depleted water supplies, check each other's injuries and mull over the record we are about to set.

Darkness comes earlier than we hope, with three kilometres still to cover. We've learned one lesson from Mount Zeil and each of us powers up a head torch, bathing the path ahead in bright light.

'Ah, that's better, now I can see the eyes of all the spiders before I crash into their webs!' says Pat, leading the way.

'This has been *such* an amazing adventure, guys. I'm almost tearing up at the thought of it all being over,' Luke puffs out as we run through the warm evening air.

'Come on, guys,' I pant, feeling more than a little emotional myself. 'This isn't a goodbye, more a see-ya-later. Surely we can do something after this. It's only the start of our adventures together!'

'How about the Nepalese Nine or the Tibetan Ten?' Pat shouts, laughing at the thought.

'What's wrong with the New Zealand Nine? It's a little closer to home!' I reply, not knowing I've just opened the lid on another potential expedition.

Sophee and Bonnie have flown up from Brisbane to meet us at the finish line. What's more, Pat doesn't know it, but I've secretly been working with his wife, Steph, to ensure that she and their two girls, Ivy and Alice, will be there too.

As we come crashing through the final few hundred metres of the trail, the welcome party hears us and sends a cacophony of noise back at us through the night air, sounding like a gang of hungry cassowaries.

The flicker of their torchlights in the distance signal the end of the trail. We let Pat arrive first to be greeted by the open arms of his wonderful family.

'Oh my god, oh my god, oh my god, I had no idea!'

Things to remember when planning an expedition

Setting out to fulfil your dream with a massive expedition is a must-do experience at least once in your life. Get your planning right from the start and things will go a lot more smoothly ... trust me!

But it's easy to overlook the simple things when your head is deep in the planning. The following are some of the elements that must be covered to ensure everything is taken care of *before* you leave:

- **Permits.** If you do everything by the book and want to minimise the risk of failure, ensure you have all necessary documents *before* you leave, including land access permits, filming rights, vehicle licences, visas and passports.

- **Weather and seasons.** What is the expected average weather for the area you are visiting, and how different has it been in the run-up to your leaving? It may require a rethink of clothing and equipment.

- **Emergency exit.** If things go horribly wrong, how will you get yourself and the team out safely?

- **Fuel stops.** Diesel, gas and petrol supplies can and do run out. Will you have enough to get you through if the next stop comes up empty?

- **Regional holidays.** Make sure you know when local banks, shops and borders will be closed.

(continued)

Things to remember when planning an expedition *(cont'd)*

- **Food and water.** If you're out in the wilds, do you know where the next restocking locations are?

- **Transport to and from the start point.** Book flights early, or make sure someone can drive/fly/sail you in and out of a remote location.

- **Excess baggage.** There's always more than you plan for.

- **Clothing for all conditions.** If the weather turns foul, have you got the gear to protect yourself and your equipment?

- **Power sources and convertors.** Cross a border and things could change. One international adaptor and a power board will usually suffice.

- **Back up and send home.** Don't carry *all* your important data with you. Back it up and send it by registered post to a safe address back home.

- **Spares and repairs.** Repairs in the field are cheaper and easier than sending something away to be repaired. Are you carrying the basic tools and parts to get you safely out of danger?

The best life in the world

Since leaving university in 1997 I haven't been bored. My first overseas travel adventure began a life that has been both challenging and exciting, and has almost incidentally provided a realistic way of running a profitable business. Starting small and building a trusted, successful brand are the most important prerequisites for creating an expedition and a lifestyle that pays for itself.

Developing my people skills, working hard on my projects and taking the risk to follow my dreams has opened doors that otherwise might never have been revealed. The situations we put ourselves into and the people we meet offer opportunities to network, brainstorm, float ideas and develop contacts. In a world where email, social media and online connections have largely displaced traditional modes of communication (I am as guilty of this as anyone), the art and power of networking through a face-to-face meeting or a telephone call should never be underestimated. By using a balance of all these approaches, I can foster relationships, build my audience and win the support of sponsors and business partners.

There's no point in having a dream if it stays that way. Planning an expedition, be it next week or next year, means I can focus on the things I love to do in life, which can make all the difference if I'm caught in the daily grind. Always having the next adventure in planning has become my philosophy.

Travel is the best classroom in the world. It has exposed me to life and people outside of my own community, helping me to better understand other cultures, to hear and reflect on opinions widely different from my own. I think, and hope, I'm a better person because of it, and one day I want my children too to travel and perhaps live, study and work around the globe.

Losing two great friends in tragic accidents while they were travelling helped me to realise how fragile life is — that it could be snatched away without warning — and yet what a gift it is. It was my wake-up call from a life spent 'living for the weekend', and it gave me the incentive to plan, save and execute my first expedition, Afritrex.

Since that first journey around Africa, the expeditions and travel I've embarked on have often taken me out of my comfort zone, and each time it has enabled me to better understand who I am, including my faults, and to learn from the experience in order to make the next adventure more successful.

Afritrex turned my initial selfish travel bug into 'travel with a purpose'. During my time on the road I embraced the digital world of blogging and social media to bring publicity and exposure to my adventure. In this way I developed a set of skills that ultimately led to my winning the 'best job in the world'.

What I learned during the Best Job about using social media platforms for exposure and promotion formed the model I continue to use today to market both my own brand and, more especially, the brands of the companies I partner with and the places I visit. It's a model that allows me to tell a story that inspires and motivates others.

As my brand has become more established and trusted, I have reached out and inspired a wider audience through television documentaries and other media, which has in turn made my brand even more attractive to potential partners.

The more you put yourself out there, the more opportunities come your way. Being in the right place at the right time is part of the equation, of course. I wouldn't have met my darling wife Sophee on Daydream Island were it not for the long chain of events that led me to the Whitsundays, from Afritrex to meeting Bre to filming my video to the Best Job itself. Sophee and I were married on November 3, 2012, back in the Whitsundays again.

So what's next? Close readers will already know the answer! I'll be taking on the New Zealand 9 as my next world-record challenge.

In late 2014 our team will make an ambitious attempt to complete the 545 kilometres of New Zealand's nine great walks in just nine days. Then there'll be just enough time to relax over Christmas before Sophee and I take off on our next adventure together — driving the Colonel from Singapore back to London over eight months, another overland voyage of discovery for us both.

Life is full of opportunities for adventure.

You have just one chance on Planet Earth.

Use it!

Index